Jazz IN BLACK & WHITE

Duncan Schiedt

The Photographs of Duncan Schiedt

Indiana University Press
Bloomington and Indianapolis

This book is a publication of

Indiana University Press

601 North Morton Street

Bloomington, IN 47404-3797 USA

http://iupress.indiana.edu

Telephone orders 800-842-6796

Fax orders 812-855-7931

Orders by e-mail iuporder@indiana.edu

The paper used in this publication meets the minimum requirements of American National Standard
for Information Sciences—Permanence of Paper for Printed Library Materials, ANSI Z39.48-1984.

Manufactured in China

Library of Congress Cataloging-in-Publication Data

Schiedt, Duncan P.

Jazz in black and white : the photographs of Duncan Schiedt / Duncan Schiedt.

p. cm.

ISBN 0-253-34400-X (cloth : alk. paper)

1. Jazz musicians—Portraits. I. Title.

ML87.S35 2004

781.65'092'2—dc22

2003017157

1 2 3 4 5 09 08 07 06 05 04

Frontispiece: Louis Armstrong, 1963

The quotation on p. 128 is from Nat Hentoff, *Jazz Is* (New York: Random House, 1976). Used by permission of Nat Hentoff.

CONTENTS

Preface

When I was young, a time when everything was cast in black and white, and before maturity brought shades of gray into my life, I fell in love. Not just once, but three times.

The first love affair was with music—a special kind of music. My ears suddenly seemed open to sounds that would stay with me through the next seventy years and more. I was in England, an all-American boy enjoying a two-year sojourn, challenged by the experience of attending an English school—short pants, blazer, school tie, beanie, and all the new customs and accents to be learned. It was there I learned to play piano by ear, and it was there that I first heard jazz—or swing music, as it was called then. I heard it over the BBC radio, and the recordings were by people with unfamiliar names—Benny Goodman, Fats Waller.

Soon enough I was back home, to find that my family had moved from Atlantic City, my birthplace, to New York City, where I arrived in early 1936, just in time to enroll in high school. Almost immediately I picked up an old recording by Fats Waller at a used furniture store on the corner. As the saying goes, it was the start of something big.

The next object of my affections was—you guessed it—a girl. Again, neither the memory of that girl nor the intensity of my feelings ever quite left me. But this book is not about her, so let's move ahead a year or so to my third passion.

It happened during a weekend visit to an old school friend in Ventnor, next to Atlantic City. Frank had hardly greeted me when he proudly showed me his darkroom, which occupied part of the family basement. I knew next to nothing about cameras or the process of producing negatives or prints, but within an hour of my first exposure to how it was done, I was hooked.

So, you see, my story is centered around two loves—and wonder of wonders, these two loves are compatible! My life's work has been in photography, from recording atomic bomb tests to filming documentaries, and along the way I discovered how to bring jazz and photography together so that I could savor them both. It became considerably more than a hobby.

It all started with something of a minor miracle, given my utter inexperience. The very first roll of film I exposed was at the New York Paramount Theatre on Times Square. With a brand-new Argus camera, I sat in an aisle seat in the fifth row. My heart was pounding as the thrilling sounds of Benny Goodman's theme song, "Let's Dance," pierced the semi-darkness, and slowly there rose into view an array of silhouetted figures marked by tiny lights on music stands. I could hardly contain myself as the crowd around me roared its enthusiasm. I tried desperately to recall what the photography magazines had said about exposing for stage shots. I must have remembered well, for the

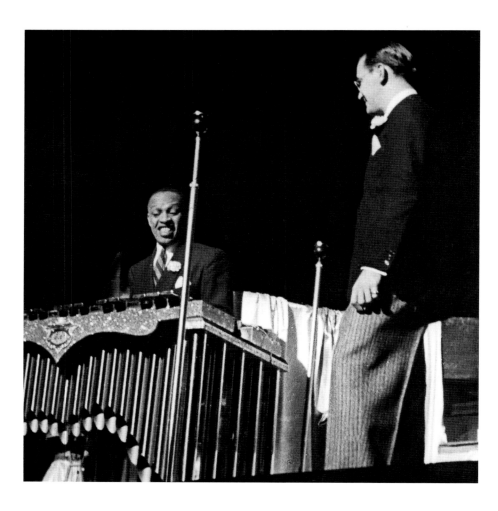

Lionel Hampton and Benny Goodman, 1939

eight to ten frames I exposed came out perfectly. I still enjoy looking at the accompanying shot of Lionel Hampton and Goodman during one of Lionel's solos.

More than sixty-three years have passed since that night, and like so many heartbeats, the clicks of countless exposures have vanished. But for each one there remains an image, a moment captured for all time—an image of a memory, if you will. It is my peculiar passion.

Some have asked why, when color photography is so dominant and so easily accomplished, I stay with black and white images. My easy answer is that jazz is a black and white music. Its range, from blinding brilliance to deepest shadings, seems to demand the drama that black and white can so easily provide. Consequently, when I take a photo of a jazz subject, I *see* it in those terms.

Many other photographers have traveled this path. I hope that each of them has known the joy of the music and the joy of the final print that has remained undimmed for me. If, in looking at this book, you can understand one or the other, or even both, then the trip through its pages will have been worthwhile.

A word about this book's format: Opposite each photograph is a page of text, featuring a brief biographical sketch of the person pictured, followed by a personal memoir connected with the photo session.

At first I was unsure how these images could best be organized into a coherent sequence. Various ways were considered—alphabetical, by instrument played, chronological—but each had its drawbacks. It was finally decided to divide the subjects into groups representing the periods of jazz in which their influence was greatest. Thus the first group represents figures from the classic early years of jazz, including the Swing Era. Next are those who are seen as transitional figures. So-called "modern" jazz players follow, then some of the younger "revivalist" players who focus on past styles. Finally, there are a few of the singers of jazz and several non-musicians—writers and producers whose contributions have illuminated musical paths we might otherwise have never traveled. Even this arrangement is fraught with imperfections, but isn't this true of jazz itself?

Acknowledgments

Oscar winners and authors customarily take time to thank all the individuals they deem responsible for their success. I am no exception.

In first place must be the many musicians who grace these pages. Without their patience (and sometimes dubious consent!) there would be no book. My only regret is that space forbids including all those whom I have photographed.

I thank Peter and Carolyn Harstad, two good friends who introduced me to Indiana University Press. They got me "off the dime" when I was suffering from acute inertia.

My dear friend Liz Kirk became my sounding board for the text, and helped me avoid embarrassing syntax and convoluted sentences. More than that, she knows about photography and appreciates good jazz, a happy combination.

At Indiana University Press, I thank former director Peter-John Leone, who listened with interest to our original presentation and saw value in what was essentially a raw, no-frills idea. Music Editor Gayle Sherwood was a believer in this work from the outset, and her input has been immeasurable. Not in the least, it has been fun to have her in my corner!

As the momentum grew, designer Sharon L. Sklar, whose work is so happily evident throughout, and Managing Editor Jane Lyle, who refined the prose even further, were joined by editorial, marketing, and sales people whose often unseen hands have much to do with a successful outcome. They include Linda Oblack, Bryan Gambrel, Marilyn Breiter, Mary Beth Haas, and Tony Brewer.

DUNCAN SCHIEDT

PITTSBORO, INDIANA

Louis Armstrong

b. August 4, 1901, New Orleans, Louisiana

d. July 6, 1971, New York City

If jazz music had to be represented in the history books by only a single individual, that person would certainly be Louis Armstrong. From his birth in an atmosphere of poverty to his eventual eminence worldwide as "Ambassador Satch," the genial genius of this music traveled on an upward spiral that seemed preordained. Though his brand of music would be challenged by succeeding generations of players, the record shows that Armstrong was personally responsible for many of the giant steps forward taken by jazz in the 1920s and 1930s. Legions of trumpet players have proudly named him as their prime inspiration, not to mention the jazz and pop singers who followed his vocal innovations in building their own careers.

Louis (he preferred to pronounce it "Lewis") moved along the classic pathway taken by so many early jazzmen. He departed the musical seedbed of New Orleans via trips upriver playing on excursion boats, finally reaching the Land of Opportunity—Chicago and the band of Joseph (King) Oliver. The older musician became both mentor and father figure to young Louis. The band's pianist, Lil Hardin, a classically trained musician, saw in the newcomer a precious talent—and a potential husband. They would soon marry. It was she who encouraged him to accept an offer from New York bandleader Fletcher Henderson.

Armstrong's impact on New York was monumental, among both black and white players. Within two years he returned to Chicago and commenced a series of small group recordings that made his name known across the country. In 1929 he went back to New York, where he appeared in Harlem nightclub revues and made a memorable impact on Broadway, introducing the song "Ain't Misbehavin'."

Armstrong entered the 1930s encumbered by mismanagement and difficulties with the Mob, who controlled the entertainment centers where he worked. He was forced to go on the road and eventually settled in Europe, where he was lionized everywhere, his phonograph records having prepared the way.

When he returned to the United States, he signed with Decca Records, fronted his own large band, and made several Hollywood movies. It was a life of constant touring that continued well into the 1940s. His manager at the time, Joe Glaser, saw the obvious—Armstrong had become an institution, and his public would be better served with a small combo built around Louis's unique personality. From then on, backed by a quintet of outstanding musicians, he survived the changes that were occurring in jazz. He maintained his popularity by recording with other important jazz figures, such as Duke Ellington and Ella Fitzgerald. Late in life, he demonstrated that he could still make hit records with such offerings as "Hello Dolly" and "What a Wonderful World."

Louis always claimed to have been born on July 4, 1900, but research points to August 4, 1901, as the true date. A performer almost to the end, he died a month shy of his seventieth birthday.

I was nearly thirty years old when I first encountered Louis. The good-natured way he tolerated my nervous suggestions for photos was typical of how obliging he would be at other times through the years. Backstage at New York's Roxy Theatre in 1950, he was relaxing between sets on a day bed, his hair protected by a white cloth. I visualized him warming up as he reclined, and asked him to pose that way. Later in the hour, jazzman Eddie Condon arrived with a rosebud, and another picture suggested itself. This one appeared as the feature photo in an issue of Record Changer *magazine that was devoted to Louis's fiftieth birthday.*

On another day, still at the Roxy, visitors included Count Basie and pianist Willie "The Lion" Smith. Armstrong went about his preparations as they talked, while I wondered how I would cover this gathering with my camera. When he got around to using an eyecup, in desperation I said, "Help him, fellows." And they did, or tried to. Looking back on that day, I am grateful that neither of them was tempted to get more physical!

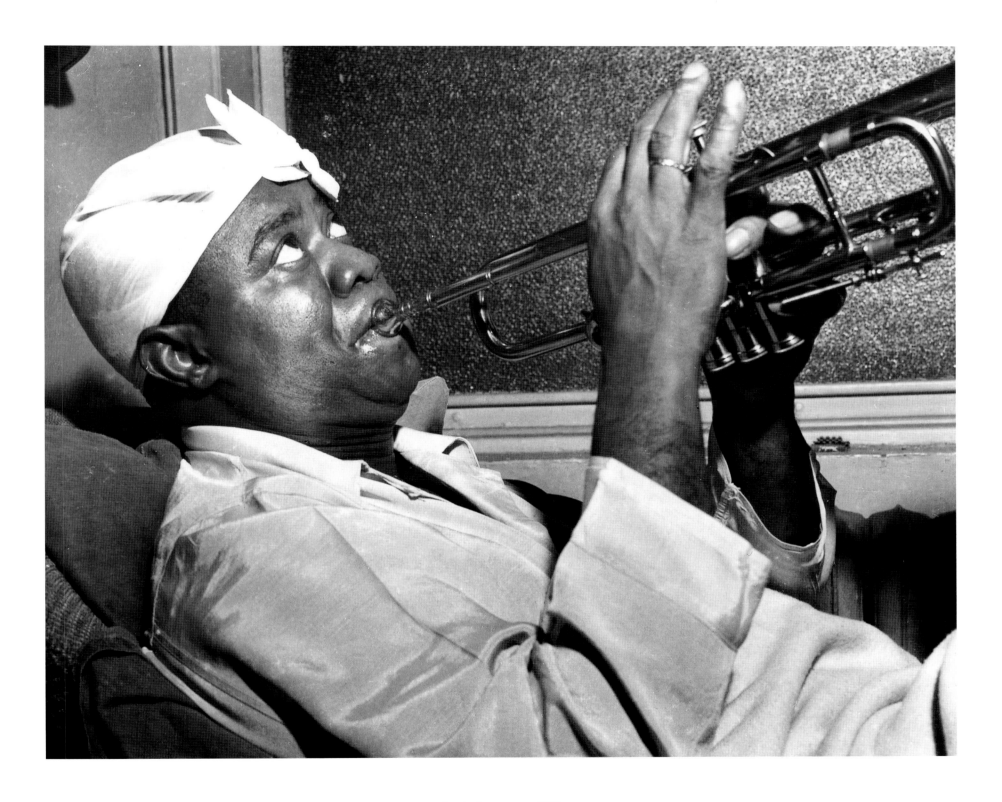

Louis Armstrong, 1950

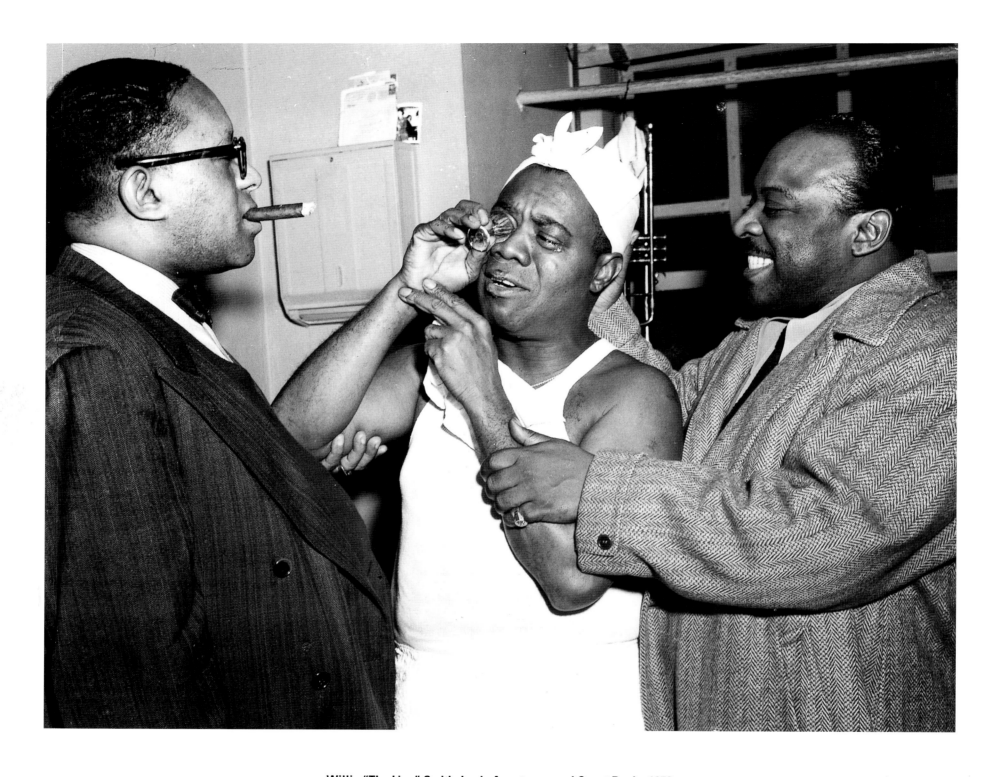

Willie "The Lion" Smith, Louis Armstrong, and Count Basie, 1950

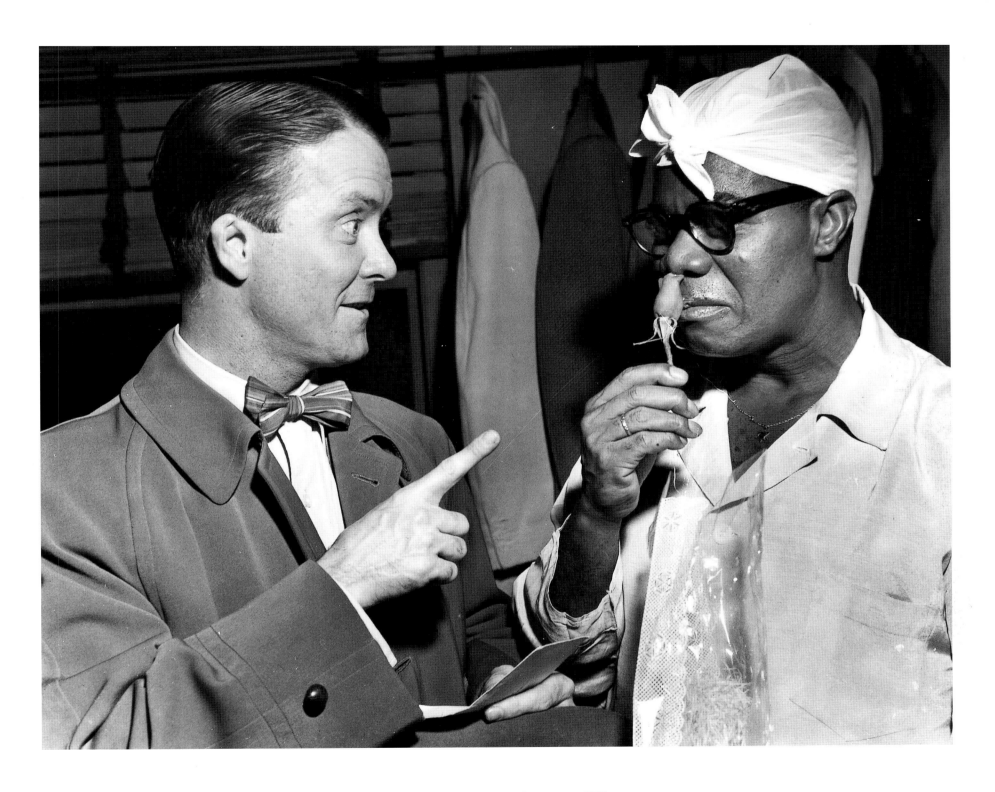

Eddie Condon and Louis Armstrong, 1950

Sidney Bechet

b. May 14, 1897, New Orleans, Louisiana

d. May 14, 1959, Paris, France

A musician of awesome power and inventiveness, Sidney Bechet was oddly fated to achieve his greatest recognition only in later life, and then largely in France, where he ended up as an almost revered figure.

He began his musical career in New Orleans, displaying a ready desire to learn from the established masters of early jazz and ragtime. His arrival in Chicago brought him to the attention of the prominent leaders Fred Keppard and King Oliver, both former Louisianans. He was a specialist in the reeds, but settled on clarinet and soprano saxophone as his primary instruments.

Bechet moved to New York as the center of jazz shifted eastward, but he stayed close to his New Orleans roots by recording with Clarence Williams and Louis Armstrong, as well as playing briefly with one of the early Duke Ellington outfits. As with Armstrong, it is not easy to picture Bechet as a mere sideman for long in any orchestra. Such was the creativity and distinctive sound of each of these musicians that their talents would demand greater exposure.

Bechet made his first trip abroad in 1919 with the Will Marion Cook ensemble and attracted critical notice in newspaper reviews for his solo abilities. The welcoming reception and the free lifestyle that he found in France were in stark contrast to his situation at home, where he was virtually unknown to the general public. In the U.S., only jazz fans seemed aware of the influence and stature of this musician, who during the Depression was reduced to operating a combination cleaning and tailor shop in Harlem, with only sporadic recording activity to keep his name alive.

Bechet moved permanently to France in the 1950s. Playing as dominant a musical role as ever, no matter what the size of the group, he found a welcoming home for the rest of his days. He died on his sixty-second birthday, mourned by innumerable European fans. Ironically, his passing was little noted in the United States.

I saw Sidney Bechet twice—once on the bandstand at a raucous jam session held at the Stuyvesant Casino, an upper-floor catering hall on Second Avenue in New York, where this photograph was taken, and on another afternoon in a Fifty-Second Street coffee shop, where I was having a quick lunch at the food bar. As I sat listening to an orchestral rag tune on the jukebox, I was aware of a figure easing onto the next stool. I looked up only when he casually asked, "What's the name of that tune they're playing?" As I replied "Dill Pickles," I was slightly overcome at the realization that my neighbor was none other than the legendary Sidney Bechet. That I, a jazz neophyte, was able to enlighten him about a melody at least ten years older than I, and one that he surely had known in his own youth, was something of a thrill.

His coffee break ended all too soon, and I have always regretted that I did not have a camera along. But etched in my mind is the small pride I carried away from the event!

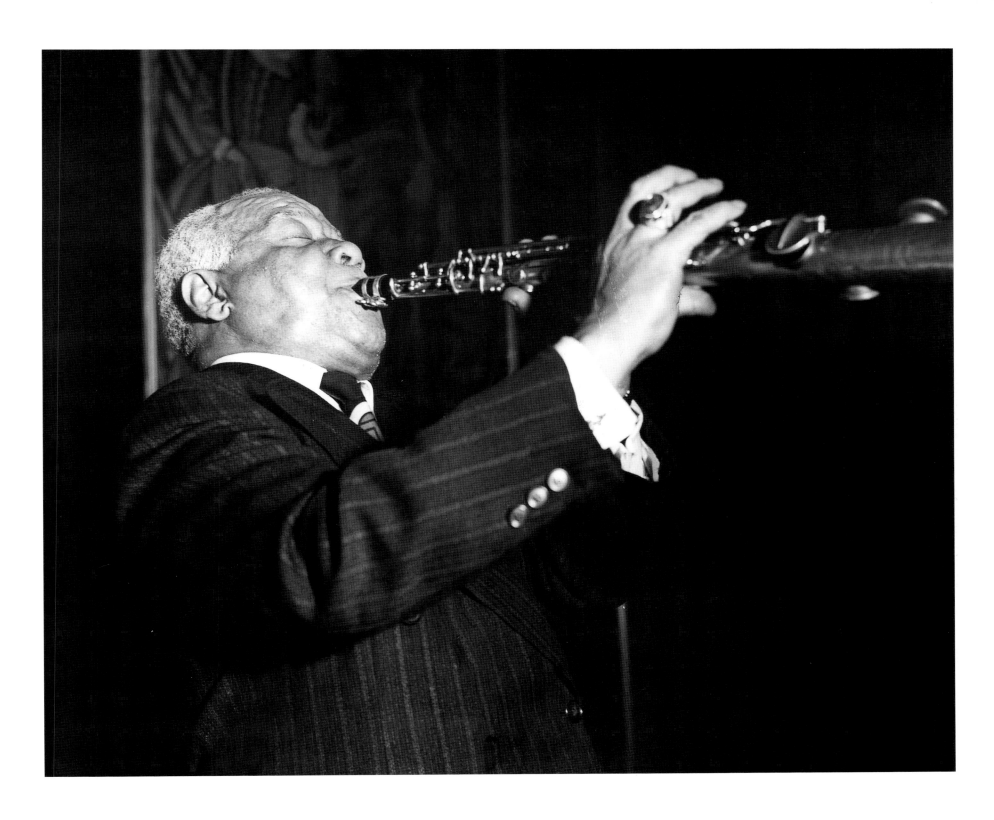

Sidney Bechet, ca. 1949–50

Willie "The Lion" Smith

b. November 25, 1897, Goshen, New York

d. April 18, 1973, New York City

One of the triumvirate of Harlem-based pianists most often identified with the "stride" school of jazz players (the other two were James P. Johnson and Thomas "Fats" Waller), Willie Smith is remembered for his forceful personality, his independent spirit, and his legendary competitiveness at the piano. But it is his body of distinctive compositions that attracts pianists today. His recordings, relatively few in number, often featured these songs with evocative titles such as "Morning Air," "Echo of Spring," "Passionette," and "Fading Star." In their delicacy, these works seem to belie the rather formidable image he nurtured throughout his life.

Receiving his early education at Goshen in a Hebrew school, young Willie became fluent in Yiddish, which he would use to his advantage in later life. As a pianist, he was mostly seen in a solo role, or as a member of a small combo, where his striding left hand could, when necessary, provide the entire rhythm. His unique nickname came as a result of his service in France during World War I, when he was noted for his prolonged and courageous performance on the battlefield with his artillery unit.

Almost alone among his contemporaries, Smith was able to move into television, and he did it with aplomb. His ebullience and fertile recall, as well as his moments at the piano, made him an ideal talk show guest.

The Lion, already a legend in his own Harlem, was a primary source for me as I began to research the life of Fats Waller for a biography, which was published some fifteen years later under the title Ain't Misbehavin'. *Willie took to the project with enthusiasm. He volunteered to be my guide through the district and its historical sites, he with his trademark derby hat, a gold-headed walking stick, and a fresh White Owl cigar, and I, a neophyte writer, keeping pace with my camera case and my notebook. Our forays took us to such disparate places as Luckey's Rendezvous, a popular St. Nicholas Avenue restaurant where many pianists would drop in to perform for each other; "Fat Man's"—a rib joint operated by one of Waller's former bass players; and various walk-up apartments occupied by old friends and obscure retired entertainers.*

This picture, taken in Willie's own apartment, is perhaps my most famous image. It was taken at his request, to illustrate a profile of him that was due to appear in an issue of True *magazine. It is surely how he would have liked to be remembered—a rugged competitor at the piano, rippling off a series of complex chords and "putting the eye on" any brash young upstart who might approach the piano to show off his own prowess. The lighting was provided by a single "peanut" flashbulb. The handkerchief in his back pocket provides an appropriate (albeit accidental) counterpoint to the scenario.*

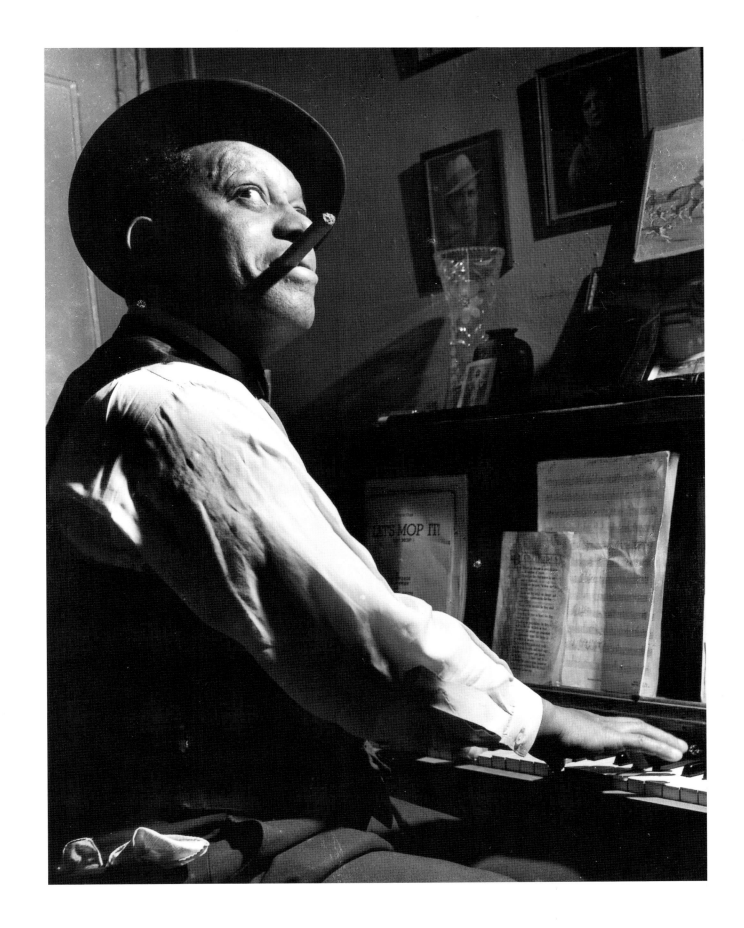

Willie "The Lion" Smith, 1949

W. C. Handy

b. November 16, 1873, Florence, Alabama

d. March 28, 1958, New York City

William Christopher "W. C." Handy is often called "the Father of the Blues." That might be regarded as a misnomer, for his appropriation of a number of folk melodies and lyrics he had heard on the streets in younger days, and his subsequent publication of them under his own name, seems to smack of dishonesty. In his defense, however, it has often been said that without Handy, some of the classic blues songs we know today would probably have been lost forever. Imagine the jazz world without such standards as "Memphis Blues," "St. Louis Blues," "Yellow Dog Blues," or "Ole Miss."

A cornetist, Handy toured with his own military-style band for years, playing in public concerts and at medicine shows and carnivals. He eventually entered the music publishing business in Memphis in collaboration with a partner, Harry Pace. His first big success was the publication of "Memphis Blues," which gained notoriety as the theme song for politician "Boss" Crump.

After moving the firm to New York in 1918, Handy became a significant player in the music publishing business, thanks to his blues hits. He later included sacred music in his company's catalog, but it was "St. Louis Blues" that paid the office rent for decades, according to Tin Pan Alley gossip.

I climbed the stairs to Handy's publishing offices sometime in late 1949, as I recall, and noticed the many vintage photos that hung along the walls—long-gone performers behind dusty glass, but names still familiar to the collector of old blues recordings. I was making the call with Ed Kirkeby, my collaborator on a book about the life of Fats Waller, and expected some interesting talk from the venerable Mr. Handy.

As Kirkeby and he talked, and I took notes, I noted a broad smile developing on Handy's face. It was clear that, though blind, he could see in his mind's eye the Fats Waller of olden days, and relished the memory. I made a dive for my 4×5 Speed Graphic camera, opened it up, and quickly focused it on Handy's face, then inserted a film holder and pulled the dark slide. A book on Handy's desktop provided a bit of support for the camera, and as I reached for the shutter release, I was amazed to see that same smile, unchanging, as he listened to Kirkeby. I did get the picture, but as with many in my experience, I had no idea how good it would be until I printed it. Maybe it was how he would have liked to be remembered.

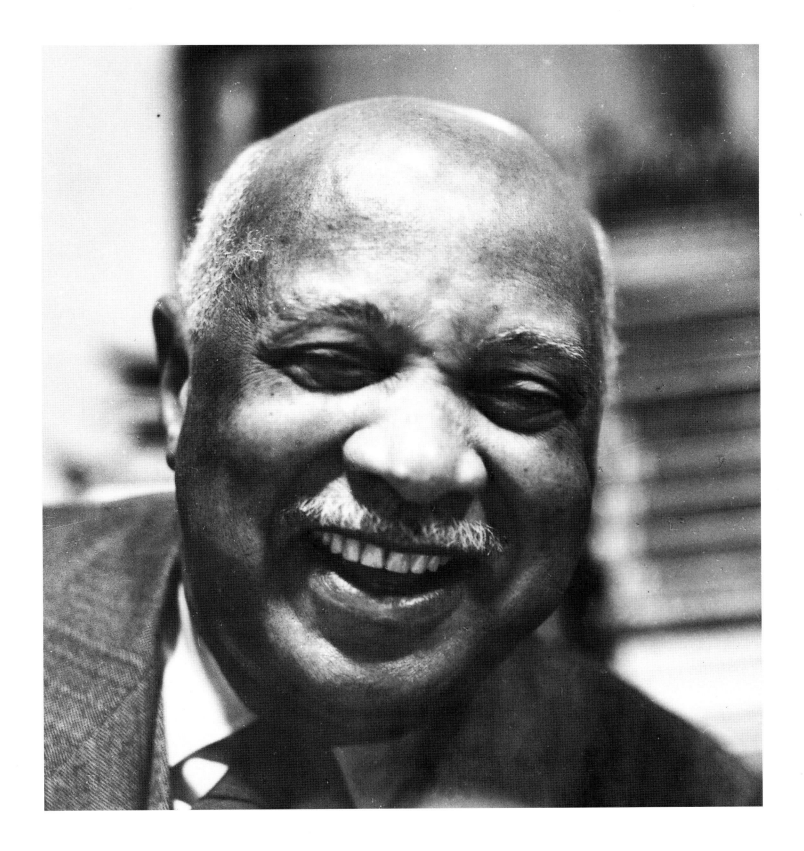

W. C. Handy, 1950

Scrapper Blackwell

b. February 21, 1903, North Carolina (?)

d. October 6, 1962, Indianapolis, Indiana

If anyone ever deserved a revival, it would be Francis "Scrapper" Blackwell. A consummate self-taught guitarist, he played the blues, and not much else, but how he could play them!

Blackwell claimed to be part Indian, and his photographs seem to confirm it. He said that he was born in North Carolina. At an early age he moved to Indianapolis, where in the mid-1920s he met a pianist and blues singer, Leroy Carr. They formed a duo and began to play in local clubs, both composing original material for their act. The blues as a musical form was then riding high, with singers (mostly female) recording for numerous companies. The subject matter of the blues ranged from unrequited love, to abused love, to Mississippi floods. The rural South was often both a theme and a recurrent implied location for these songs. Carr's repertoire reflected an urban rather than rural point of origin, and built an audience among blacks who wanted to separate themselves from the bad old days on the farm.

Blackwell and Carr were spotted by recording scouts and offered the opportunity to cut some material in Indianapolis, using the facilities of a local radio station. Their first record turned out to be their greatest hit. It was called "How Long, How Long Blues." Issued on the Vocalion label, it sold in incredible numbers, and began the team's brief but successful career on wax. There were many recording sessions, generally held in the Brunswick studio, and the money flowed. Unfortunately, so did the whiskey. Carr, who was apparently the most enthusiastic imbiber, did not survive past Christmas of 1935.

Blackwell, made of sterner stuff, survived another twenty-seven years, most of them, sadly, in obscurity. Without Carr, he seemed to have no direction or motivation, and when he was rediscovered in the 1950s by some local blues revivalists, he was doing janitorial work for the city, playing for pitifully small pay in taverns at night. His astringent guitar work, with a style that was unique, was unimpaired, and he was able to enter the LP era with two or three albums, one issued in England. The records earned high critical ratings, and it seemed as though Blackwell would join some of his contemporaries in the great blues renaissance of the 1950s and 1960s. But it was not to be. While he was drinking with a man twenty years his senior, an argument broke out, and in the quarrel that followed, Scrapper Blackwell was fatally shot.

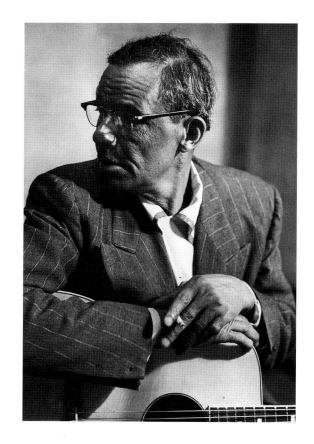

These photographs of Scrapper were taken during a concert at an Indianapolis house that had been converted into an art gallery. Vocals were provided by a female blues singer named Brooks Berry, while Scrapper accompanied. He occasionally contributed a song of his own, as well as solos on guitar and, surprisingly, piano in the Leroy Carr style.

Blackwell was, for me, an ideal subject. His leathery skin (the Indian heritage?), his fine features, and his complete lack of camera consciousness guaranteed a session in which I could devote my whole attention to the picture content. Another point: The femininity of the guitar's shape rarely fails to enhance any composition, and Scrapper's instruments were no exception, despite the fact that his own guitar was rarely out of hock! I look back on these photos, and the others I took of him, with a bittersweet memory of an unforgettable, all-too-human character who deserved better.

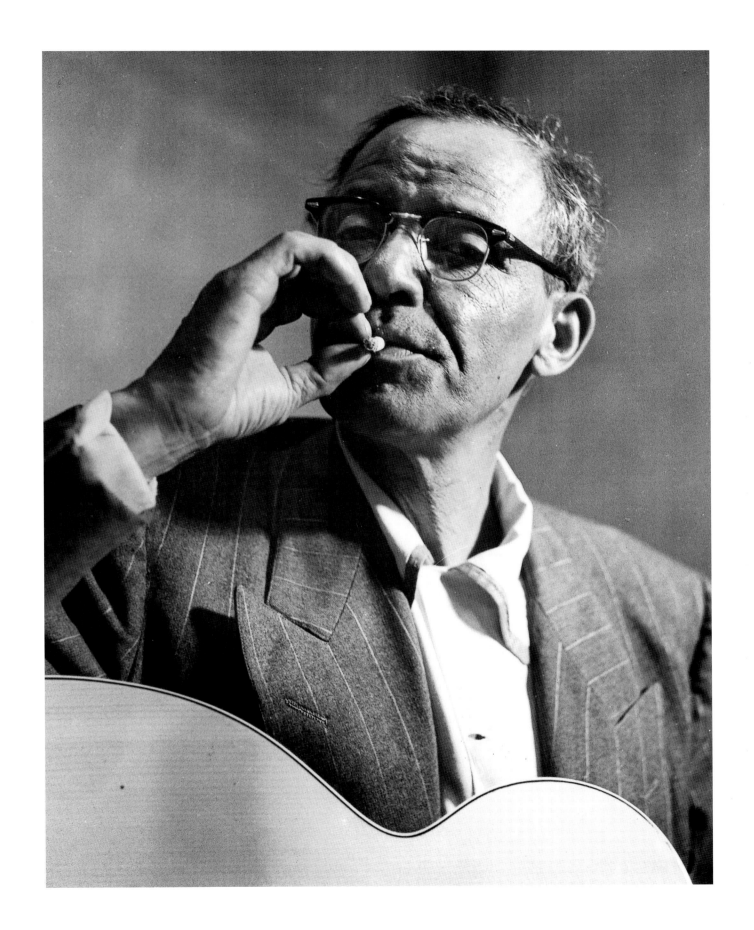

Scrapper Blackwell, 1960

Muggsy Spanier

b. November 9, 1906, Chicago, Illinois

d. February 12, 1967, Sausalito, California

With a face that his mother and all photographers could love, Francis "Muggsy" Spanier played Dixieland jazz with relish, his forceful style owing much to King Oliver, his boyhood idol in Chicago. For economic reasons, however, he often worked in dance bands, where he was able to provide the hot solos that leaders liked to incorporate into their more lively arrangements. One of his long-term jobs was with the Ted Lewis band, which included a booking in London and a pair of Hollywood feature films. A later connection found him replacing trumpeter Harry James in the Ben Pollack band. A bout with tuberculosis caused him to spend a period in a New Orleans sanitarium, but he returned to music in 1938.

Muggsy Spanier's Ragtime Band emerged at this time, an eight-piece outfit specializing in traditional jazz, Dixieland, and blues. Joining him in the band was the veteran George Brunis on trombone, a former mate in the Ted Lewis orchestra. A successful engagement at the Sherman Hotel in Chicago, coupled with sixteen glorious sides recorded for the Bluebird label, gave the band an eighteen-month run of popularity before bookings flagged and forced its disbandment.

The ensuing years were always busy, though most traditional musicians had to struggle for a living. Spanier was able to hold a cornet chair in the Bob Crosby band, and he had important gigs with Sidney Bechet and Earl Hines. He finally formed another combo of his own, with the ever-ready Brunis on trombone. Among jazz enthusiasts, Muggsy is remembered for his aggressive but not loud style, his consistent devotion to the music he loved, and the quality of his performances.

I first saw Spanier in New York at the Stuyvesant Casino, where he was trying to hold his own against the waves of noise coming from the beer-drinking collegians. Under such conditions it was hard to listen to the nuances of a horn player's style, and it wasn't until I encountered Muggsy (and George Brunis) in the Midwest, at Columbus and Cleveland, that I could appreciate his musical worth. As a photographer, I was always appreciative of that pugnacious-looking face. Some of the greats were like that; you could hardly get a bad photograph of them. I am glad I saw and heard Spanier. He was one of a kind.

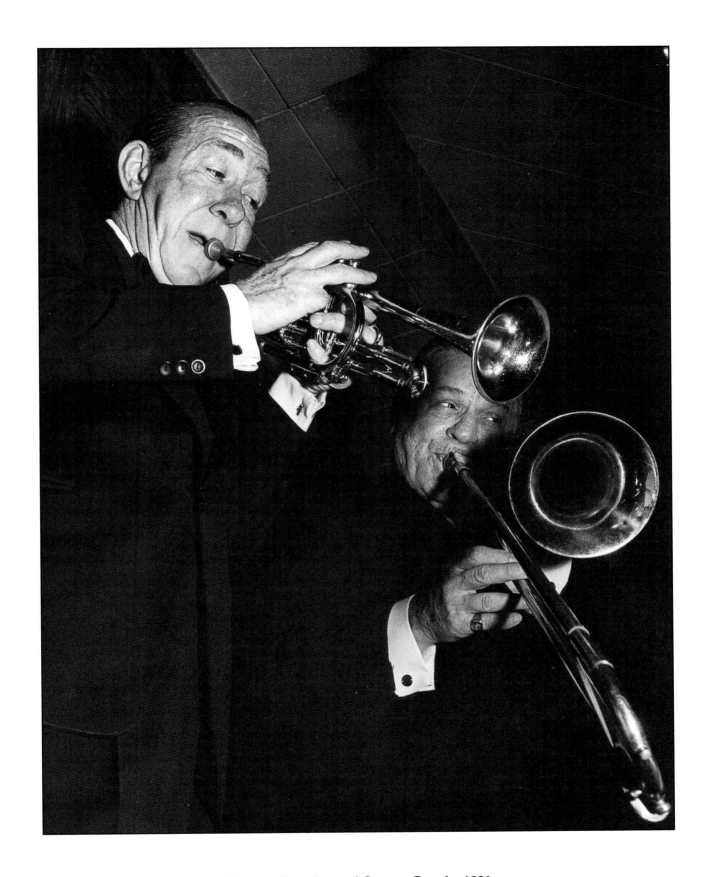

Muggsy Spanier and George Brunis, 1961

Joe Venuti

b. September 6, 1903, Philadelphia, Pennsylvania

d. August 14, 1978, Seattle, Washington

Joe Venuti once claimed to have been born on an ocean liner as his parents emigrated from Italy to the United States. The spoof was typical Venuti trickery; he may have been the greatest practical joker in jazz, but he was also a true innovator who made the violin into a jazz instrument while preserving intact a classical tone and technique.

A schoolmate, young Eddie Lang (born Salvatore Massaro), a guitarist, became Venuti's professional partner in dance bands in and around the Philadelphia–Atlantic City area. One of Venuti's presumably manufactured stories has the pair tossing a coin to see who would play which of the instruments they had bought at a pawn shop. If the tale is true, they obviously made prescient choices, for each would become a master of his selected instrument.

The pair seemed joined at the hip in their careers, for they recorded throughout the 1920s in many settings with many bands, including the prestigious orchestras of Paul Whiteman and Jean Goldkette. Arrangers set aside entire choruses in which the duo was featured. Inevitably this led to recordings in which Joe and Eddie were the principal soloists in a jazz quartet.

In 1933, Lang died following a botched tonsillectomy, and Venuti, somewhat adrift after losing his partner, attempted to make his mark with a dance orchestra of his own. His rather casual attitude toward discipline contributed to the group's eventual failure after several years of struggle. Success came through radio, where he became a Bing Crosby sidekick. He was in demand as a film studio musician and, much later, at jazz festivals here and abroad.

Only a few jazz violinists have attained top rank, and Venuti, the first to be widely recognized, is generally regarded as the greatest. His early recordings, especially those with Lang, are still unsurpassed. Even his penchant for practical jokes failed to lessen his popularity and respect among fellow musicians. Two quick examples: During the making of the film *King of Jazz,* he is said to have poured flour into the bell of one of Paul Whiteman's tubas, so that when the downbeat came, half of the orchestra was enveloped in a white cloud! Another time, during a stage show featuring cowboy star Roy Rogers and his famed horse Trigger, Venuti is said to have used his violin bow to stimulate Trigger's nether region to the point that when the unsuspecting Rogers emerged from the wings astride the animal, the audience was thrown into an uproar.

Venuti's long professional life enabled several generations to enjoy one of the true originals of jazz while he was still at the top of his game.

I was fortunate enough to hear Venuti in Indianapolis on more than one occasion. One time he showed up at a local bar where I was playing piano with a Dixieland combo. Having such a historic figure sitting out front did nothing to calm my nerves, and I am sure that he was merely being kind when, after sitting in for a few tunes, he complimented me on my playing. Needless to say, he immediately became one of my favorite musicians!

This photograph, taken at the Murat Shrine Club in 1974, shows Joe bending to the microphone while veteran trumpeter Max Kaminsky looks on. Joe had been struggling with a small microphone that kept falling off his violin, and he finally tossed it aside. Also at this jazz club concert was another old friend of Joe's, trombonist Bill Rank, who had come up from Cincinnati. I vividly recall the warmth with which the three of them greeted and embraced one another in what was the late autumn of their lives.

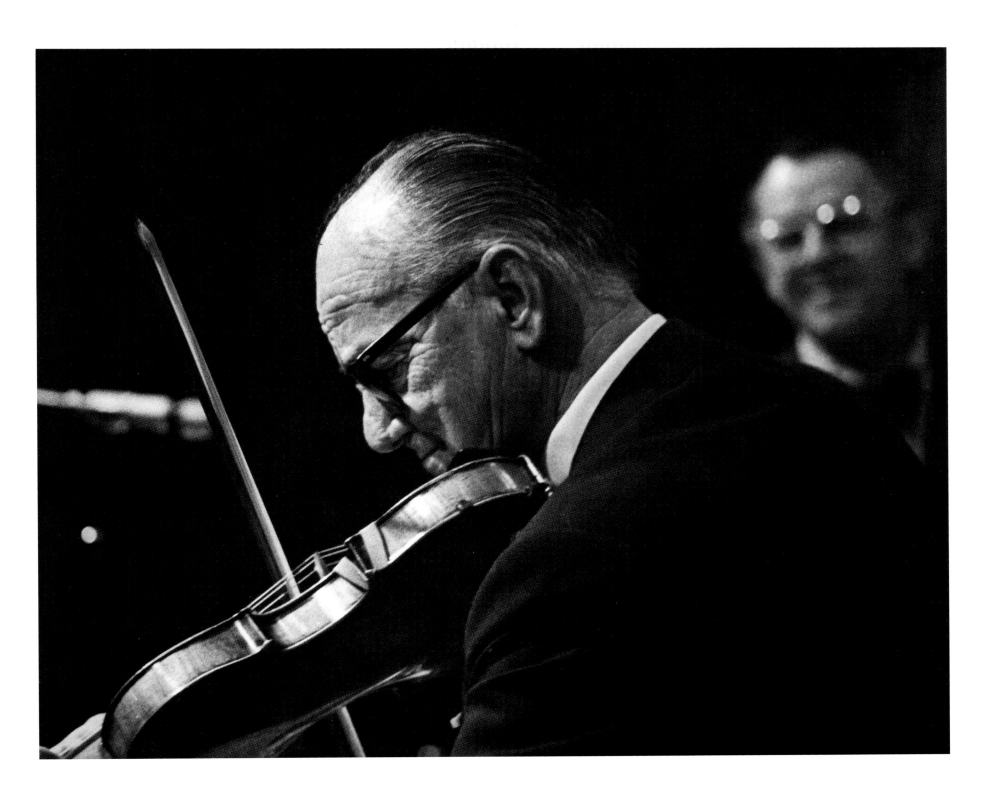

Joe Venuti (with Max Kaminsky, background), 1974

Stephane Grappelli

b. January 26, 1908, Paris, France

d. December 1, 1997, Paris, France

Unusual for a violinist of his accomplishments, Stephane Grappelli was mostly self-taught, having had only a brief stay at the Paris Conservatory, where he had his sole dose of formal instruction. His early performances were as a street musician and in a small movie theater pit orchestra, but once he had heard jazz, his whole outlook was transformed. By the time he was twenty, he had switched to piano and was playing in dance bands. Though he returned to the violin, nothing much occurred until the formation of a quintet sponsored by the Hot Club of France, a group made up of jazz fans in Paris. The key member of this little combo was the Belgian Gypsy guitarist Django Reinhardt. Although a fire had damaged his left hand, depriving him of the use of two fingers, Reinhardt was able to devise a personal way of covering the frets. The inventiveness and sheer excitement of his style made him one of the great international figures in jazz.

Grappelli, an equally important voice in the ensemble, was also a fine swinger, a counterpoint to the guitarist. Two other guitarists and a bass player completed the group, but they were mere musical support for the two principals. The repertoire consisted of American standards and original compositions from within the Quintette.

During World War II, Reinhardt lived and performed in France, while Grappelli remained in London, where the group had been appearing at the outbreak of hostilities. There would be a reunion after the war, but increasingly they would go their separate ways. After Reinhardt died in 1953, Grappelli's career followed a number of paths. He recorded with American jazzmen and had a notable career revival at the 1969 Newport Jazz Festival. He maintained an active concert and club schedule until his eighty-ninth year, performing for President Jacques Chirac just two months before his death.

Stephane Grappelli was rather an obscure figure to me, and though I knew about Django Reinhardt, I had no hope of ever seeing either one of them. Thus I was delighted to read that Grappelli was scheduled to appear in concert with the Indianapolis Symphony sometime during 1987. By then I knew him to be one of the top three or four violinists in jazz history. Unfortunately, I did not have an "in" at the symphony, and decided I would have a better chance for photography at the trio's rehearsal, which was in the early afternoon.

He was the soul of courtesy. He allowed me complete freedom to move about on the bare stage, while his bassist and guitarist went through the "head arrangements" with him. The only light was from some work lamps, which proved to be quite flat, and I didn't feel that I was getting anything special. Toward the end of my roll, I was crouching down near him and was about to shoot when someone came in on my left, casting a shadow on the violinist's face. As Grappelli looked up to respond to the visitor, I clicked the shutter, and a picture suddenly had come together through no talent of mine. I can only blame instinct for making me record it.

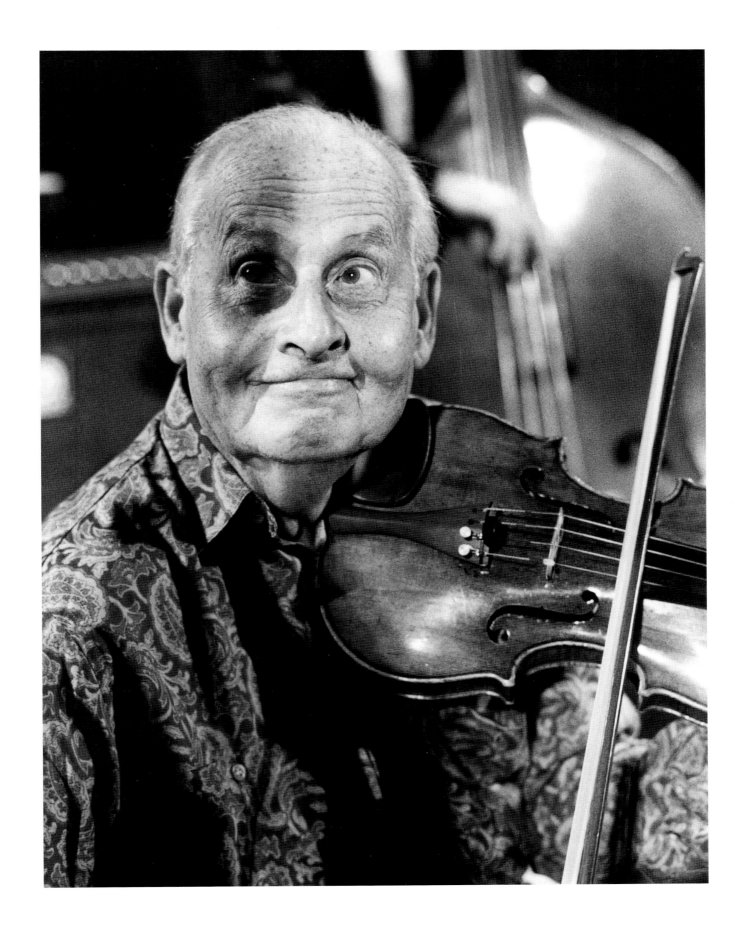

Stephane Grappelli, 1987

Jack Teagarden

b. August 29, 1905, Vernon, Texas

d. January 15, 1964, New Orleans, Louisiana

When historians compile lists of the most influential early jazz players, the black pioneers seem to dominate the field. But one white musician who always seems to make those lists is Jack Teagarden.

In the latter half of the 1920s, the young trombonist arrived in New York almost unheralded, but with years of barnstorming throughout the Southwest behind him. His attack and his burry tone were so different that even the established musicians in the big city were astounded, and bandleaders fell over each other trying to secure him for their recording dates. Red Nichols, Ben Pollack, Roger Wolfe Kahn, and others employed him, and the Texan was equal to the task. Possessing a fine vocal style that was at once bluesy and drawling, "Big T," as he was known, would make history from then on. Paul Whiteman, whose orchestra was something of a Mecca for professional musicians, signed up Jack for his mammoth organization, and virtually took him out of circulation for years as far as the jazz world was concerned.

Following his Whiteman period, Jack concentrated on small group jazz, except for a stab at a big band and the money he thought could be made there. Like many a master musician, he was not cut out for the discipline and the detail of running a full-size outfit and keeping it employed. He was always in demand in the recording studios, and in 1948 he was asked to join the new Louis Armstrong combo to be called the All-Stars. Indeed they were—Louis himself, Earl Hines, Barney Bigard, Big Sid Catlett (later Cozy Cole), Arvell Shaw, and Teagarden. Jack toured with the band until 1951, when he left to form his own small unit, with which he worked until his death during a booking in New Orleans.

This photograph was taken backstage at the long-gone Roxy Theatre in New York, during an engagement of the Armstrong All-Stars early in 1950. Like his boss, Jack was the soul of cooperation. The fact that I'd come to talk about his memories of Fats Waller seemed to mellow him, as it did all those I approached, and this image, taken with a 4 × 5 Speed Graphic camera and a single flashbulb, deliberately used the trombone bell as an extension of Jack's musical voice. Not particularly subtle, but I think it's a compelling picture anyway.

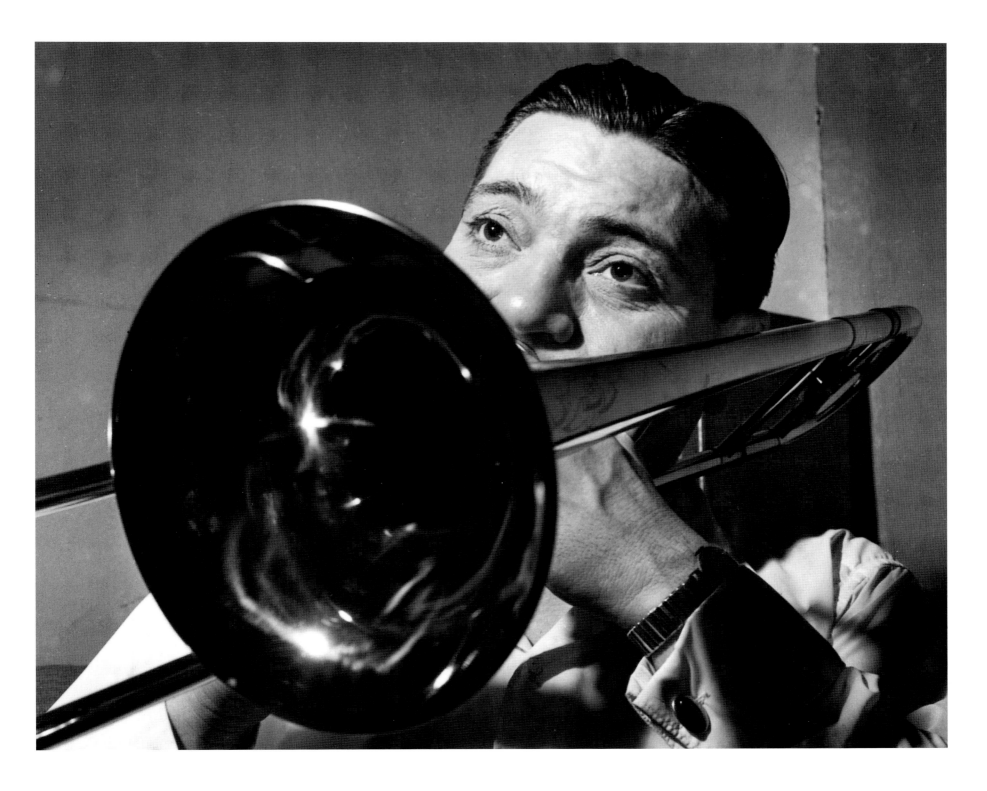

Jack Teagarden, 1950

Doc Cheatham

b. June 13, 1905, Nashville, Tennessee

d. June 2, 1997, New York City

Only a very few jazz musicians live into their nineties and continue to play their instruments, especially trumpet. Adolphus "Doc" Cheatham not only played until he was almost ninety-two, but in his later years he played as well as, if not better than, ever before in his long career. He was finally able to show his gift for strong and true performances, which in most of his earlier years had been submerged in brass sections, albeit famous ones.

As a saxophone player early in his career, Doc went from vaudeville pit bands to the swirling jazz world of Chicago's South Side, where he first encountered Louis Armstrong. From then on it was all trumpet. His splendid tone and immaculate technique led to his employment with many celebrated bands, including those of Chick Webb, Sam Wooding, Wilbur deParis, Benny Carter, Teddy Wilson, and Cab Calloway (a six-year stint). Even Benny Goodman acknowledged his dependability and musical quality by hiring him.

Doc's later years were rewarding, with a long-term gig in New York leavened by frequent jazz festival bookings and a belated but devoted following of new fans. A gentle, sincere vocal style only added to the old gentleman's popularity.

My quest for jazz photo opportunities inevitably brought Doc Cheatham in front of my camera, and I confidently shot a half roll, only to be disappointed at the results. Blaming the existing lighting, I resolved to do better next time.

The next time came and went. But still I was not satisfied. I studied the pictures, and suddenly it came to me: It was his hair that disturbed me. It looked like an ill-fitting wig! I recalled several photographs taken years earlier that showed Doc to be getting bald. He was trying to maintain a youthful image by covering up.

Some years later, at a collectors' convention, I noted that Doc was to be an honored guest. I loaded my camera once again, still on the hunt. Studying him closely as he played, I realized that rather than wear a hairpiece, Doc had let the hair at the back of his head grow long, then combed it forward.

Still determined to get a good picture, I asked Doc if I could photograph him in the privacy of his hotel room. He readily consented. I wondered what I was going to do this time. The glare of the afternoon sun streaming on a light-colored wall gave me an idea: Why not try a silhouette, and rid myself of the hair factor altogether?

It was the answer, a happy solution to a vexing problem. I can hardly think of a more pleasurable moment in the darkroom than when I saw the images from this session. I had done justice to a grand old man of music.

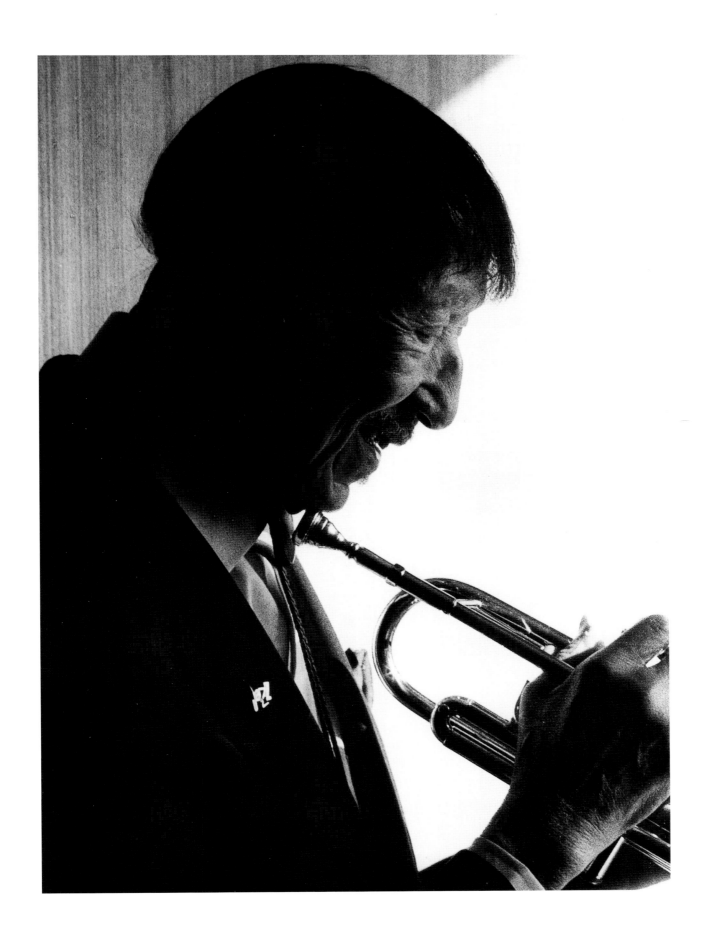

Doc Cheatham, 1993

Eddie Condon

b. November 16, 1905, Goodland, Indiana

d. August 4, 1973, New York City

Slightly built Albert Edwin Condon, without whom jazz would have been perhaps less joyful and certainly less colorful, left his small-town Hoosier background and family (musicians all) for the road at age sixteen. He played banjo in a band improbably called Peavey's Jazz Bandits. It didn't take long for him to find and haunt the nightspots on Chicago's South Side, where other white jazz players, including Bix Beiderbecke, virtually sat at the feet of King Oliver, Louis Armstrong, Jimmy Noone, the Dodds brothers, and blues singer Bessie Smith. Teaming up with a former jockey named Red McKenzie, who could play the comb and sing pleasingly, Eddie organized a recording session with OKeh, which history has marked as a seminal event—the birth of a style to be known as "Chicago Jazz." Still a bunch of youngsters, the players included such names as Frank Teschemacher, Jimmy McPartland, Joe Sullivan, Bud Freeman, and Gene Krupa.

Though the years would find them loosely affiliated, they went their separate ways, working in conventional dance bands where the money was steady. They gradually drifted to New York, where "scuffling" for a living was almost the rule. Condon, a consummate self-promoter, managed to survive the Depression by participating in numerous jazz recording sessions, playing nights at downtown clubs where traditional, or Dixieland, jazz was in favor. One notable spot was Nick's, in Greenwich Village, where a number of the Chicagoans reassembled on the stand. By this time Eddie had moved from banjo to four-string guitar. He sported a bow tie, which, along with his slicked-back hair, became a trademark.

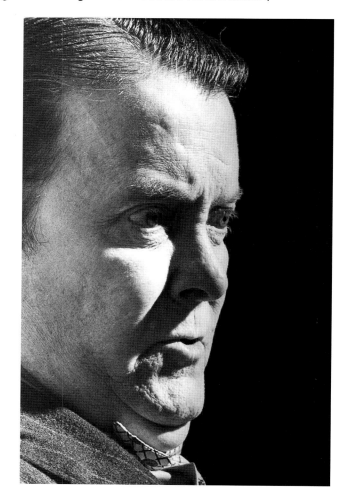

Condon's ready wit and quotable remarks attracted much attention among jazz patrons, as well as contacts with publicists, who would be useful when Club Condon, Eddie's venture into entrepreneurship, opened in 1945. It was an immediate success, aided by Condon's frequent exposure on radio, in fashionable magazines, and later on a television series. His music helped to put Commodore Records on the map as a jazz label. The personnel always included some of the old Chicago players he had grown up with. Not a bad career for a kid from Goodland, Indiana.

Space does not permit me to say much about the Condon wit, samples of which can be found in many books on jazz. One of his famous lines referred to the 1940s bebop musicians—"They flat their fifths, we drink ours." Another time, commenting on the criticism of jazz by French writers, he opined, "We don't tell them how to stomp on grapes . . . !"

I visited Club Condon with my camera and was warmly received by Eddie, who was aware of my research on Fats Waller. I wasn't prepared for the frequency with which he departed the bandstand and visited with the patrons at their tables, leaving the band to carry on, which it did. In my brief conversation with Eddie, I noticed the variety of expressions that crossed his Irish face. Another encounter, at a private house party in Indianapolis, gave rise to the studies here. I was pleased, in future years, when musicians who had known Eddie would say, "Man, you caught him there—that's just the way he looked."

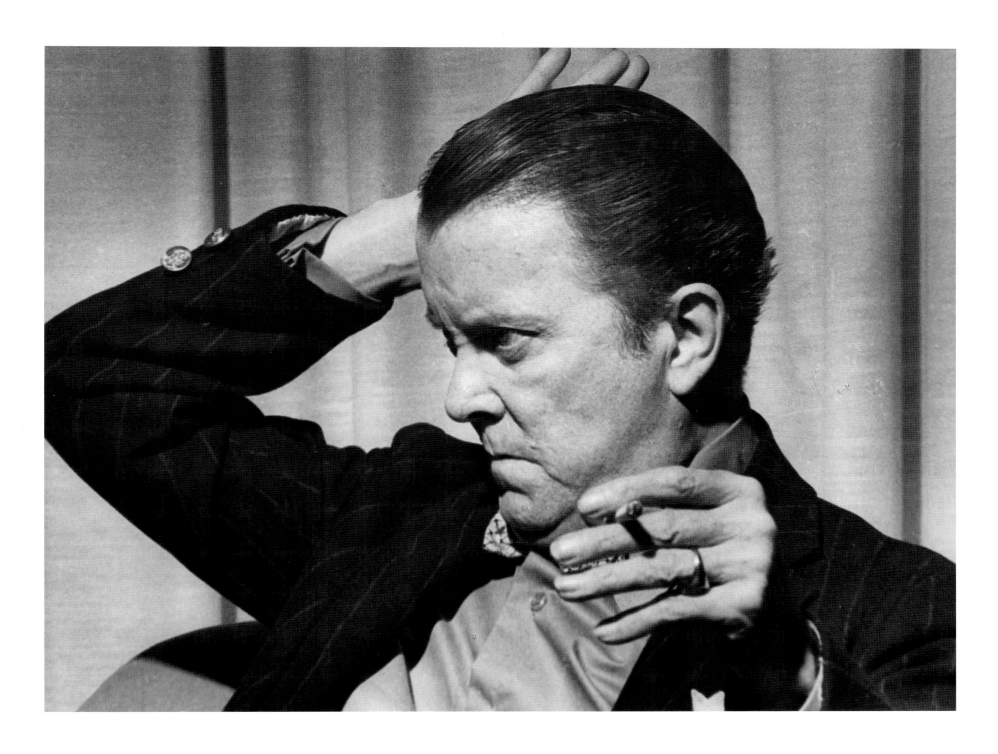

Eddie Condon, 1971

Bobby Hackett

b. January 31, 1915, Providence, Rhode Island

d. June 7, 1976

Listening to a Bobby Hackett cornet solo is like turning a precious stone in your hand. Its facets reflect dazzling, constantly changing glints. His music was like that. Perhaps it would be more apt to call it a string of musical pearls, recalling his famous solo on the Glenn Miller recording "A String of Pearls."

As a schoolboy, Bobby showed interest in playing a variety of musical instruments, among them guitar and cornet, both of which he would pursue in his professional life. After briefly leading his own band in Providence, he migrated to New York, where work was readily available with society bands. Soon he began to sit in with more jazz-oriented combos, where his lyricism and tone were immediately noted. As a leader, he had an extended booking at Nick's in Greenwich Village, and became a regular at the Commodore recording sessions. As a featured soloist during Benny Goodman's Carnegie Hall concert in 1938, he emulated a famous predecessor, Bix Beiderbecke, and thereby became mischaracterized as a Bix imitator. In fact, their styles were markedly different, though each had a deep sense of chord construction. Hackett's tone owed nothing to any other musician, and his seemingly limitless chordal ideas certainly derived from his experience with guitar. This approach to playing his horn necessarily precluded the exhibitionism fashionable among many swing players.

In 1941 Hackett was hired by Glenn Miller's band. He was assigned to play guitar, though on occasion he would become the jazz soloist in the trumpet section. After the Miller band broke up, Bobby had a variety of big and small band connections, including radio staff work at NBC. His name was by no means a household word, and it wasn't until he began to record romantic "mood music" LPs that he became widely known. Those records were nominally under the aegis of comedian Jackie Gleason, but if Hackett's name was not also printed on the album, people would ask who was playing that marvelous horn.

Recording and touring occupied Hackett's final years. A diabetic, he failed to adjust his drinking habits, and his death at age sixty-one seemed unjustly premature for such a productive musical mind.

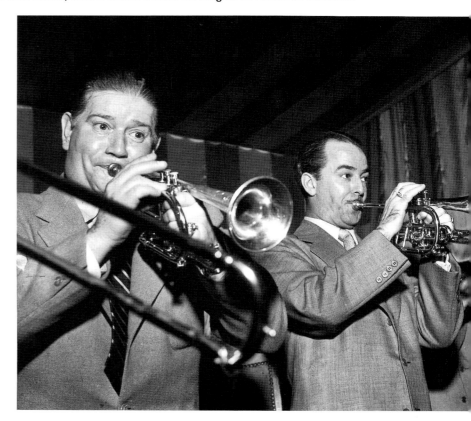

Like most of his fans, I took to Hackett's sound the moment I first heard it. I quickly learned not to expect great volume or super-high notes. What I did get from him were thoughtful musical constructions that were just right, whether he was performing in ensemble, as soloist, or as accompanist to jazz-aware singers such as Lee Wiley.

I first saw him at Club Condon, where he was paired for the evening with the redoubtable Wild Bill Davison, whose brash cornet style was in complete contrast to Bobby's. Years later, he made appearances at Indianapolis nightclubs and with Eddie Condon for a 500-Mile Race appearance. I went to LaRue's supper club to photograph the band, where I took the cigarette lighter shot, among others. Bobby, a hi-fi fanatic, invited me to his guest apartment behind the club to hear some tapes played on his equipment, which he carted around on his travels. Clapping a pair of headphones on my ears, he turned on the tape player and, half-smiling, waited for my signs of amazement. The music was classical, and it was wonderful to hear. So, of course, was he, and I miss him.

Bobby Hackett, 1961

Wild Bill Davison and
Bobby Hackett, ca. 1949–50

Pee Wee Russell

b. March 27, 1906, St. Louis, Missouri

d. February 15, 1969, Alexandria, Virginia

The jazz community has always been peopled with individualists, but it is hard to think of a more strangely endearing player than Charles Ellsworth "Pee Wee" Russell. His somewhat mournful face, slender figure, and diffident manner would make you look twice at him, but the sound of his clarinet, and the motivating thought behind his work on this difficult instrument, could make your jaw drop.

Russell grew up in the Midwest, but he was a well-traveled musician, playing riverboats and tent shows in Texas and Mexico before returning home to work with local dance orchestras and attend college. In the fall of 1925 he joined a band at the Arcadia Ballroom in St. Louis, which also included saxophonist Frank Trumbauer and cornetist Bix Beiderbecke. All three were then on the brink of fame in the music world.

In 1927, after gigging around Chicago with the young swingers there, Pee Wee made the New York scene and recorded on tenor and clarinet with the Red Nichols combo. His sound gradually became less pure (if it had ever been pure) and more earthy. It seems he felt that the more he got into jazz, the more he ought to alter his attack and tone to match the mood of the music. Whatever the cause, by the time he became associated with the Eddie Condon crowd as its regular clarinetist, the Pee Wee Russell style was fully formed. Writers have gone to great lengths attempting to describe it, using words such as "strangled" and "pops and squawks," but the right words cannot be found; you have to hear Pee Wee to know.

The picture that was to come out of his work on the bandstand is regrettable. His fellow musicians, trading on the eccentricity of his style, made him a virtual clown to the audience, who, upon seeing his doleful face, went along with the gag. Pee Wee could only accept the situation and take even more outlandish solos. But things would change.

After an illness from which he almost died, his career entered a sort of renaissance. On the monumental CBS television special *The Sound of Jazz* (1957), he played in both traditional and experimental modern settings, paired with the avant-garde Jimmy Guiffre in an impressive departure from his usual style. In the ensuing years, Pee Wee took up painting at the urging of his wife. He became a beloved figure at festivals, and was able to record music of his own choosing. His legacy includes a number of oils and countless recordings, but only a few people have attempted to duplicate his distinctive sound.

I have always been very glad that I got this photograph. It's the only one of many that I feel shows Pee Wee at ease and comfortable with himself. It was taken in a tent that served as an offstage "green room" for musicians at the French Lick (Indiana) Jazz Festival in the late summer of 1959. The other musicians in the band, gregarious types such as Jimmy McPartland and Bud Freeman, were gladhanding everyone in sight, while Pee Wee, as usual, looked as if he wished he were somewhere else. But in a one-on-one-situation, as here, we established a rapport, brief though it was.

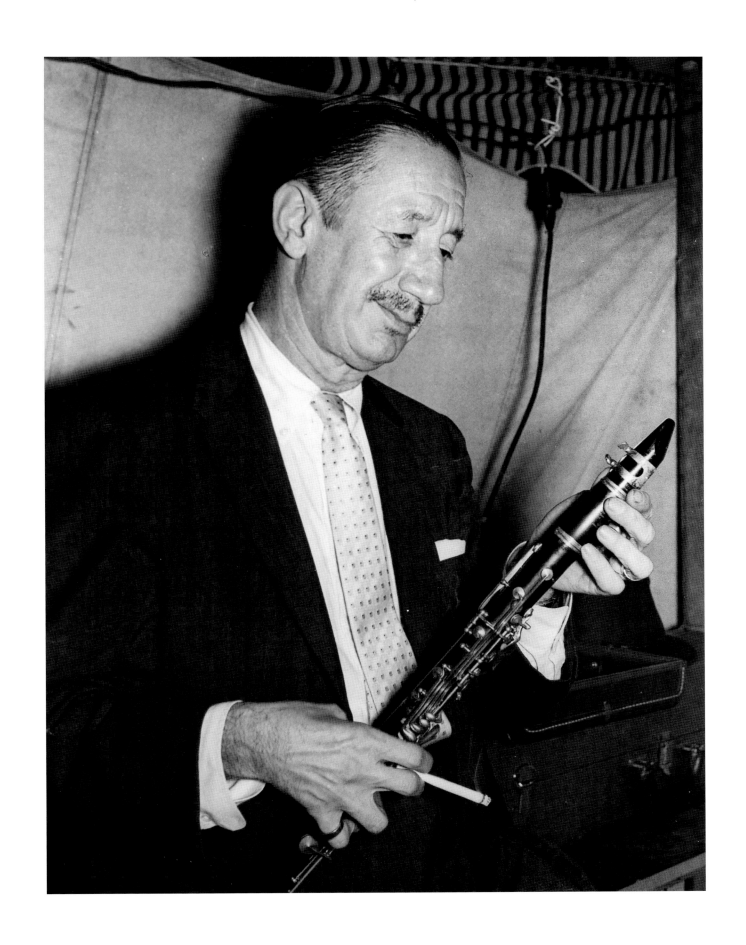

Pee Wee Russell, 1959

George Van Eps

b. August 7, 1913, Plainfield, New Jersey

d. November 29, 1998, Newport Beach, California

To a public accustomed to seeing guitarists onstage accompanied by fireworks, light shows, gyrating dancers, and ear-splitting sound emanating from monster speaker columns, it's hard to imagine the subdued yet vital role of guitarists in earlier generations. These men fleshed out the harmonic nuances of dance band rhythm sections, and that was the world in which George Van Eps grew up.

The Van Eps family was intensely musical. George had three brothers who also turned professional—on piano, trumpet, and saxophone. They were preceded by their father, Fred Van Eps, the most famous of them all. In the early part of the twentieth century, he was a prolific recording artist on banjo. Before the development of electric recording, the banjo, with its cutting sound quality, was highly esteemed, and banjo solos sold well.

George started on banjo, playing in his brother's band at age thirteen. He first broadcast as a soloist a year later. After hearing Eddie Lang, he immediately took up guitar. Within a very short time he himself was teaching others.

While still in his mid-teens, he joined the Smith Ballew band for two years, then played in a succession of recording and working bands, including Benny Goodman's. He was selected by arranger Glenn Miller to fill the guitar chair in the orchestra being assembled for Ray Noble's American debut. He followed Noble to California, where work was plentiful in Hollywood studio orchestras and on major radio programs. George wrote a guitar textbook, and he developed a startling innovation—a seven-string guitar, which provided extra capability in the bass notes but required him to devise special tuning and fingering.

Ill health curtailed his musical activities for some years, but he resumed work in the studios in connection with a revival of small group jazz, where his inventive chordal stylings and flawless technique provided memorable choruses. He was by now using amplification, but always with restraint. The era of the LP record would at last bring George Van Eps into the spotlight.

Regrettably, I was able to see Van Eps only once. It was a remarkable experience. I had been a long-time fan of his recordings, and as I had so often done with cornetist Bix Beiderbecke and bass saxophonist Joe Rushton, I played his solo passages over and over on the turntable.

Van Eps was a mild-mannered individual, and he looked the part, entirely befitting a man who had early training as a watchmaker. He was often to be found inventing things. On the bandstand, when not soloing, he was constantly attentive to what the other musicians were doing, and this photograph shows that clearly. But it also illustrates what I had in mind at the time—to show the guitarist's essentially supportive role, relied upon and valued by his colleagues, but too often submerged both visually and aurally in the overall picture.

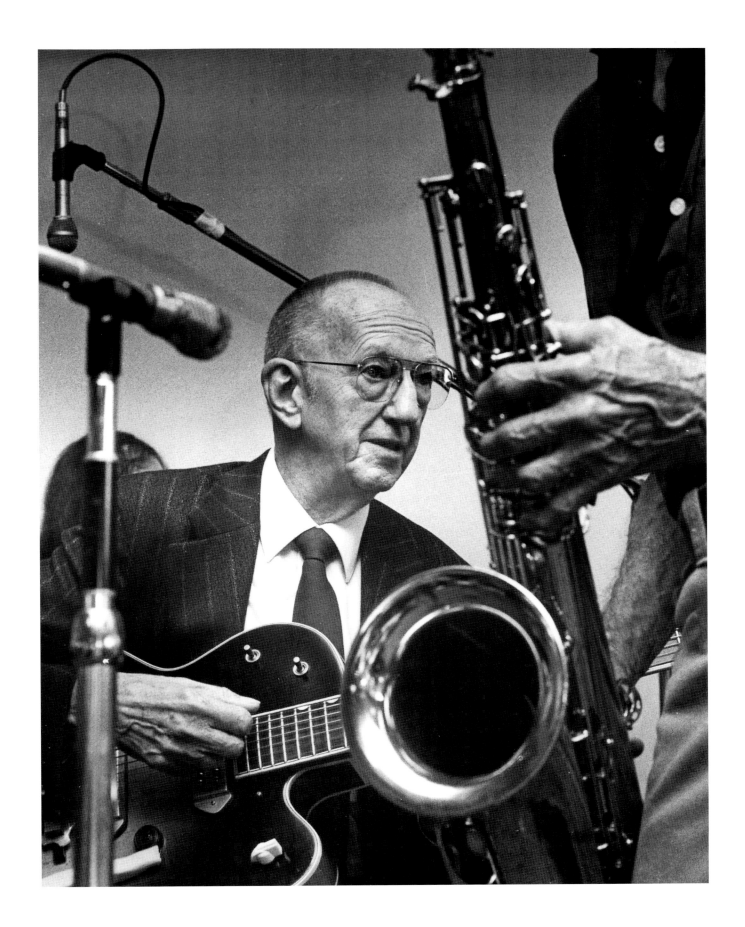

George Van Eps, 1986

Eddie Miller

b. June 23, 1911, New Orleans, Louisiana

d. April 6, 1991, Los Angeles, California

Eddie Miller started playing clarinet at a very young age, and got his early experience on the streets of New Orleans. He was only seventeen when he was lured to New York and the big band world, where he met and became friends with the leading tenor saxophone musician of the day, Coleman Hawkins. By this time, Eddie was himself playing tenor, and he was developing fast, with a fine, pure tone and a mature improvisational skill.

After a long connection with Ben Pollack's Orchestra, he became a charter member of the Bob Crosby band, a cooperative outfit that would pioneer the concept of big band Dixieland. His was the tenor saxophone voice in a "band within the band" called Bob Crosby's Bobcats. He also continued to play clarinet exceedingly well, and often soloed, despite the presence of other, equally capable members such as Matty Matlock and Irving Fazola.

Following military service in World War II, Miller, then based in California, found studio orchestras to be a lucrative and dependable way of life. Ample opportunities for recording came in jazz and non-jazz ensembles. Film work, such as the musical drama *Pete Kelly's Blues,* plus its offshoot television series and LP record albums, brought the Eddie Miller sound to yet another generation.

Two of his former Bob Crosby colleagues, trumpeter Yank Lawson and bassist/arranger Bob Haggart, formed an all-star unit for nightclub, festival, and concert appearances, and Miller was included. The size of the group varied, usually from eight to ten pieces. Their name? Not exactly self-effacing, they were known as the World's Greatest Jazz Band. And they very nearly were, for the twenty-odd years they existed. But diminished bookings and the graying of both the musicians and their audiences brought the end of the road. Miller was felled by a stroke while still an active member.

Here was another case where I had been a fan long before I was privileged to see and photograph someone. At a jazz party hosted by producer Joe Boughton in 1986, someone had the brilliant idea of re-creating the "Pete Kelly" band of movie fame, and a stellar group of musicians arrived from the West Coast carrying the original Warner Brothers arrangements. Eddie Miller played his usual tenor role, and original cast members George Van Eps, guitar, and Ray Sherman, piano, were also present, augmented by highly capable musicians from both coasts.

I was in seventh heaven all weekend. I shot roll after roll of candid pictures of the great names, which also included saxophonist Bud Freeman and bassist Bob Haggart. This is not to overlook younger players such as cornetist Randy Reinhart and the fledgling combo headed by Howard Alden and Dan Barrett, whose photos can all be found elsewhere in this book.

Two studies of Eddie Miller remain poignant souvenirs of that weekend. One, a closeup of Eddie in the midst of rehearsing for an evening performance, captures a faintly quizzical expression as he looks over his glasses toward someone out front. The other, inspired by the sight of him heading for the local pier, saxophone case in hand, was included simply to show in a generic way how the professional dance band musician might typically go to work on a summer day. The photograph soon became much more than that, as Eddie was approaching his final chorus. It was fitting to title it "Farewell to Eddie Miller." To this photographer and fan, it was.

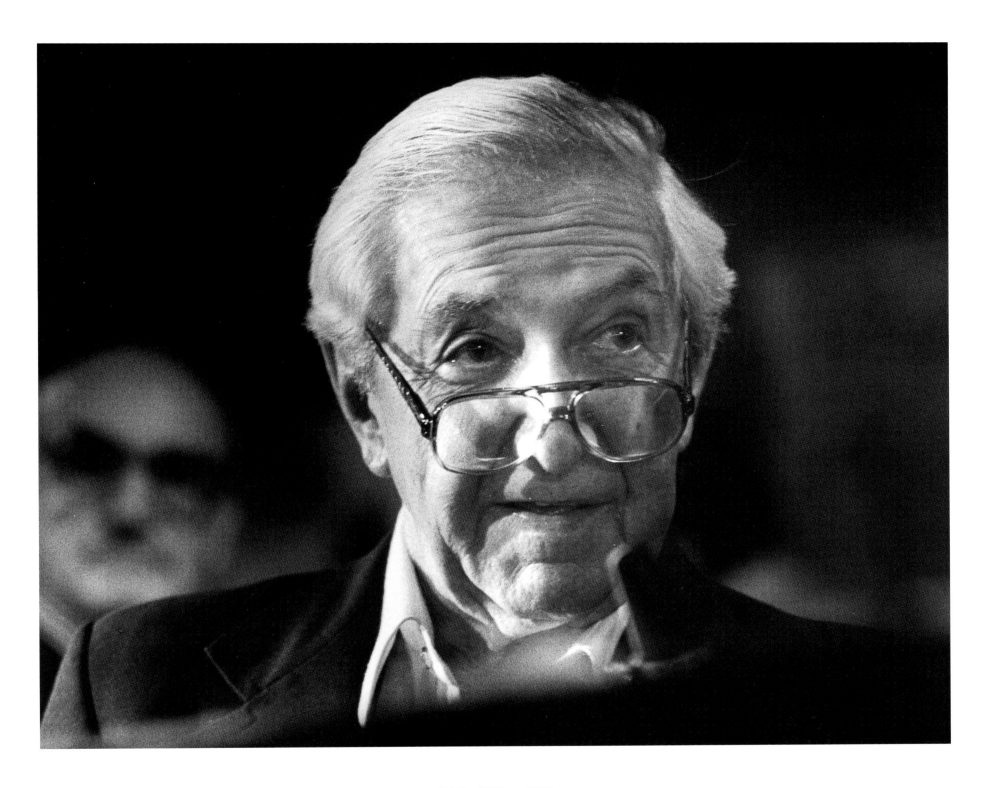

Eddie Miller, 1986

Red Allen

b. January 7, 1908, New Orleans, Louisiana

d. April 17, 1967, New York City

Henry "Red" Allen's father led a prominent New Orleans parade band, and the son received excellent early training on trumpet. As his style began to include more modern approaches, Red moved confidently into the big bands up north, notably the Luis Russell outfit, where he was groomed by Victor Records as an answer to the reigning "jazz king" Louis Armstrong, whose records for the OKeh label were the current rage.

The effort met with only moderate success. Red remained for a time with Luis Russell. His career path led to the role of sideman in other prominent orchestras in the nascent Swing Era. A memorable stint in the mid-1930s Fletcher Henderson orchestra featured hot, unpredictable flights on his horn, which today suggest that Allen may have been a major precursor of the bebop period, still a decade away.

Rejoining Luis Russell's big band brought the supreme irony: This soon became the official "Louis Armstrong Orchestra." There could not be two trumpet stars on the same bandstand, and Allen's individuality could be expressed only on recordings made for a competing label—small group swing, playing the pop songs of the day, with vocals by Red. These may have been intended to answer the success of another star of the day, Fats Waller, but they are capable of standing on their own.

For the rest of his life, Allen moved easily between traditional jazz, swing, and the avant-garde music of the 1940s and 1950s. At times he led his own combos. Some nights he could be found vying with the young experimenters in Harlem (his forward-looking ideas belied his age), and he became a sort of elder statesman of jazz, culminating in a memorable performance on the famous CBS television program *The Sound of Jazz* in 1957. He played until the very end of his life, succumbing to cancer just after returning from a tour of Britain.

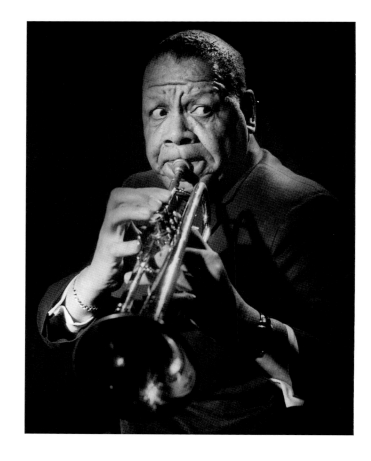

I first saw Red Allen in action at New York's Stuyvesant Casino, a Second Avenue catering hall where I photographed the weekly jazz sessions featuring well-known veterans of the big band era who were unable to find steady work. The patrons were mostly of college age, and their noise level increased with their consumption of beer, which was served by the pitcher. As a consequence, the horn players, iron-lunged men such as Allen, Hot Lips Page, and Jimmy McPartland, were obliged to blow even harder. While favorable for a photographer, this did not make for good listening!

I next encountered Red in 1962, in Indianapolis. Contacting him at a fashionable nightclub where his band was playing, I asked if he would come downtown to the studio where I worked and let me take some publicity-type portraits of him. He instantly agreed. He showed up exactly on time, dressed immaculately. It was perhaps the easiest sitting I ever had, with his genial cooperation and his marvelous, photogenic face.

The second photograph dates from two years later, in Columbus, Ohio, at, I believe, the Grandview Inn. Red and his pianist, Sam Price, were relaxing at the bar between sets, and I was praying that there was enough ambient light to get a decent image. Just before I pressed the shutter release, someone behind me cracked a joke. As the picture plainly shows, Sam got the joke immediately, while Red was still working on it when I took the shot. It remains my favorite photograph of all time, a precious memoir of an unforgettable man and musician.

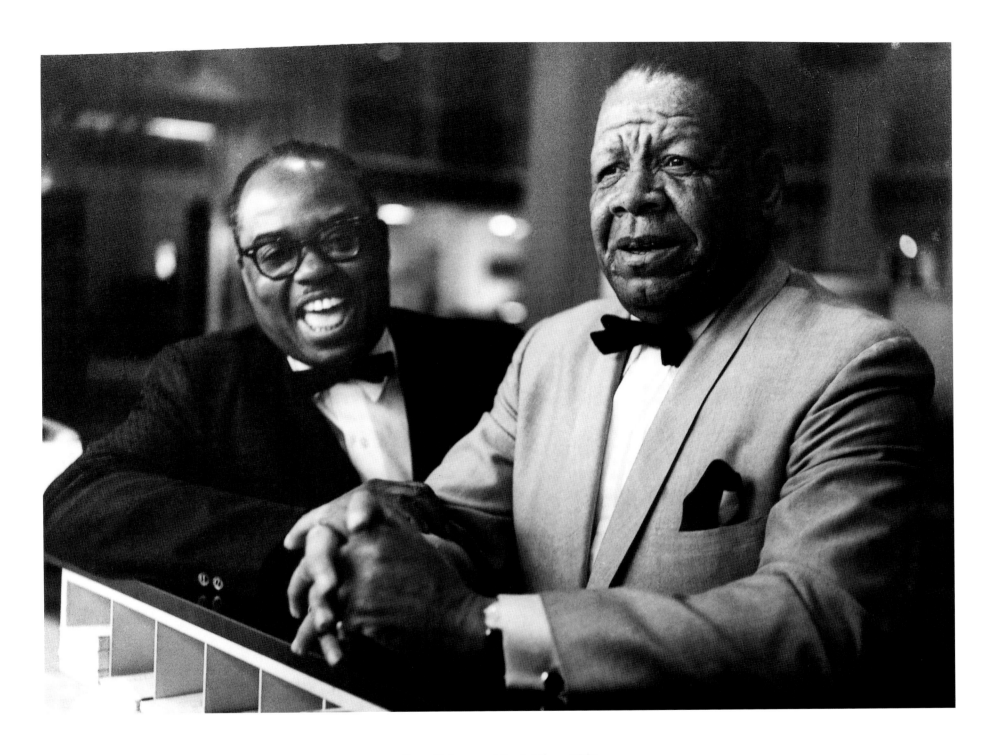

Sam Price and Red Allen, 1964

Red Allen, 1962

Hot Lips Page

b. January 27, 1908, Dallas Texas

d. November 5, 1954, New York City

A consummate trumpet player whose ability to play and sing the blues made him legendary during his lifetime, Oran "Hot Lips" Page never achieved the fame he deserved. A member of the famous Bennie Moten band in Kansas City during the early 1930s, he joined the new band of Count Basie formed in 1936, and went on to be a budding star in the local nightclubs. The New York–based agent Joe Glaser (who also managed the Louis Armstrong Orchestra) signed him to a contract, and he left for the "Big Apple." He was installed at the head of a band of his own, which failed to win sufficient popular acclaim. The subsequent years found him gigging around New York, where he was employed in several bands under white leadership. He participated in myriad jam sessions in Harlem and downtown.

An extended engagement with Artie Shaw's successful swing band during 1941–42 resulted in several hit recordings featuring Page's horn and Armstrong-like vocal timbre. But his was always a distinctive and immediately identifiable talent. Only forty-six years old when he died of a heart attack, Lips nevertheless earned an indelible place in jazz history.

I first encountered Lips at one of the rowdy Bob Maltz jam sessions at the Stuyvesant Casino. It was probably in 1948 or 1949. Though we didn't get to converse, I could see immediately that he was a natural pacesetter among the musicians present, and was fully capable of overcoming the usual din with his trumpet. Sadly, it served only to hide the subtleties of his playing and the humor of his blues songs.

This photograph, slightly unsharp as it is, is a favorite of mine because of the almost palpable power of performance that it suggests. I remember Lips as a fun-loving and dedicated player whom I would like to have known much better. When I want to raise my own spirits, I need to do no more than play his memorable duet recording with Pearl Bailey, "Baby, It's Cold Outside."

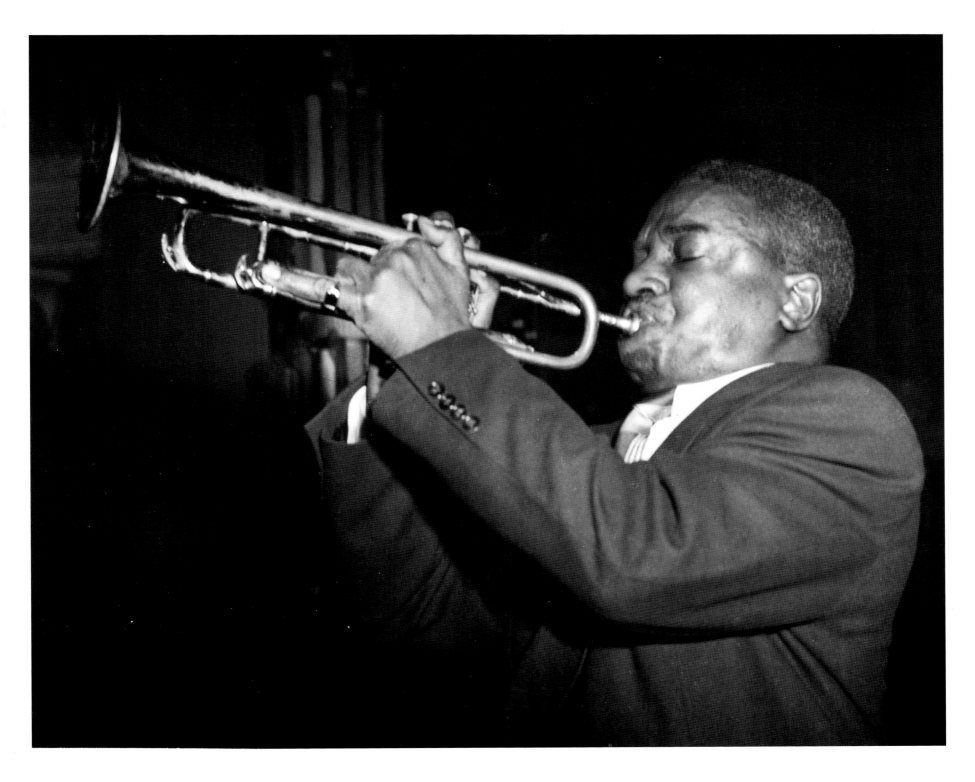

Hot Lips Page, ca. 1949–50

Johnny Hodges

b. July 25, 1907, Cambridge, Massachusetts

d. May 11, 1970, New York City

If any single musician, other than the leader, provided the "soul" of the Duke Ellington Orchestra, it had to be the alto saxophonist Johnny Hodges, whose haunting sound as section leader and soloist lingers in the memory of millions of music lovers around the world. His style, inspirational to numerous other saxophonists, was languorous on ballads and the Ellington mood pieces, but also oddly appropriate in more rapid tempos. He combined a pure saxophone tone with a characteristic "reaching" for notes, which lent a plaintive flavor to his music.

Hodges received little formal musical training, but he absorbed some early insights from Sidney Bechet in New York. He was a sideman with Willie "The Lion" Smith and drummer Chick Webb prior to joining Ellington in 1928. Thus began an association that would continue, on and off, for forty-two years. Hodges passed away suddenly in the office of his dentist, after which the Duke said that his band would never sound the same again. Fans fondly recall the Hodges sound on such recordings as "Jeep's Blues," "Day Dream," "Isfahan," and "Warm Valley."

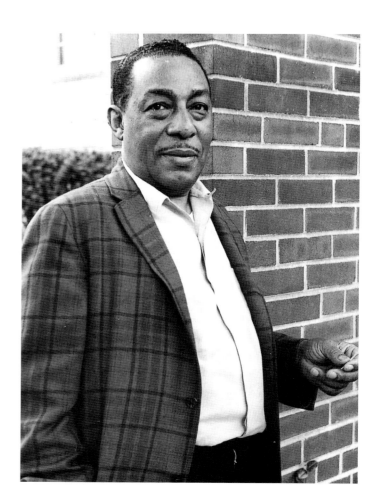

My observations of Johnny Hodges at work were frequent, as the Ellington orchestra was often booked in the Midwest at theaters and ballrooms. However, in what seems an almost miraculous occurrence, Ellington was part of a jazz package show engaged for the Indiana State Fair in 1961. Others on the bill were George Shearing and Al Hirt's combo. I hastened to cover the event with my camera, and was delighted to find that the show would be outdoors, with plenty of spotlights trained on the stage.

Exposures under these conditions were relatively easy, and I was able to concentrate on specific musicians as they took their turns. The first photograph shows the diminutive Hodges capturing the audience with one of his matchless performances. A spotlight in a picture frame can often be the bane of a photographer, but in this case I saw it as an integral part of the composition.

Johnny's stage manner was in sharp contrast to the glorious sound that issued from his instrument. Unlike some others, he always played with his eyes open, his gaze roaming across the audience as if "counting the house." Seated in the saxophone section, playing familiar tunes for perhaps the thousandth time, he could seem almost bored. Therefore, when I was able to take a snapshot of him a year later at Wabash College, I was happy to find him affable and able to conjure up a smile for me.

Johnny Hodges, 1962

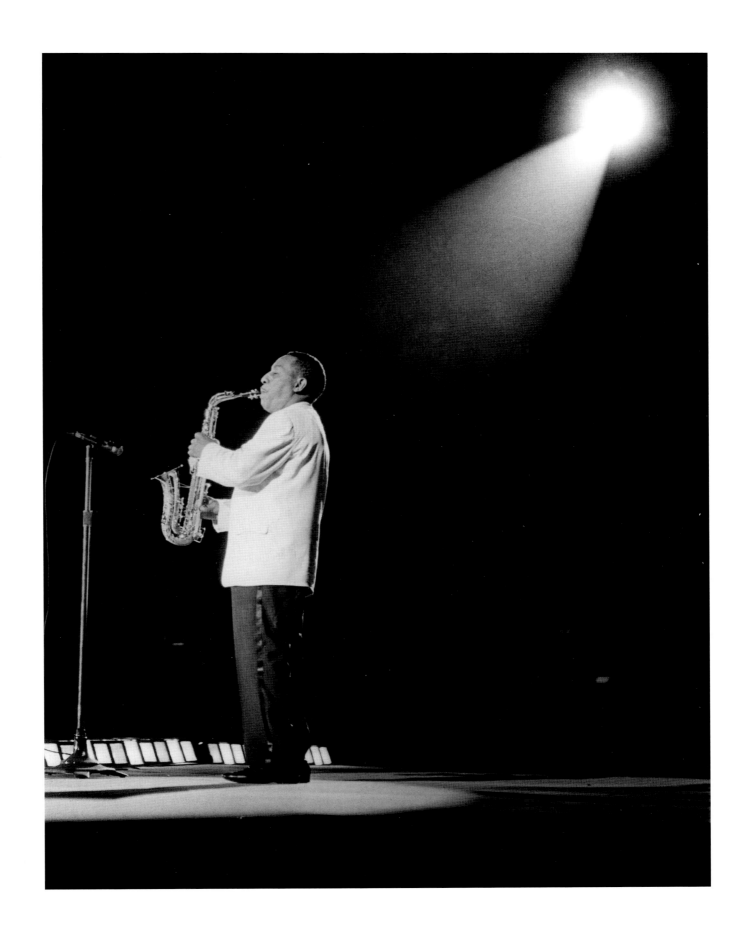

Johnny Hodges, 1961

Harry Carney

b. April 1, 1910, Boston, Massachusetts

d. October 8, 1974, New York City

Lawrence Brown

b. August 3, 1907, Lawrence, Kansas

d. September 5, 1988, California

Two stalwart members of the Duke Ellington Orchestra were Harry Carney, who anchored the saxophone section with his deep-toned baritone sound, and Lawrence Brown, whose unique, often haunting trombone tones were inimitable.

Carney was playing professionally in bands by his early teen years. Among his Boston friends were future saxophone greats Johnny Hodges and Charlie Holmes. While visiting New York with them in 1927, he was able to play in the Savoy Ballroom and was picked up by Ellington, who, ironically, was about to play a Boston engagement. Harry remained with Ellington for forty-seven years, initially under his guardianship because of his youth. He became one of Duke's most trusted associates, often driving the leader from one date to another.

Despite his dominance on the baritone sax, which earned him first place in many jazz popularity polls, Carney also excelled on clarinet, as can be heard on Ellington records. Amiable in nature, he apparently was not possessed of a large ego, and his name rarely appears on a record label except as sideman. In contrast, other Ellingtonians were listed as leaders by the Duke in small group sessions on other labels in order to avoid contractual problems with his principal label.

It is hard to imagine the Ellington sound without Carney's big baritone, and indeed, as if bereft, he followed Duke in death by only a few months.

Lawrence Brown, three years older than Carney, spent a number of years in California before he joined the Ellington orchestra in 1932, enlarging the trombone section to three, unusual for the day. He would stay, with one nine-year absence, until 1970. His quiet, flowing style, in contrast to that of his section mates, provided a perfect lyrical hue for Duke's palette. Following his departure from Ellington, he put down his horn for good, and took a government job.

This happy moment took place as the two veterans relaxed by the Ellington band bus prior to playing a dance at Wabash College in Crawfordsville, Indiana. It was spring 1962, and I had come to do some school photography, with jazz photos far from my mind. Once I saw the band bus, however, first things came first, and I saw the chance to depict the two as friends, not just fellow band members. As a footnote, Duke was not present for the gig; his son Mercer directed the band, and Billy Strayhorn was deputized on piano.

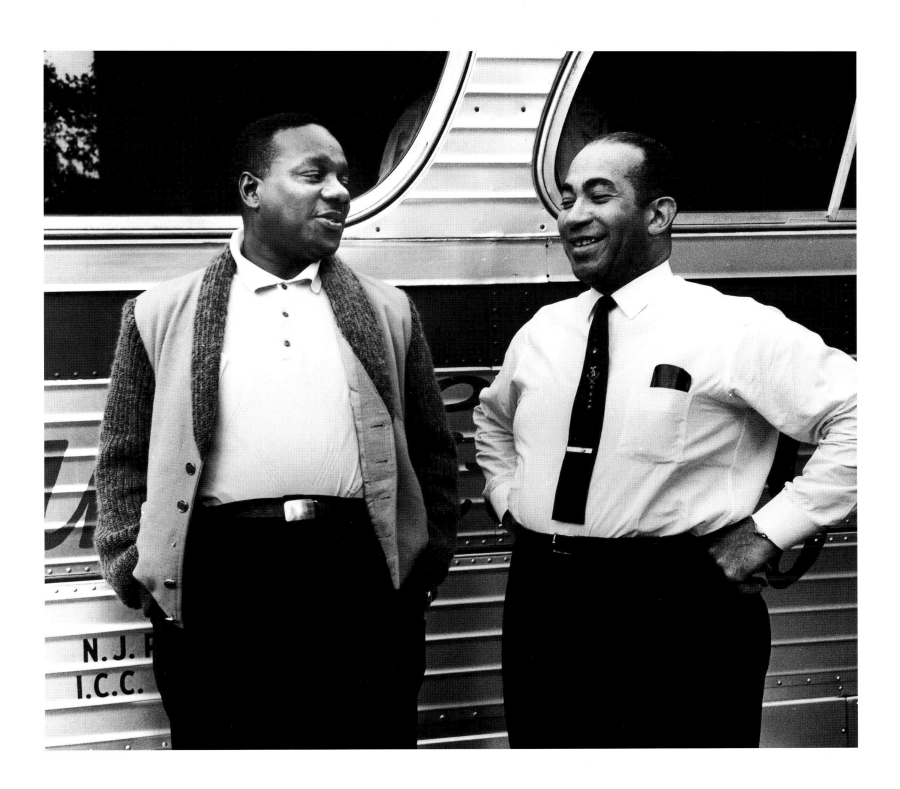

Harry Carney and Lawrence Brown, 1962

Lester Young

b. August 27, 1909, Woodville, Mississippi

d. March 15, 1959, New York City

If one hallmark of a major and ultimately influential jazzman is the presentation of a singular playing style, then Lester Young is a textbook example. This giant of the tenor saxophone began on that instrument only after early experience on drums and other instruments available in the Young family band.

After leaving the fold, he had various associations in bands ranging from Arizona to Minnesota, finally settling into the Kansas City scene in the early 1930s. He contributed to the local musical excitement provided by the Blue Devils, Bennie Moten, and the transplanted East Coast pianist Count Basie. Word of this remarkable talent was carried by fellow musicians and reached the ear of the New York leader Fletcher Henderson, who was then seeking to replace his departed tenor star Coleman Hawkins.

Hawkins, even at this time a near-legend, had brought the tenor saxophone to jazz playing almost single-handedly, and he stood virtually alone among his contemporaries. His big, robust tone and ferocious attack were dominant, and seemingly set the style for tenors for all time. When Lester Young was inserted to fill the tenor chair, the contrast between the newcomer's dry and economical style and the more aggressive approach of Hawkins was dismaying to the Henderson veterans, and Young's foray into New York was cut short by their influence with the leader.

The next time he came to the city was with the powerhouse band of Count Basie, then on the threshold of fame. The Lester Young sound and his uncanny sense of timing were fully developed. It was as if a large fork had opened up in the jazz road; one followed either the old Hawkins way or that of the newcomer. Basie, an experienced musician and leader, sensed the value of this contrast, and capitalized on it by placing Young's "cool" sound on the bandstand in apposition to that of a Hawkins-influenced player, Herschel Evans. Their "battles" were a delight to the fans.

Critics in the jazz press, often slow to embrace something new, did not universally take to Young's style. But from his very first recording, a small group session featuring Basie regulars, it was evident that a creator of rare ability was present. His solo on "Lady Be Good" is so original, and so logical, that he himself may never have exceeded it in the hundreds of exciting recordings he made in later years.

There were many recordings in the following years, but the verve of his playing gradually slipped away as Lester leaned increasingly toward ballads and languorous tempos. His idiosyncratic dress and speech tended to attract as much attention as his music, though he was still a force. But it was his declining health, exacerbated by a drinking habit, that finally took him down. He died in a lonely hotel room in New York after returning from a European tour.

While I had been excited for many years by the wonderful solo passages that lit up so many of Lester's records with Basie, our paths did not cross until the twilight of his career, in 1957. It was at one of the jazz package shows that periodically visited Indianapolis, and I made sure to be backstage, courtesy of a friendly stagehand. I caught sight of Lester wandering aimlessly through the scene, pausing to look in on a dice game, then moving on, seemingly uninvolved with anyone else. I was toting my 4 × 5 Speed Graphic camera in those days, and I may have appeared to be a press photographer, for when I requested his cooperation for a photograph, he assented right away. We took a couple of shots backstage, then one or two in the dressing room. If I had known that this would be the last time I would ever see him, I would have made more of the occasion. Ah—hindsight!

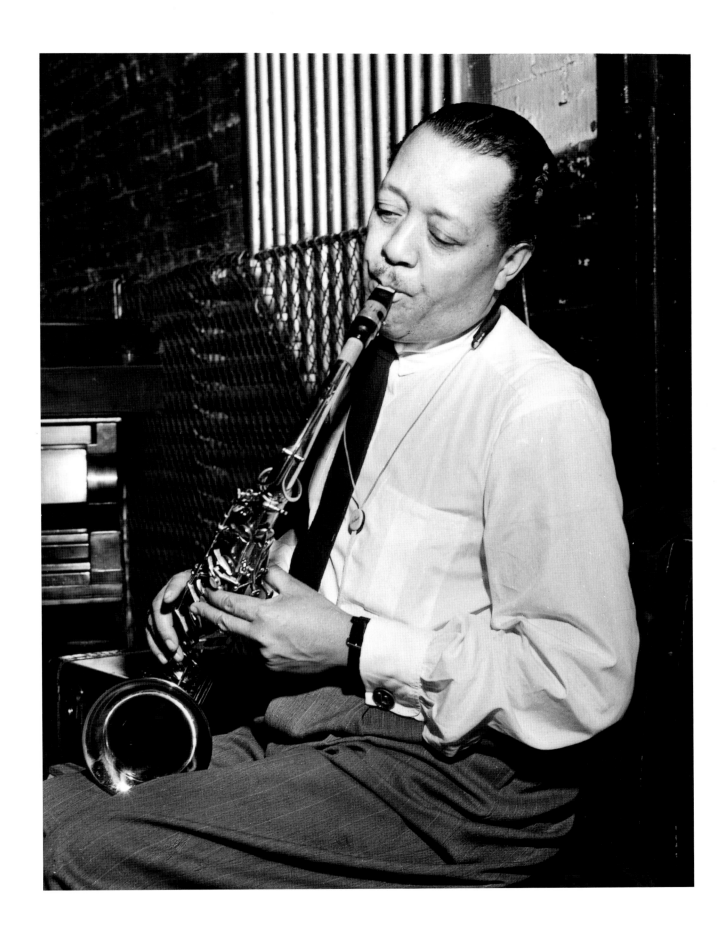

Lester Young, 1957

Helen Humes

b. 1913, Louisville, Kentucky

d. September 9, 1981, Santa Monica, California

Jimmy Rushing

b. August 26, 1903, Oklahoma City, Oklahoma

d. June 8, 1972, New York (?)

Two early vocal careers were to merge in the late 1930s when Helen Humes and Jimmy Rushing became the principal singers for the Count Basie band in New York. Rushing, the original "Mr. Five by Five," was an appealing personality who could double on piano, but he is remembered primarily for his exuberant vocal style, though he was not strictly a "shouter." He could render pop songs and authentic blues, and do a little soft-shoe dancing if required. He was a veteran of bands in the Southwest during the early jazz era, and ranged as far as California, appearing at one point with the legendary Jelly Roll Morton. Settling in Kansas City after much touring, Jimmy became the singer with Bennie Moten. After that leader's death in 1935, he joined Count Basie, with whom he eventually went to Chicago and New York. After 1948, Jimmy appeared in an incredible number of venues, including bands led by Benny Goodman, Bob Crosby, Harry James, and Buck Clayton. In addition, he made a number of excellent recordings under his own name in the LP era. Jazz festivals and overseas appearances kept his name alive until his eventual passing.

Following the call of show business, Helen Humes left Kentucky, and in 1927 she made her debut recording for OKeh in Chicago. Possessing a fairly small though sweet voice, she offered an alternative to the more robust Rushing, but she was seldom recorded with the Basie band. In 1941, after leaving Basie, she spent many years on tour, doing club work and residing in such locations as California and Australia. She finished her days in Louisville, now and then making a mild comeback.

I remembered seeing these two at their "home base"—the Apollo Theatre in Harlem. But I never saw them together until one night at the French Lick Jazz Festival in Indiana when they were part of an all-star aggregation. Catching them seated together, in animated conversation, seemed a near-miracle, and I simply had to record the shot as Jimmy entertained Helen with some story.

From this 1959 festival, I have an indelible memory (and accompanying photographs) of Helen, Sarah Vaughan, and the vocalese team of Lambert, Hendricks, and Ross as they delighted the massive crowd with their version of a jam session—with a single microphone, yet!

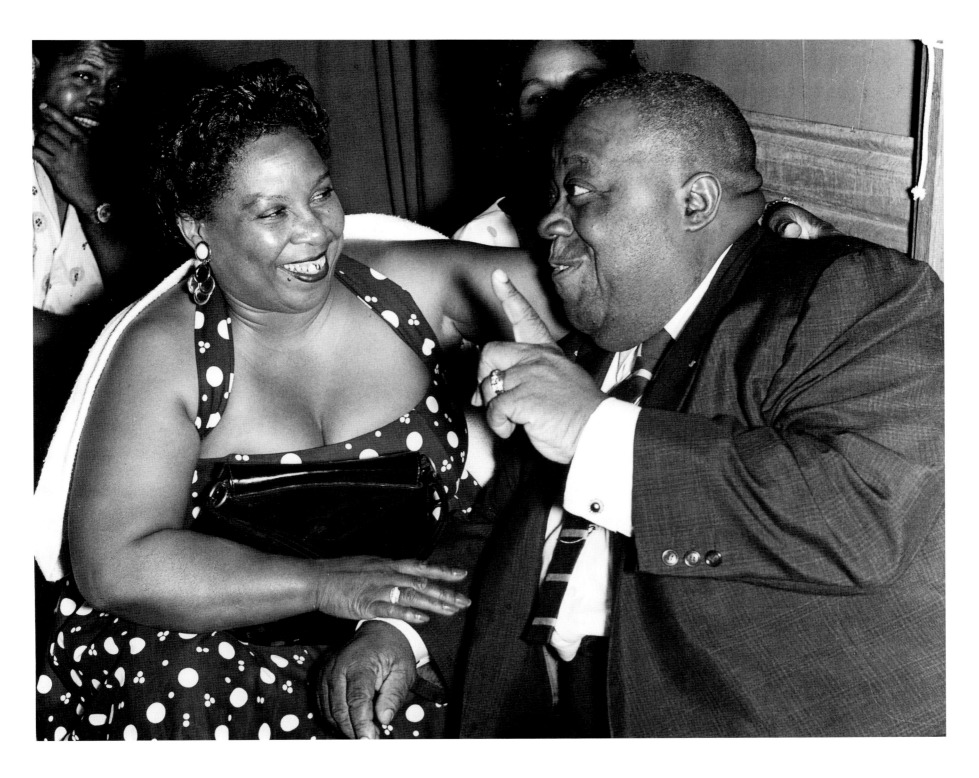

Helen Humes and Jimmy Rushing, 1959

Bob Haggart

b. March 13, 1914, New York City

d. December 3, 1998, Venice, Florida

Robert Sherwood "Bob" Haggart, one of the most gifted and beloved figures in all of jazz, began his long musical career as a member of his school band, playing piano, trumpet, and eventually string bass. Earlier, however, he had taken up banjo and guitar, including some lessons from the renowned George Van Eps. By age twenty-one, after some dance band experience, he entered the new Bob Crosby band (formed from the breakup of the Ben Pollack Orchestra) as its bassist and youngest member. The band, a cooperative outfit, was headed for great popularity as purveyors of big band Dixieland—not a difficult task, for the key members either were from New Orleans or had an affinity for the style.

Haggart, a tall, friendly man with a wry sense of humor, proved to be a great asset, for in addition to his performing ability, he made use of his multi-instrumental talents in composing and arranging. His most enduring song, "What's New?," became a standard ballad, while some of the instrumentals he wrote for the band are mileposts in its history: "Big Noise from Winnetka," "I'm Prayin' Humble," "Smoky Mary," and "South Rampart Street Parade."

Bob's middle and later years were crammed with musical activity. After 1942, when he left the Crosby band, he worked in New York radio staff orchestras, took part in various reunions of the old band, and appeared on countless recording sessions as bassist and/or arranger. In the LP era, he and an old band friend, trumpeter Yank Lawson, made a memorable series of records as the Lawson-Haggart Jazz Band. This studio partnership was followed by the creation of a working band that took its members to all parts of the country, helping to keep traditional and mainstream jazz alive during some lean years. It was the band's backer, promoter Dick Gibson, who suggested that they call themselves the World's Greatest Jazz Band, a grandiose title that the group's members accepted only reluctantly. Judging from its all-star membership, however, the name was not too great an exaggeration. When its touring days were over, Bob and Yank would occasionally reassemble the group for individual appearances.

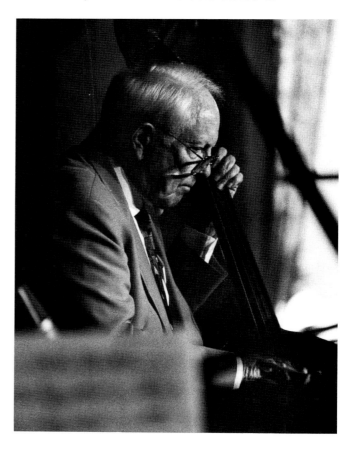

A move to Florida did not dim Bob Haggart's activity, and the last twenty years of his life included golf, occasional arranging, and appearances at jazz parties and festivals. "Hag," as he was known to his friends, enjoyed keeping up correspondences and painting in oils.

I look back on Hag as one of the most approachable musicians I ever knew. Like Louis Armstrong, he was ever courteous to the photographer who had an idea for a picture. And with his cheerful attitude, the odds were that something good would emerge. This first image, one of my favorites, owes little to me, for I just happened to see him relaxing off the stand and asked him not to move a muscle until I had my camera ready. He complied, and I knew from the half-amused expression on his face that he was wondering what kind of portrait this would turn out to be! At the time, I felt it would be something special, and of all the pictures I ever took of him, it is the most purely human one. It typifies what I always strive for—a glimpse of the essential inner person.

Bob Haggart, 1986

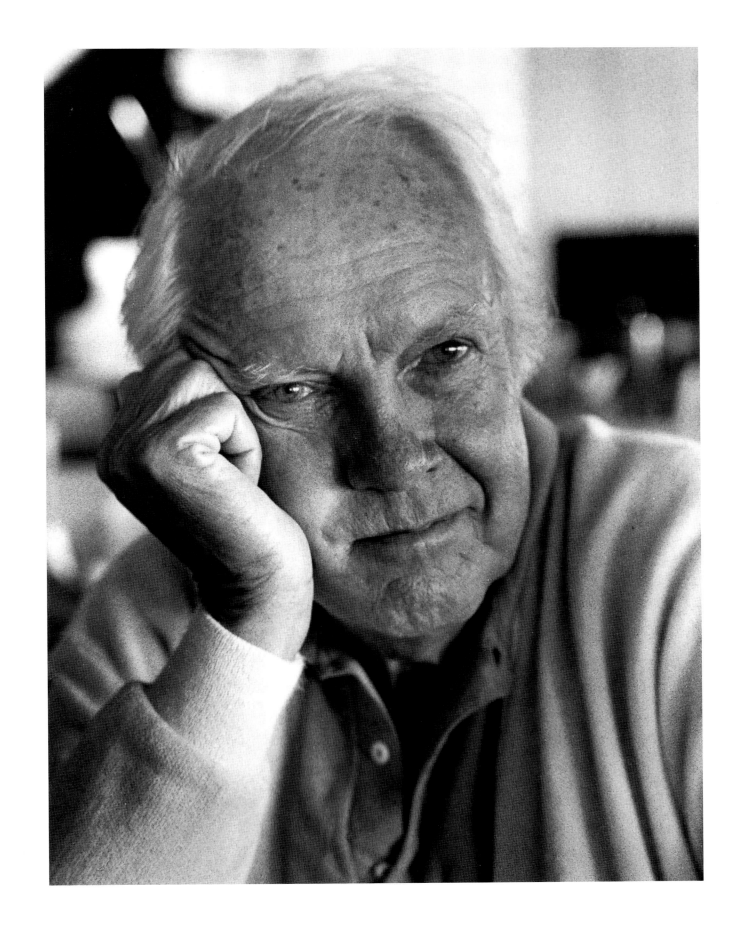

Bob Haggart, 1997

Art Tatum

b. October 13, 1909, Toledo, Ohio

d. November 5, 1956, Los Angeles, California

If you want to know the true extent of musical genius, it is not enough to believe what the scholars and critics say. You must listen to those whose ears are most keenly attuned to the nuances and the dynamics of performance—other musicians. In the jazz world, only the rare name is spoken with virtual awe among players, and one of those names is Art Tatum. In this he joins a very few individuals—Armstrong, Ellington, Parker—and the list usually ends there. Of the four, however, Tatum remains the least known despite his massive talent. There are apparent reasons: the handicap of near-total blindness; the absence of a significant body of composition; a low-key manner approaching indifference while performing; and, importantly, an impression of self-isolation in his artistry. This last is evident when you consider how few times Tatum successfully filled a piano chair in a band. Like Sidney Bechet, he had an overpowering technique that dominated everyone else. Tatum surely wanted to be part of a team, but he seldom was able to achieve it.

A stunning soloist, Tatum arrived in New York during the Depression as an accompanist to the singer Adelaide Hall. Privately, he was introduced to the reigning kings of the keyboard in Harlem, and astounded them all. Nobody had ever heard jazz piano played like that, and they became immediate fans. In later years, the great Fats Waller, upon seeing Tatum enter the Fifty-Second Street nightclub where he was playing, announced to the audience: "Ladies and gentlemen, I am a piano player, but God is in the house tonight."

Tatum inspired many pianists to greater things, but few could approach his mastery of the entire keyboard. Consider the rippling runs and pregnant suspensions, his advanced harmonic instincts and startling interpolations of other tunes. Famous classical musicians, composers, and conductors would leave a Tatum performance shaking their heads in wonder.

His career included engagements in posh nightclubs, on radio, and in recording studios. He won his share of popularity polls, but the fame he deserved eluded him. For years he led an effective trio using seasoned players on bass and guitar, but they were not really needed, except to provide him relief.

Like many of the great pianists, Tatum had a number of "set pieces"—carefully worked-out routines that were varied only slightly, if at all. These appeared on a number of different labels, and it wasn't until the 1950s that producer Norman Granz began a long-dreamed-of project, to record Tatum solo, in depth. In all, a series of 121 standard ballads and rhythm tunes were released on Granz's label, a magnificent tribute without parallel in jazz history. It was timely, too, for it found Tatum at the peak of his powers, despite an illness that would take him in 1956 at the age of forty-seven.

While researching the life of Fats Waller, I was struck by the number of musicians who would start talking about Tatum and his impact on Waller and the other Harlem pianists. Ironically, it was Fats to whom Tatum attributed his initial piano style. The Waller influence is most apparent in Tatum's swinging left hand "stride" patterns.

I had to see for myself, so I went to Café Society Downtown in New York, armed with my trusty Speed Graphic camera, which was usually good for getting past a suspicious doorman or head waiter. As was my thrifty practice, I took only three photos that evening, but I spent a lot of time listening to Art's performance. One vivid memory remains: There was a young, well-dressed but noisy audience (today they would be called "preppies") whose conversation and clinking of glassware covered up much of the marvelous music being played. Such rudeness did not escape the ears of the pianist, who stopped dead in the midst of a complex chorus, breaking into a childish rendition of "Mary Had a Little Lamb." He continued until the noisy crowd, aware of their own rudeness, quieted down, whereupon he picked up the next measure of the tune he had been playing. I felt like cheering!

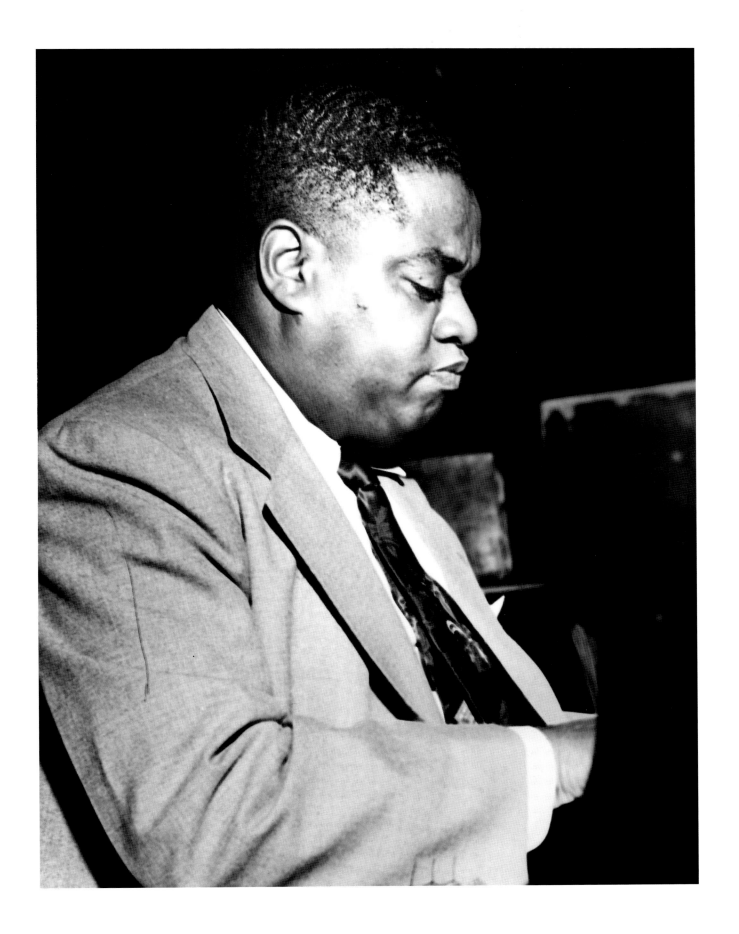

Art Tatum, 1950

Arvell Shaw

b. September 15, 1923, St. Louis, Missouri

d. December 5, 2002, Roosevelt, New York

A durable bass player, Arvell Shaw, like the legendary Ellington player Jimmy Blanton, worked on Mississippi riverboats with pianist Fate Marable. After service in the Navy in World War II, he joined Louis Armstrong's big band for two years. He took a couple of years off to study harmony and composition, then rejoined Armstrong, who by then was fronting the All Stars, a six-piece combo. After 1956, Shaw frequently worked in a trio led by Teddy Wilson, and during subsequent years he became a popular musician at jazz festivals here and abroad.

I had been impressed that Louis Armstrong thought enough of Shaw's bass work that he would bring him out front to do a specialty bit. So it was no surprise that when I covered the Teddy Wilson Trio's appearance at Indianapolis's Embers Club in 1961, there, out front again, was Arvell.

As a photographer, I was always concerned that my subjects would blink at the moment of exposure, ruining a good picture. In this case, however, the closed eyes were part of the picture. They convey Shaw's intense concentration on his solo, for they remained shut during the whole time, and I doubt if he was even aware that I was right in front of him, camera to my eyes.

Electronic flash, almost dead-on, provided the stopped action and the wire-sharp detail that characterizes this picture. That fall, I was delighted to be awarded a first-place ribbon at the Indiana State Fair for this photograph.

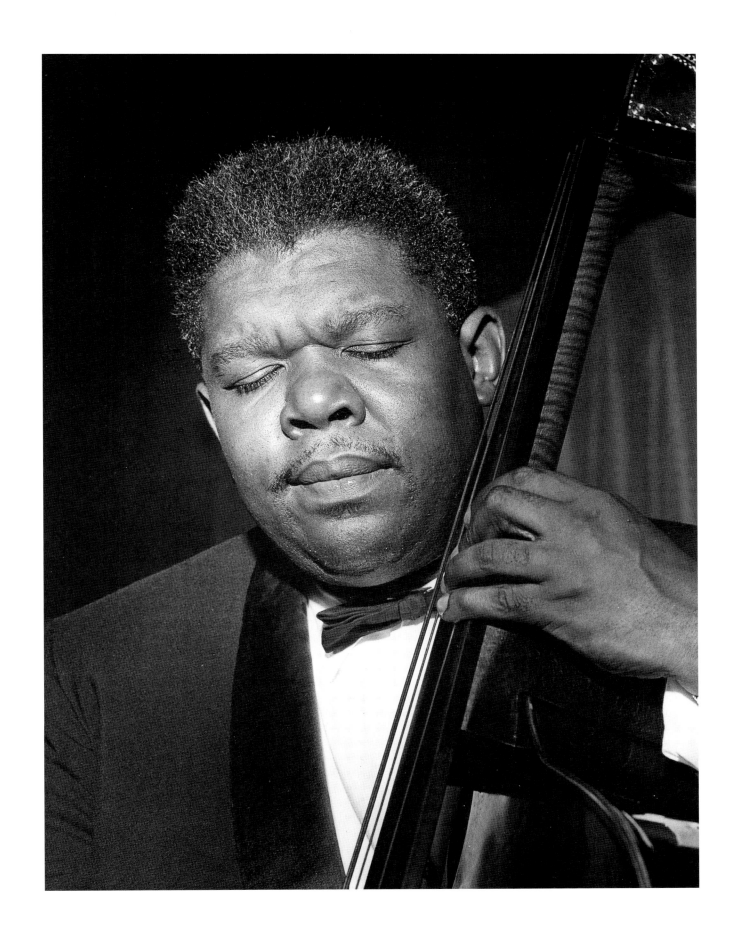

Arvell Shaw, 1961

Joe Wilder

b. February 22, 1922, Colwyn, Pennsylvania

A package of talent who has been charming audiences for nearly sixty years, Joe Wilder bears a surname that reflects neither his trumpet style nor his personality. To the contrary, he is one of the most sensitive and durable musicians in jazz.

Joe came out of a musical heritage. His father decided to broaden his own abilities by taking up bass violin in his nineties! While still a teenager, Joe joined the Les Hite band, then moved on to Lionel Hampton ("We were all underpaid"), Dizzy Gillespie, Jimmie Lunceford (the leader's final band), Sam Donahue, Herbie Fields, and Lucky Millinder. In the midst of all this activity, he served in the United States Marines in World War II, during which time he led a band of his own. He was a member of the Count Basie orchestra in the 1950s, a period of renaissance for the Count.

Wilder, the soul of professionalism, is blessed with what it takes to succeed in the music business: an engaging manner, an ability to relate to colleagues, employers, and audiences (many of whom, including this writer, are proud to call him friend), and, of course, outstanding musicianship. He has a beautiful open tone, a great ear for subtle harmonic changes, and a distinct articulation of notes that is classical. He has been in demand for radio and television orchestras, and on Broadway he was in the pit orchestra for *Forty-Second Street*. He is a key member of the famous Smithsonian Jazz Masterworks Orchestra, and has recorded with Eileen Farrell, Benny Carter, and others, in addition to records that feature his tasteful trumpet and flugelhorn work. Wilder is one of the most sought-after and appreciated musicians on the jazz festival scene.

Joe caught my eye (and ear) during the Conneaut Lake Jazz Festival in 1986. I was very impressed with his sound, the way he attacked notes, and his obvious good musical taste. What I did not know (but would soon discover) was that he was also an accomplished and dedicated photographer. This would bring us together, and I admired his equipment, which always seemed a step or two ahead of my own—and still does!

Joe's mobile face, furrowed deeply in concentration while he was playing, lit up with a broad smile when the tune ended, simply calling to be captured on film. He would return the compliment by photographing me, and I can honestly say that Joe is a "miracle man" when it comes to making a silk purse out of you–know–what.

This photo proved to be a favorite of Joe's wife. The pose and expression seem to have devout overtones, reminiscent of paintings of early Christian martyrs. But I like it, too!

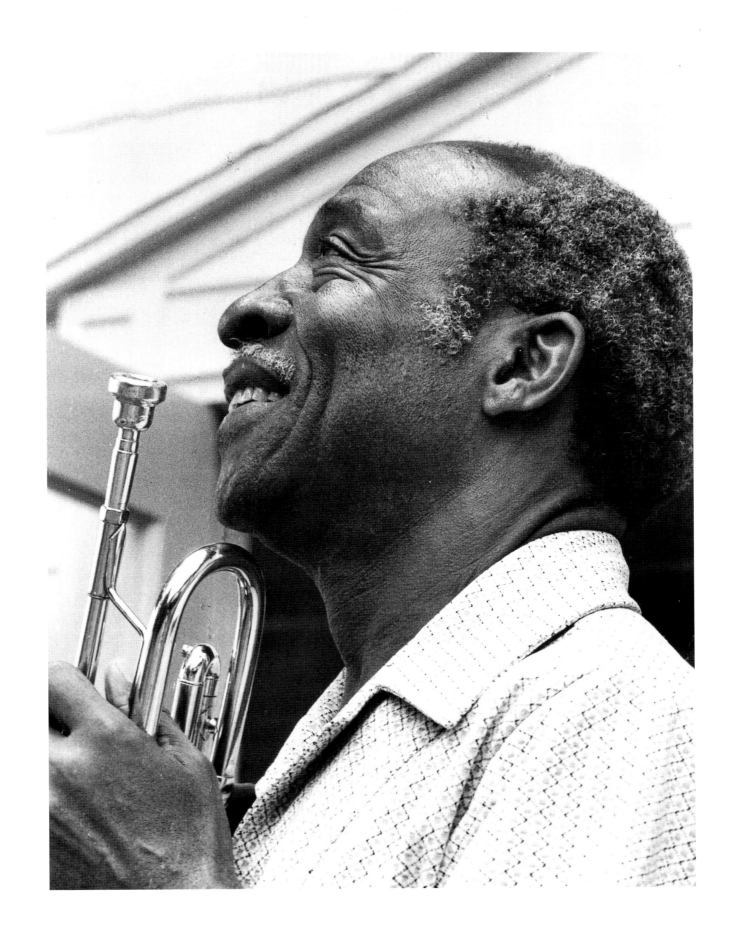

Joe Wilder, 1992

Jonah Jones

b. October 31, 1909, Louisville, Kentucky

d. April 29, 2000, New York City

Robert Elliott "Jonah" Jones was a gifted trumpeter whose name was synonymous with hot jazz and boundless good humor on the bandstand. Beginning on alto horn, he took as his inspiration young Louis Armstrong, and soon graduated to trumpet. His peripatetic early musical career was to stand him in good stead throughout his life. No matter how many abrupt changes he experienced in his life, Jonah always seemed to land "butter side up." A stint in Buffalo, New York, where he played with pianist Lil Armstrong's band, led to his acquaintance with jazz violinist Stuff Smith. Together they formed a small swing and novelty combo, which reached New York's Fifty-Second Street in the mid-1930s. The Onyx Club would be their musical home for years, featuring high-spirited music, Stuff's amplified fiddle, and Jonah's derby, muted trumpet, and vocals. It was an anti-Depression prescription for the public, but a grueling regimen that could really take its toll.

Jonah moved to the more secure surroundings of the big band when he signed with Cab Calloway, an association that would last from 1941 to 1952. His arrival was marked by a famous recording, *Jonah Joins the Cab.* Among his section mates was young Dizzy Gillespie, another well-known prankster, who had already been with Calloway for a couple of years. Dizzy's sudden departure a few months later was precipitated by a storied incident involving a spitball shot from the brass section that unfortunately landed on Calloway. Only years later did it come out that Jonah was the culprit.

As the big band business declined, and work became less frequent, Jonah worked in a combo with Earl Hines, on Broadway in the musical pits, and even in New York society dance orchestras. Wherever he worked, he was always a valued member of the group. But in 1955 he decided to invest in his own combo, built around his personality and a fresh repertoire. Public acceptance followed immediately, and prestigious nightclub bookings led to a long-term recording contract. His quartet would become familiar to television audiences, notably as a part of the nostalgic Fred Astaire specials.

Though the sound of his group became stylized and did not seem to break new musical ground after its initial impact, it retained a wide popular appeal, and led to several overseas tours, including Europe, Asia, and Australia. Active until his final days, Jonah died in his ninety-first year.

Like many of my musical subjects, Jonah was a target of opportunity. He had been appearing at Indianapolis's fashionable Embers nightclub, and he was one player I wanted in my files, so I called him at his hotel to request an appointment. To my pleasure, he seemed genuinely interested in having a photo session in his room. It turned out to be a valuable talk on his early days in music as well, with an emphasis on the Midwestern scene and Indianapolis, where he had played for a time.

The photographs from that session, taken by the ambient light in the room, principally from a nearby window, were a revelation to me, as I had previously relied on flashbulbs or strobe lighting. Everything seemed to work well in this sitting, and I am sure that the comfort we felt with each other that afternoon was what made the day a memorable one. Each time I look at this picture, I sense the generosity of spirit that lies behind that face.

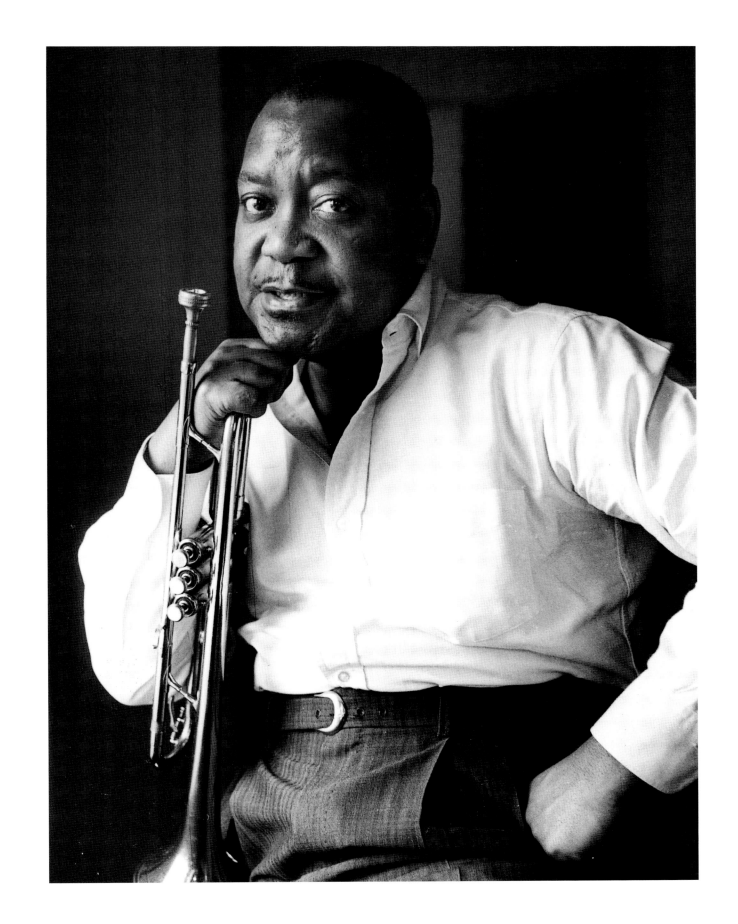

Jonah Jones, 1962

Gerry Mulligan

b. April 6, 1927, New York City

d. January 19, 1996, Darien, Connecticut

Coleman Hawkins

b. November 21, 1904, St. Joseph, Missouri

d. May 19, 1969, New York City

After Harry Carney, there were few baritone saxophonists of note until Gerry Mulligan came along. A versatile musician who also played piano and reed instruments, he was a talented arranger as well, writing charts for both the Gene Krupa and Claude Thornhill bands. In the latter he met another arranger, Gil Evans. Their 1957 collaboration with Miles Davis on the landmark LP *Birth of the Cool* was important in introducing the laid-back, readily accessible music known as "cool" or West Coast jazz.

Mulligan preferred to work with small combos, usually without a piano. In the early 1950s, his quartet with trumpeter Chet Baker, bassist Red Mitchell, and drummer Chico Hamilton was wildly popular on the West Coast. Mulligan appeared in the 1957 CBS special *The Sound of Jazz,* blowing the blues for Billie Holiday amid such giants as Lester Young, Roy Eldridge, and Ben Webster. He later experimented with a big band, then took groups abroad, finally returning to the successful quartet format.

Coleman Hawkins reached the musical heights in his early twenties, and remained a force in jazz until his final days. He can legitimately be credited with popularizing the tenor saxophone in jazz. By the turn into the 1930s, he was at the top of the heap, where he stayed without challenge until the emergence of Lester Young in the late 1930s.

After a long stay in Europe, Hawkins returned to a changed musical scene in New York. Fifty-Second Street was now a showcase for the Swing Era players, and small groups and singers such as Billie Holiday and Maxine Sullivan presided in the crowded basement bistros. Hawk took a nine-piece band into Kelly's Stable, a spot on the fringe of the "Street." A specialty piece he was performing on Johnny Green's great ballad "Body and Soul" caught the ear of a Victor Records executive, and it became a landmark jazz recording, with its bare theme statement followed by sixty-four bars of pure improvisation around the melody. Hawkins was once again in the front rank. More changes were coming, however, and Hawkins was not to be left behind. Unhesitatingly, he entered the controversial places where bebop was spoken. He spent the rest of his career leading small groups, recording, and appearing with touring package shows such as Norman Granz's "Jazz at the Philharmonic."

In his mid-sixties, Hawk seemed to be losing his zest for either living or playing. Yet a few days before his death of pneumonia, a friend found him dressed for a gig and clutching his saxophone case, crawling toward the door of his apartment.

In looking back across the years, I am struck by how much we owe to those producers who risked money and spent energy in bringing top jazz talent to the country and overseas. Were it not for their touring package shows and festivals, jazz could not have enriched our lives so happily. This photo of Mulligan's quartet (which included Bob Brookmeyer, valve trombone; Bill Crow, bass; and drummer Gus Johnson, who unfortunately is not visible), with guest artist Coleman Hawkins on tenor saxophone, was taken in 1962 at the Ohio Valley Jazz Festival in Cincinnati, an edition of George Wein's famous Newport Jazz Festivals. One of the beauties of jazz is the ability of master players to work together seamlessly no matter what their perceived "school" may be. I am aware that the idea is almost impossible to illustrate in a photograph, but it comes to mind each time I look at this image.

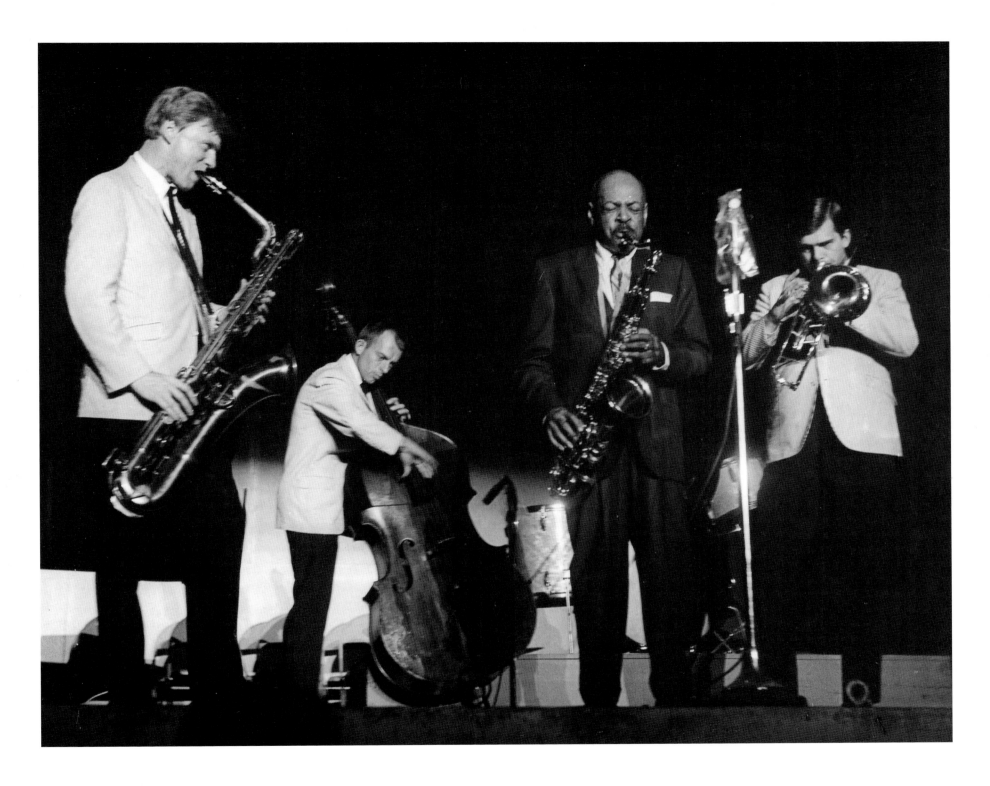

Gerry Mulligan with Coleman Hawkins (Bill Crow on bass, Bob Brookmeyer on valve trombone), 1962

Zoot Sims

b. October 29, 1925, Inglewood, California

d. March 23, 1985, New York City

John "Zoot" Sims started playing the clarinet in school, but an early professional job led him to focus on tenor saxophone. He performed in the Bobby Sherwood, Sonny Dunham, and Benny Goodman orchestras before finally getting on record with a Joe Bushkin group in 1944. World War II service intervened, following which he rejoined Goodman. He then moved on to Woody Herman, with whom he became a vital member of the Four Brothers, an all-star saxophone section boasting Stan Getz, Herbie Steward, and Serge Chaloff. Zoot was in great demand by leaders for his attractive, swinging style, loosely identifiable with the Lester Young approach. He was hired by Artie Shaw, Benny Goodman, Stan Kenton, and Gerry Mulligan. He also enjoyed doing freelance work, appearing in England numerous times as a single. He was deservedly admired by his fellow musicians, and is extensively represented on recordings.

This photo was taken backstage between sets at one of the great jazz package shows that used to come to Indianapolis. My records show it to be the year 1957. The greatest are often the most cooperative, and I found Zoot to be quite willing to adjust his reed for the camera, the cigarette in his mouth trailing a bit of smoke. In recent years I have found that musicians who knew him well think that this is one of the best pictures they have seen of him. One bought it expressly to give to Zoot's widow.

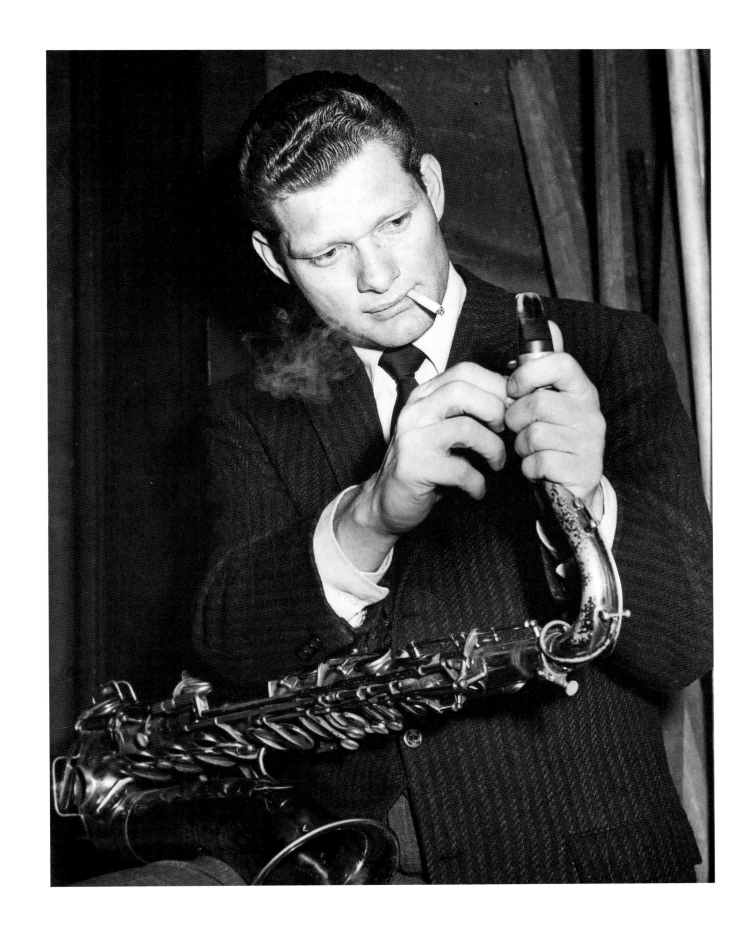

Zoot Sims, 1957

Jake Hanna

b. April 4, 1931, Roxbury, Massachusetts

At the tender age of five, John "Jake" Hanna could have been seen beating a drum in a local marching band. He followed up this precocity with jobs in local and touring bands, including that of Ted Weems, in the early 1950s. A stint in the Marian McPartland Trio was followed by a similar job with pianist Toshiko Akiyoshi, then important big band spots with Maynard Ferguson and Woody Herman.

Hanna worked a lot in New York, and also in the Boston area, where he got his kicks playing with the likes of Buck Clayton, Bud Freeman, Pee Wee Russell, and Vic Dickenson at George Wein's Storyville club. An eleven-year stint with the Merv Griffin house band followed, taking him at one point to the West Coast, where he made valuable contacts and significant recordings. Today, Jake is one of the "good humor" men of jazz, always cheerful and ready with a favorite story. He can be seen at a number of major jazz festivals around the country, where he shows what swinging percussion is all about.

The Elkhart Jazz Festival, a well-supported weekend event in Indiana that thrives on the efforts of local volunteers and corporate sponsorships, began in a downtown motel. The performance areas there, which were sufficiently removed from one another so as not to interfere, included an atrium with a temporary stage at its center. This was bordered on two sides by a balcony that enabled the patrons to look almost directly down on the players. The angles were interesting. Compositionally, I was particularly taken by Jake's drum and cymbal layout as seen from above. Bassist John Bany, who filled one corner of my frame, didn't hurt a bit. This shot is from the 1993 festival.

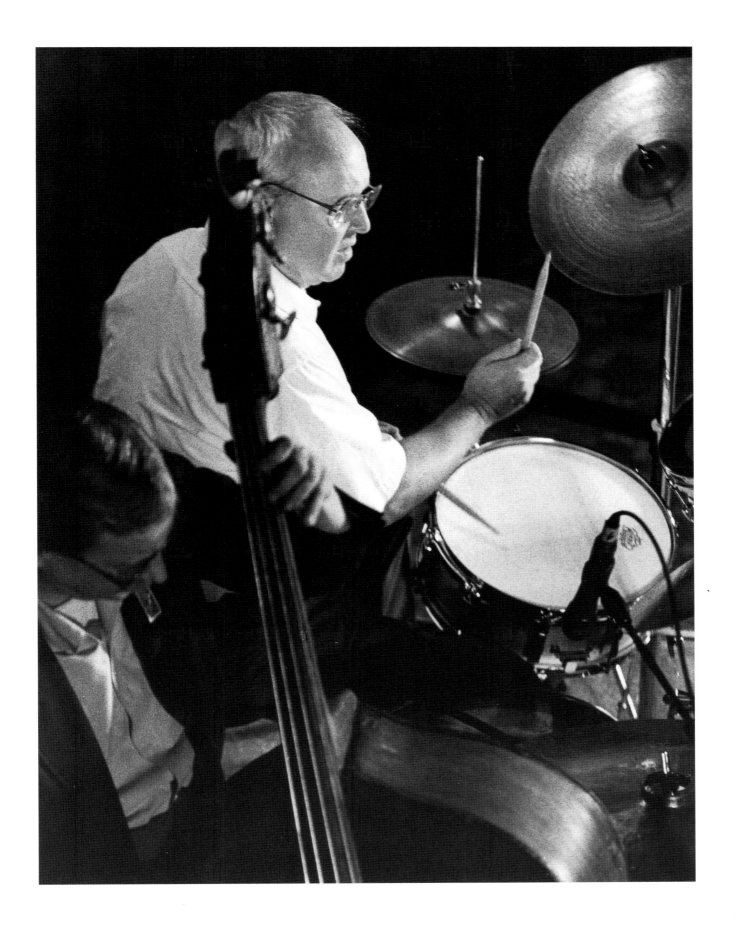

Jake Hanna, 1996

Barney Kessel

b. October 17, 1923, Muskogee, Oklahoma

Barney Kessel is probably the only guitarist to have played professionally with both Charlie Parker and Chico Marx! One of his early connections was with the two-fingered piano-playing Marx brother, who ran a band that also included a very young Mel Torme on the drums. Of much more substance was Kessel's lot in the popular big bands led by Charlie Barnet, Hal McIntyre, and Artie Shaw. With the latter, he can be heard on some records by the small band within the band, the Gramercy Five.

Other interesting career moves included a year with Oscar Peterson, Norman Granz's Jazz at the Philharmonic concerts, and studio backing to myriad jazz and pop artists, ranging from Frank Sinatra to Judy Garland to the Beach Boys, jazz pioneer Kid Ory, blues veteran T-Bone Walker—even Elvis. All this and commercials, too! Adaptability was Kessel's watchword, and it is surprising that he had time enough to become a main figure in the West Coast jazz movement, playing famously on Andre Previn–Shelley Manne recordings.

Kessel and fellow guitarists Charlie Byrd and Herb Ellis joined forces for an attractive act known as Great Guitars during the 1960s. A stroke in 1992 put a premature end to his long and illustrious career as one of the exceptional masters of his instrument.

While on a summer–long trip to California in 1949, I first saw Kessel close up as he jammed with musicians of all schools at Nappy Lamare's Club 47, located in the Valley. I was able to get a decent photo of the intense young man, and I carried that memory in my head when I next saw him at a downtown hotel in Indianapolis almost thirty years later, working with two supporting musicians on bass and drums.

I had come well equipped with film and electronic flash, and my fascination with his playing kept me shooting until a man at a ringside table gently asked, "Do you have enough now?" Reluctantly I quit, but I am convinced that the old fire I had seen in California was now joined to an enhanced technique. Barney, like the finest of wine, had improved with age.

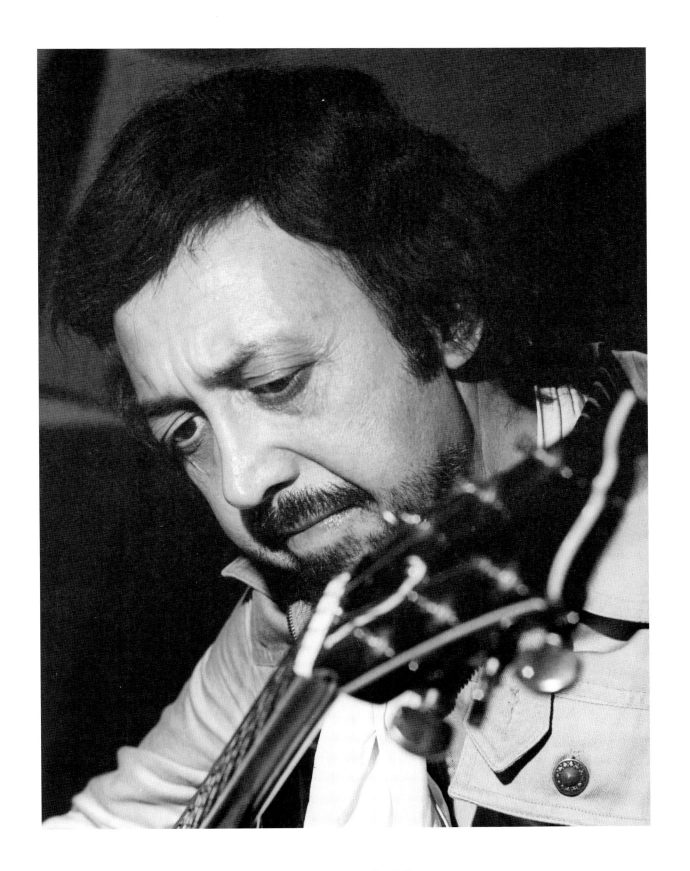

Barney Kessel, 1978

Charlie Byrd

b. September 16, 1925, Chuckatuck, Virginia

d. December 2, 1999, Annapolis, Maryland

Charlie Byrd may have started out as a small-town boy from Chuckatuck, Virginia, but he grew up to be a giant in the world of jazz.

As a youth, Byrd became proficient as a classical guitarist. In the mid-1940s he met and played with his idol Django Reinhardt during a trip to France. Though the acoustic guitar was no longer a common instrument in a jazz band, Byrd remained faithful to it and got employment with several jazz leaders around the New York area.

Along with studies under well-known classical teachers, he performed in the Washington, D.C., area for a number of years with his own small band, then joined Woody Herman for a stint. In 1961, Byrd took on a State Department tour of South American countries when the Dave Brubeck combo was unable to make the trip—and thereby hangs a tale. In Brazil he was fascinated by the bossa nova music he heard, and with his natural dexterity, using his fingers rather than a pick, he found that the ability to play this music came easily. He brought back some recordings of the music and introduced the concept to saxophonist Stan Getz, who ran with it. Their album *Jazz Samba* sold almost a million copies, and "Desafinado," as a single (with Byrd's solo unfortunately edited out for reasons of playing time), picked up a Grammy award for Getz.

A charter member (with Barney Kessel and Herb Ellis) of the "Great Guitars" group, which played for a number of years at nightclubs and jazz festivals, Byrd never strayed from his acoustic method and continued his concert and recording career until his death.

I consider myself fortunate to have seen, heard, and photographed Charlie Byrd in what I think of as his bailiwick—a downtown Washington, D.C., nightspot, the Showboat. A collector friend of mine, the late George Kay, had touted Byrd to me, insisting that we go to hear him. At showtime, the lights went down to almost pure blackness, and I hastened to get my camera out of its bag. A bass player and someone else seemed to be out there in the gloom, and a tiny spotlight shone down on a balding man crouched over a Spanish guitar. I also became aware that after some light applause, the room, which was crowded with patrons and club employees, had become deathly still. Under the circumstances, even cocking the camera shutter would have been like opening a crackling candy wrapper at a funeral, and I am surprised that I managed to make a dozen exposures without being glared at by the faithful Byrd fans around me. I never saw Byrd in person again, but I shall never forget the magic of those moments and the quietness that a great player can bring to jazz.

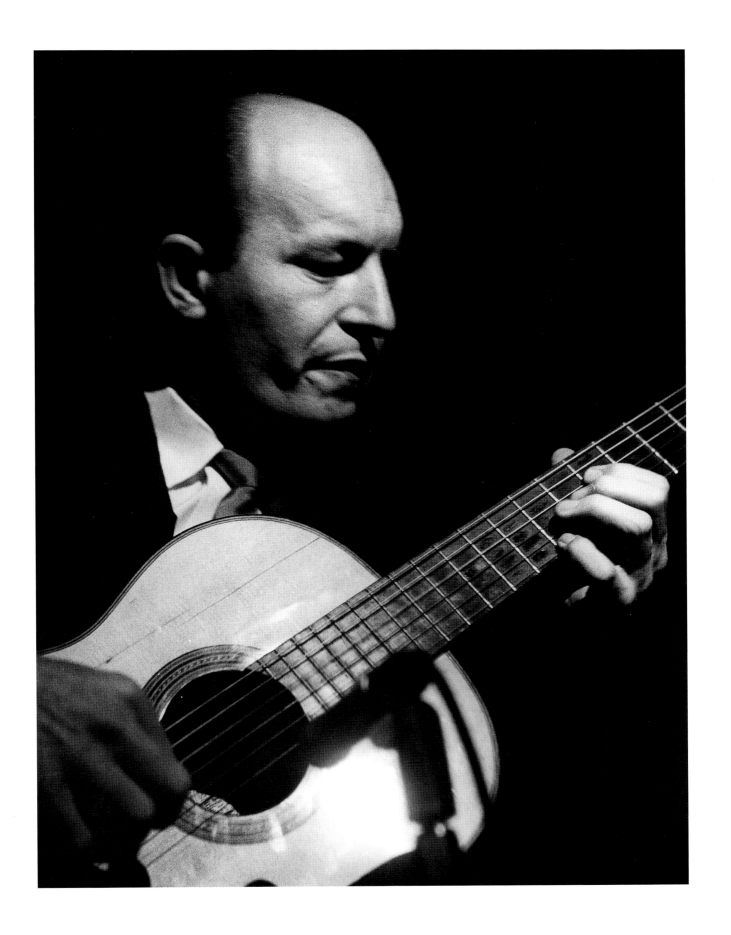

Charlie Byrd, 1961

Mary Lou Williams

b. May 8, 1910, Atlanta, Georgia

d. May 28, 1981, Durham, North Carolina

For a female jazz pianist of the twenties and thirties to have become one of the most respected musicians in the business, it follows that she had to be exceptional in what was then largely a man's world. Mary Lou Williams, née Mary Elfrieda Scruggs, was a child prodigy on piano, and was only sixteen when she married saxophonist John Williams. She played in his small group until he moved on to another territory band in the Southwest. She followed, and the combo finally metamorphosed into the Andy Kirk Clouds of Joy, with Mary Lou serving as pianist and principal arranger. Kirk knew a star attraction when he saw one, and he began to spotlight Mary Lou on the bandstand and on recordings. The band eventually reached New York and the big time, recording for Decca and playing the theater and ballroom circuits for years.

Undismayed when the big band era faltered, Mary Lou went on with her career, assembling a small group that focused on modern jazz forms in recordings and club appearances. She also played overseas. She then left music for some time to pursue religious interests, eventually composing in that genre, turning out cantatas and masses. In later years she began to reap some of the overdue benefits of her contributions, and was honored in both the musical press and the academic world.

Mary Lou was one of my prime interviewees for the Fats Waller biography, and I went to Café Society Downtown to catch her act, take a picture, and talk about Fats. She bubbled on about how Fats had grabbed her, a mere teenager, around the waist and hoisted her in the air, so enthused was he about her playing. My pencil took precedence over my camera that day, and I regret now that I took time for but a single exposure while she played before an attentive audience. Maybe we will meet again in some celestial venue, and I will find myself with a camera. Who knows?

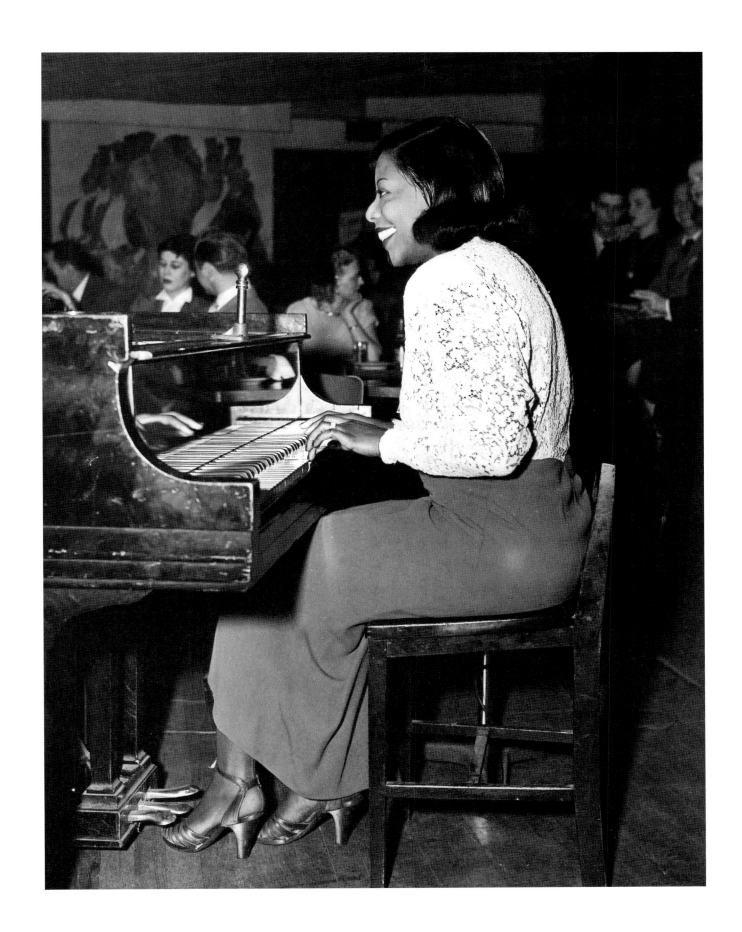

Mary Lou Williams, 1949

Marian McPartland

b. March 20, 1920, Windsor, England

If there is anyone who deserves to be called the First Lady of Jazz Piano, it's Marian McPartland. Née Turner, she began her professional life as a member of a four-piano team playing in music halls in her native England. While touring service camps during World War II, she met an American GI, the cornetist Jimmy McPartland. Jimmy's jazz roots were in Chicago during the Roaring Twenties. They married, and at war's end she came to live in the United States. Traditional jazz was on the upswing, and Marian became the pianist in Jimmy's new band.

Seemingly lured by the call of more modern styles, she went out as a featured pianist heading a trio, with a long New York engagement at the Hickory House, where various musicians were welcome to join in the jamming. Though she and Jimmy would eventually divorce, the break was never complete; they remained friends, even remarrying shortly before Jimmy's death in 1991. Meanwhile, Marian steadily built an enviable reputation as the creator of her own program on public radio. Nearly all of the important pianists, as well as other artists, have joined Marian at the microphone for conversation and performance, with the hostess taking her turn in solos or duets. As of this writing, the show continues to build her national image, generating huge respect for a gracious emissary of piano jazz.

I can always get a laugh when I relate where I first heard Marian play. I loved some 78 rpm records she had done with Jimmy, and when I read of her upcoming appearance in Kokomo, I resolved to share my pleasure with friends. Four of us traveled the forty miles to this Indiana "metropolis" to catch Marian and her colleagues. The name of the club was—hold your breath—the Pizza King! Not to worry, for it was a class place in spite of the name, with a well-dressed clientele eager to hear the lady's music. I do remember meeting and photographing her drummer, Jake Hanna (how young he looks in the photos!), as well as taking studies of Marian through the raised piano lid as she played. A few years later, I reminded Marian of the session and the unlikely venue, and we enjoyed a laugh together. Long may she live—and play!

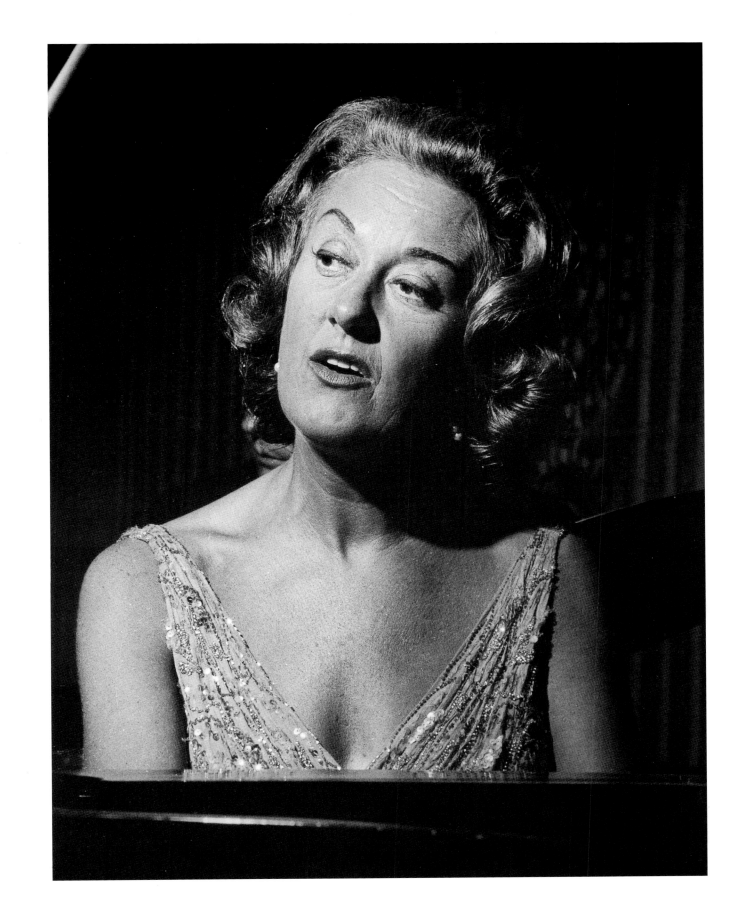

Marian McPartland, 1961

Erroll Garner

b. June 15, 1921, Pittsburgh, Pennsylvania

d. January 2, 1977, Los Angeles, California

Some called him "The Elf" in recognition of his diminutive stature, but Erroll Garner was huge among keyboard artists. From radio appearances at age ten, he moved through the jazz world, making heads turn and pulses quicken at the sound of his music. His constructions were unique, and immediately recognizable. He finally achieved the improbable: professional presentation by the noted impresario Sol Hurok. That led to solo concerts backed by prestigious symphony orchestras—even though, almost incredibly, Garner, a self-taught player, could not read music!

In the 1940s, on the way to these successes, Erroll paid his dues in small West Coast combos and in similar groups on New York's Fifty-Second Street, where he built a formidable fan base. But in the polarized world that was American jazz in those years, he seemed neither fish nor fowl—not traditional, not radical, just different. Happily, it seemed impossible for him to make an unprofitable record. His LP output is staggering; even in postwar Hollywood, his early 78 rpm records appeared on every conceivable small label.

Though no one seems to have built a career by re-creating Garner, identifiable traces of his influence can be found in the playing of a number of later pianists. Garner's signature style was built around steady left-hand chording and a delayed beat in the right hand. Melodic single-note treatment alternated with chords, sweeping arpeggios, and dramatic pauses and suspensions. But it must be heard to be appreciated. For the rare listener who is unfamiliar with his work, mere mention of his classic "Misty" suffices to bring a smile of recognition. An Erroll Garner is not likely to pass this way again.

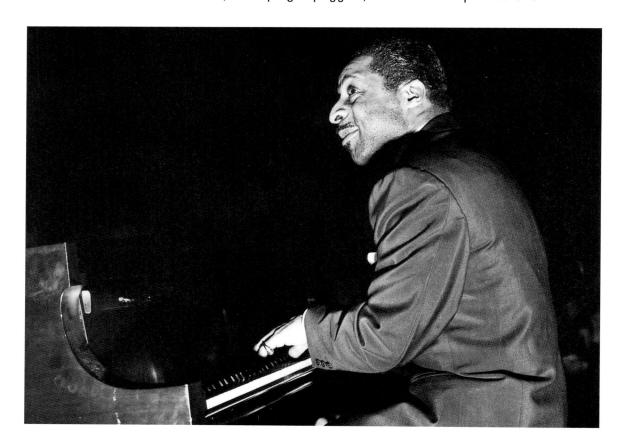

I was a long-time fan when he was booked into one of our local Indianapolis theaters. I positioned myself in the wings, close to the left end of the grand piano keyboard. If I moved slightly, I could see part of the audience, and I knew that to get a good photo of Garner at work, I would need to shoot my flash almost into their faces. Miraculously, no one complained after I got my shots, so I decided that discretion should then prevail. I took my next one as he sat on the edge of his dressing table in a back room. It was the Garner I had visualized—relaxed, friendly, and at peace with himself. But too soon he departed. The emptiness remains unfilled.

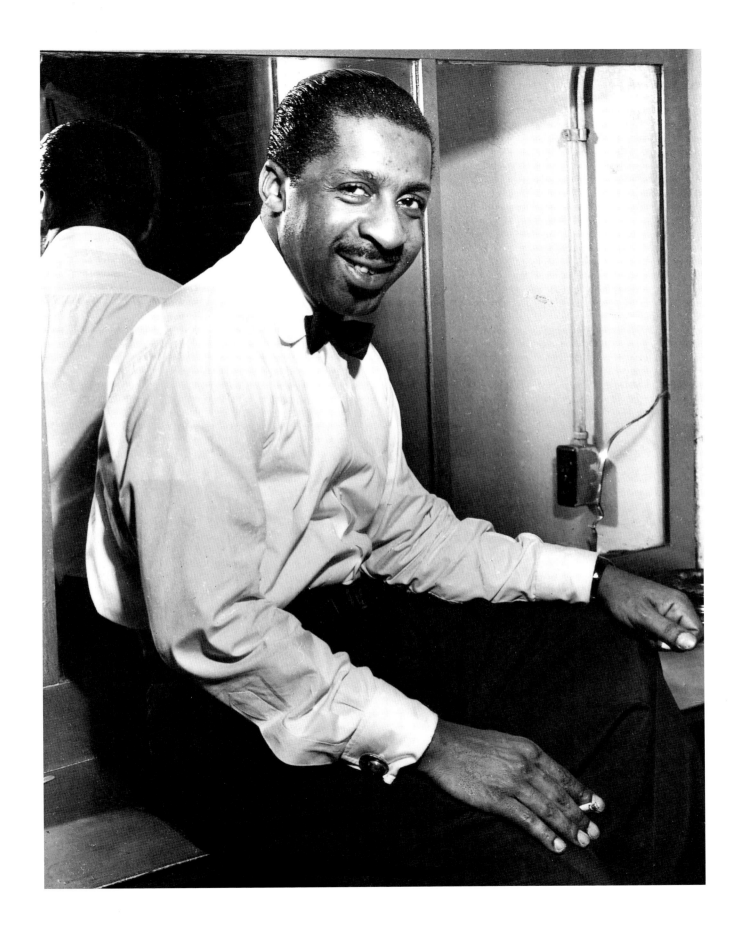

Erroll Garner, 1957

Conte Candoli

b. July 12, 1927, Mishawaka, Indiana

d. December 14, 2001, California

Secondo "Conte" Candoli showed early and prodigious talent on trumpet. At age sixteen, during his summer break from school, he sat beside his brother Pete in Woody Herman's big band. A later stint with Herman was interrupted by military service, but thereafter he embarked on a nonstop career that took him largely to West Coast venues or on the road. His affiliations included a small group led by bassist Chubby Jackson, Charlie Ventura, Stan Kenton (twice), Woody Herman (again), and Charlie Barnet. He moved permanently to the West Coast in 1954.

His talents were to make him a sought-after studio musician as well as a member of ambitious and sometimes short-lived big band assemblies. One long gig was as a member of the NBC *Tonight Show* band. Despite their fraternal closeness, Conte and his brother Pete went their separate musical ways, appearing together only occasionally, but they did jointly form a working band, which is memorialized on an LP, *The Brothers Candoli*.

Conte was equally at home with both the bop players and those who developed the "cool" school, which accounts for his prolific recording activity, including albums with Howard Rumsey's Lighthouse All Stars and a never-consummated plan to join Charlie Parker in a new band (which was aborted by Parker's death).

Conte was given the name Secondo because he was the second son in the family. Pete's career was no less illustrious, but as first or lead trumpeter (and a high-note specialist), he had fewer opportunities to "get off" with hot improvised solos, though he was eminently qualified.

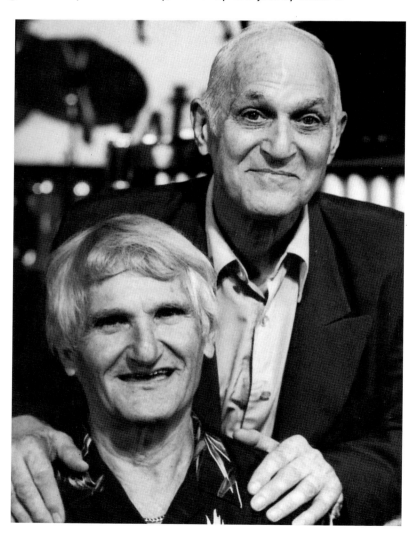

Elkhart, the city in northern Indiana known as "the band instrument capital of the world," has presented a long series of jazz festivals featuring the finest of artists, many from California. Conte was a frequent performer, and that is where I first saw him. A long-time associate, the gifted saxophonist Bud Shank, joined him on the bandstand, and I was anxious to photograph each of them singly. It wasn't until they had finished a set and were sitting in chairs offstage that I saw this photographic opportunity, the profiles of two players listening to their peers perform. The focus is on Candoli, but Shank's image provides a nice balance. The thing that strikes me most, however, is Candoli's wonderful profile, that face that I believe must be the reincarnation of some long-ago Roman emperor who graced an ancient coin!

A few years later, at a weekend festival in Fort Wayne, both Candoli brothers appeared, playing separately and jointly. Warming to the occasion, I asked them to pose together, which they were happy to do. I hope the image was a good souvenir for them, as it has been for me.

Conte Candoli, 1990

Pete Candoli (top), Conte Candoli, 1998

Charlie Parker

b. August 29, 1920, Kansas City, Kansas

d. March 12, 1955, New York City

Charlie Parker is one of a handful of jazz players who are now considered "immortals." He broke new ground in the genre and influenced a host of musicians of his own and following generations. His alto saxophone technique and his fertile ideas were brilliant. He is often credited with co-founding (with Dizzy Gillespie) the revolutionary bebop movement in the early 1940s. Even in his early recordings with the Kansas City band of Jay McShann, there is evidence of a graceful, fluid attack carrying the seeds of music that was yet to come.

In New York, amid the avant-garde musicians of the day, Charlie took menial jobs in order to stay close to the scene. He jammed with other future pioneers: Gillespie, drummers Kenny Clarke and Max Roach, pianists Thelonious Monk and a young Bud Powell. During 1944 and 1945, smaller recording companies released the new music that was coming out of these experiments and gaining a foothold in Fifty-Second Street nightspots. To say that reaction was mixed is an understatement. The jazz press, used to covering swing bands and a boomlet in traditional New Orleans jazz, found it difficult to fathom bop, let alone describe it.

Parker quickly achieved stardom in his own world, but heroin use would dog his professional career and shorten his life. He earned his share of honors—a newly opened nightclub in Manhattan was named Birdland (after his nickname "Bird"), and he was employed by Norman Granz in concert tours and on numerous records—but by early 1955 his health had deteriorated, along with his fabulous technique. He died suddenly while watching a television show in a New York apartment, to the dismay and sorrow of countless fans.

This picture was taken at Birdland, very early in 1950. Bird was in his usual straightforward stance, concentrating on what he was doing, but behind him, putting on a show of his own, was the irrepressible Dizzy Gillespie. Such antics will always attract a photographer's attention, and this time was no exception! Note that Dizzy had not yet adopted his unique upward-pointing trumpet bell.

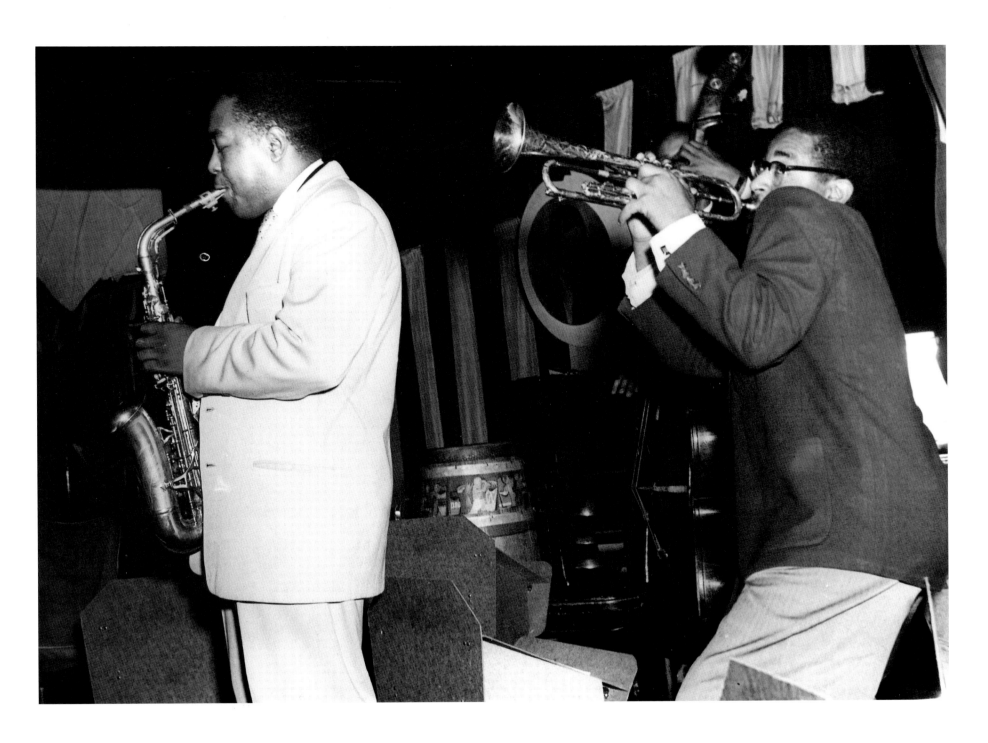

Charlie Parker and Dizzy Gillespie, 1950

Thelonious Monk

b. October 11, 1917, Rocky Mount, North Carolina

d. February 17, 1982, New York City

Lumped as he is with several other names as co-creators of bebop, it is easy to mentally confer just such status on Thelonious Monk, and then turn one's attention to other, more spectacular musicians. But there is a much greater role for this musician than as a historical footnote.

Monk and his family came to New York when he was five. He began taking piano lessons before he entered high school. He also learned to play church organ. This led to a tour with a gospel group. By the early 1940s he had entered the jazz scene. He was pianist with the resident band in Minton's Playhouse, a Harlem incubator for new ideas in jazz. In the mid-1940s, Monk worked with big bands (Millinder, Gillespie) and smaller combos (Coleman Hawkins, for one) until he was able to record under his own name, thereby establishing himself as a formidable force in modern music.

Monk was a composer of note, his "'Round Midnight" being but one of many originals since adopted by jazz players as standards in the repertoire. His keyboard style was characterized by quirky interpretations and dissonances while remaining deceptively simple. In a Monk performance there were no bravura arpeggios or flashy effects. His style might be called "bare bones" piano, but its originality and charm soon emerge.

I was really anxious to photograph Monk. I had not focused much on the modern players in my New York days, and it was with pleasure that I found him leading a quartet onstage in Indianapolis in 1959. I remember sitting out front and taking a few shots of the group, but Monk's back was turned toward the audience, and I quickly went behind the scenes for something more personal. A small grand piano provided the setting, and Monk, a lover of various forms of headgear, showed up wearing a straw coolie hat. I thought this a bit frisky, and after taking a couple of shots of him with it on, I asked him for a bare-headed pose, which he readily assumed. As the years went by, I began to like the "character" poses better than the straight version. It seems that Monk could bring almost anyone around to his way of thinking!

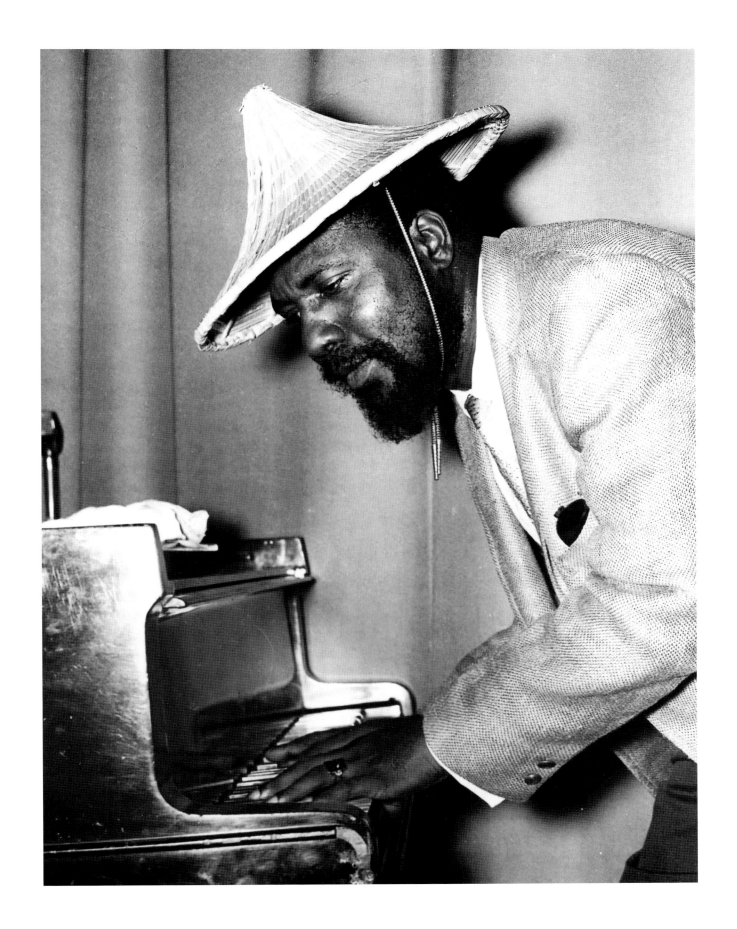

Thelonious Monk, 1959

Lennie Tristano

b. March 19, 1919, Chicago, Illinois

d. November 18, 1978, New York City

George Shearing

b. August 13, 1919, London, England

Two remarkable pianists were born in the same year in different countries, each to exert his own impact on jazz. Lennie Tristano became known primarily as a teacher; George Shearing introduced a concept of small group ensemble playing that was widely acclaimed by the public. In addition to their birth year, they also had blindness in common—Shearing's from birth, Tristano's a gradual loss blamed on a measles epidemic during his mother's pregnancy.

Lennie Tristano started to play piano and reed instruments while quite young, encouraged by his mother. By the time he graduated from the American Conservatory, he was working as a teacher, with later jazz figures Lee Konitz and Bill Russo among his pupils. Undeterred by his handicap, he moved to New York in 1946, associating with many of the bop musicians, among them Charlie Parker. Little known to the public, he retreated even further from view by opening what is considered to have been the first significant jazz school in New York.

Tristano was an experimenter, and his teachings were influential for his own students and through them for many others. Basic principles he espoused included complete technical expertise, accuracy in ensemble playing, and listening to others as one played. The end result was felt by some to be overly cerebral, somewhat lacking in the overt emotionalism that had always characterized jazz.

George Shearing took another path. Without much formal instruction, he developed his ear on his own, learning jazz from records. He later worked both as a single and in dance bands in England. During the war, he played on occasion with the French violinist Stephane Grappelli, who was living in London for the duration. In 1946, after a visit to the United States, Shearing relocated there, drawn by the musical climate. Initially attracted by the boppers, he subsequently put together the style of presentation that would bring him fame. To locked-hand chording (also a trademark of pianist Milt Buckner), Shearing added a rhythm section that included vibraphone, guitar, bass, and percussion. Playing in unison with the vibes and keeping the other instruments at a pleasing level resulted in a mellow style that paid off for many years.

Well into his career with the Quintet, it became apparent that Shearing could work in a number of modes, from Waller-like stride to polite baroque interpretations of popular melodies. As with Tristano, the ear was powerful indeed.

This photo, hastily grabbed backstage in the late summer of 1959, holds a strong memory for me. I was aware of the rarity of seeing these two artists together. I was also torn between the desire to listen to their conversation and the pressure to head for a local late-hour spot on Indianapolis's near west wide (see p. 88 on Wes Montgomery for details). I opted for the latter, but I would see these two again that evening, which would prove historic.

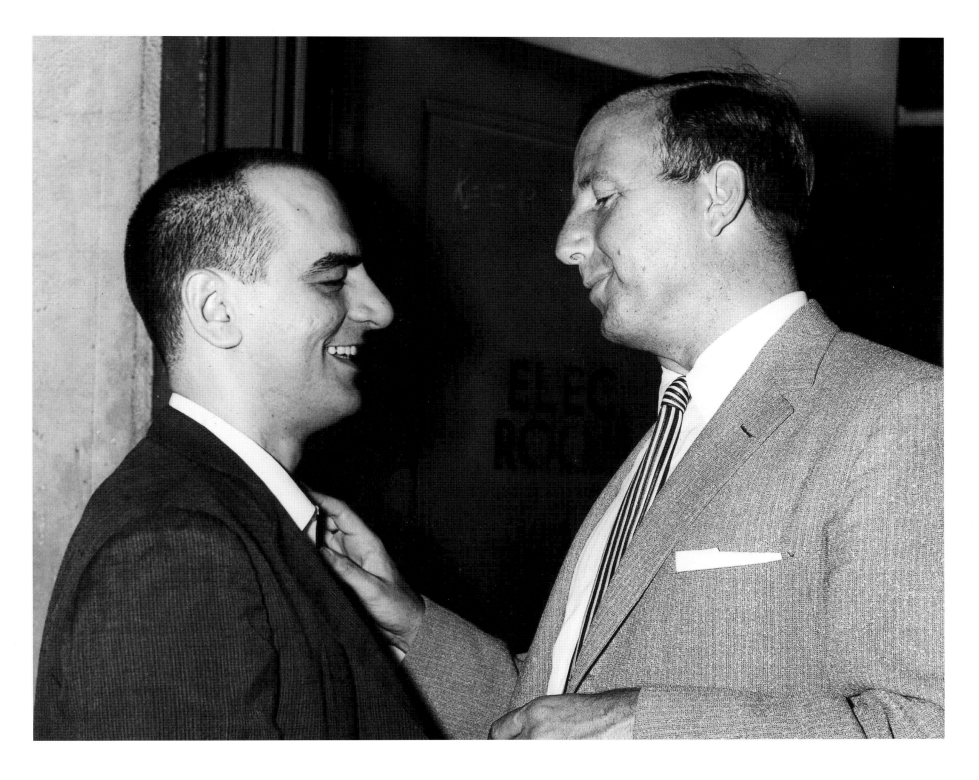

Lennie Tristano and George Shearing, 1959

Yusef Lateef

b. October 9, 1920, Chattanooga, Tennessee

Born William Evans, Yusef Lateef changed his name when he converted to Islam in the mid-1950s. He had been raised in Detroit, but it was in New York that he had important band experience as saxophonist with Lucky Millinder and Roy Eldridge. Toward the end of the 1940s he also worked with Dizzy Gillespie.

While he alternated between his own small groups and associations with other modern musicians such as Charles Mingus and Cannonball Adderley, Lateef, who had taken up flute, extended his range of instruments to include some rarely heard in American jazz—oboe and bassoon. Others, of Middle Eastern or African origin, were absolutely new to jazz. While these approaches were not guaranteed to win immediate acclaim, he persevered, broadening his musical palette to include non-jazz material. This creative musician also engages in writing and painting.

An Indianapolis club of the 1950s and 1960s was named the Topper. It was a small bar of limited capacity, but for a time it was host to a number of name jazz players, including organist Shirley Scott and vibraphonist Lem Winchester. It was not my usual port of call, but I did want to see Lateef, so I stopped by after a late night at the studio where I worked. A pause between sets gave me an opportunity to do better than take yet another action shot, and as I looked into the camera viewfinder, I was aware of a face looking back at me, one that I can describe only as beautiful—a term I normally reserve exclusively for women. I believe this face would have inspired any artist to put it on canvas or film, as it did me.

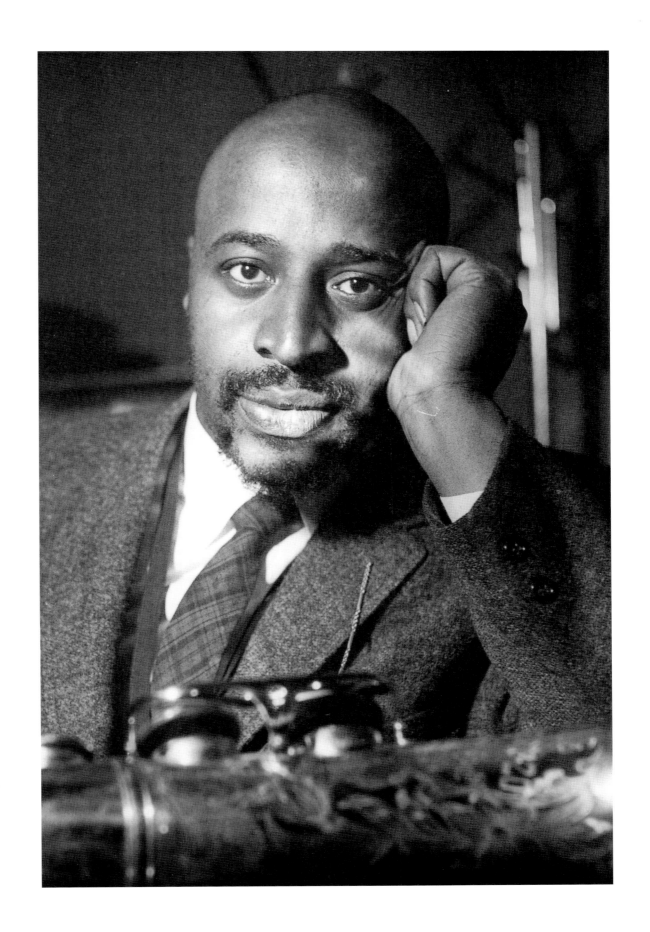

Yusef Lateef, 1961

Horace Silver

b. September 2, 1928, Norwalk, Connecticut

As a boy, Horace Silver studied both piano and tenor saxophone, but he chose to pursue the former. He was influenced by disparate musical forms: the blues, ethnic Portuguese music (his father's background), and the exciting challenge of bop. He seems to have also inherited a healthy business acumen, for he put together a trio for jobs around his home town, as well as to provide backing for visiting name musicians.

One such visitor, Stan Getz, was impressed enough to take them on tour, and in 1950 Silver found himself in New York. Engagements at Birdland and other venues followed. The following year, he was under contract with the jazz label Blue Note. After this break, he joined drummer Art Blakey in founding a new group, aptly named the Jazz Messengers. The band might well have been called the Jazz Incubators, for an incredible number of future stars would pass through its ranks during the coming years..

Silver, however, would depart in favor of his own group, a quintet known for its musical explorations, its pace-setting style, and, importantly, a flow of Silver's own compositions comparable to that of Duke Ellington in his heyday.

Silver, a slightly built man, was a musician I hardly expected to see working in the Midwest, but there he was onstage at the Ohio Valley Jazz Festival, courtesy of producer George Wein. Armed with a press pass, I kept alternating between a seat in the audience and the backstage area. After watching and photographing his performance from out front, which featured an almost frenzied attack on the piano delivered with a wild-looking expression, I expected to encounter a figure backstage drenched with sweat and in no mood for one of the jazz paparazzi, as I sometimes felt myself to be. To my surprise, he had changed clothes and smilingly consented to pose for an informal picture. Sometimes you win, and this time I did.

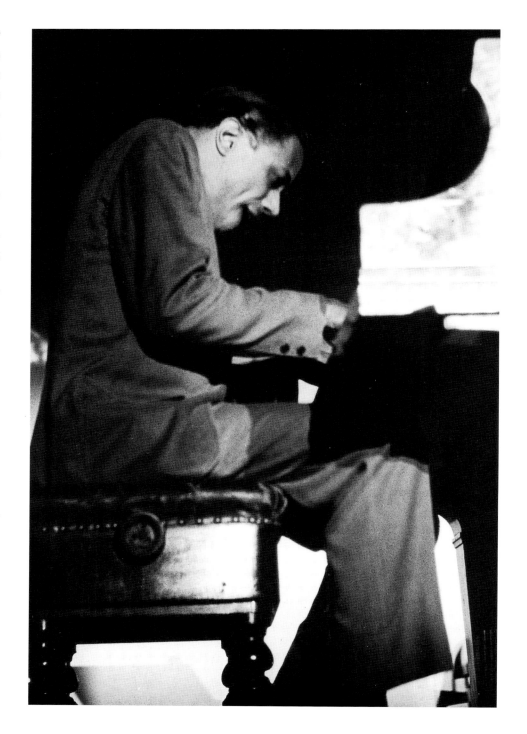

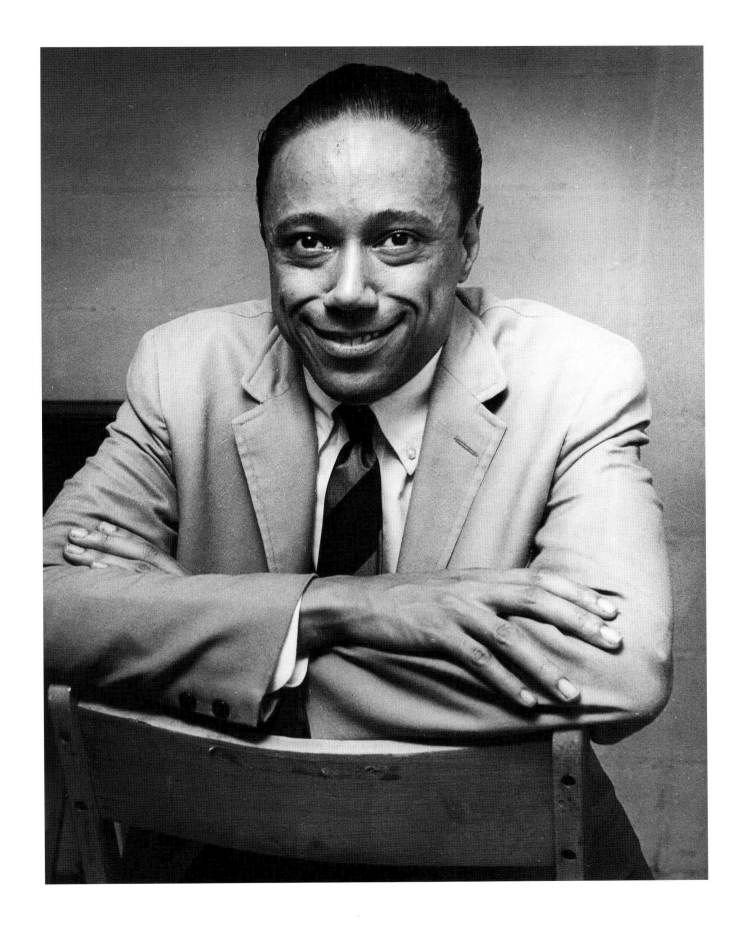

Horace Silver, 1962

Junior Mance

b. October 10, 1928, Chicago, Illinois

Julian Clifford Mance, Jr., took his early inspiration from his father, a professional jazz pianist. Junior was earning money with his piano well before his teen years. Not yet twenty, he joined Gene Ammons's band, then spent two years with the Lester Young combo.

Military service intervened, and his next important job was accompanying singer Dinah Washington. There were engagements with Cannonball and Nat Adderley, and with Dizzy Gillespie's band. The latter experience, he claims, not only was enjoyable, it was an education in previously unexplored aspects of the music and the music business. In 1961, Mance struck out on his own with a trio, and for a time the group backed singer Joe Williams. Between gigs with his own group, he could be heard with a quartet featuring saxophonists Eddie "Lockjaw" Davis and Johnny Griffin.

Mance has a secure place among contemporary piano greats. In addition, he has written a book, *How to Play Blues Piano,* and in 1988 he joined the music faculty at the New School University in New York, teaching classes on the blues and blues ensembles. He also provides individual instruction in piano and guidance in the pursuit of careers in the jazz field.

Still an active musician, Mance appears at various festivals, where his blues-rooted personal style blends perfectly with the modern music with which he came of age.

There is little to tell about this photograph. I think it speaks for itself. When you have a willing subject whom you instinctively like, even after only a minute or so of conversation, and there is a face this appealing, how can you miss? (A pause for reflection.) Actually, you can miss, as any honest photographer will admit. But this time I didn't.

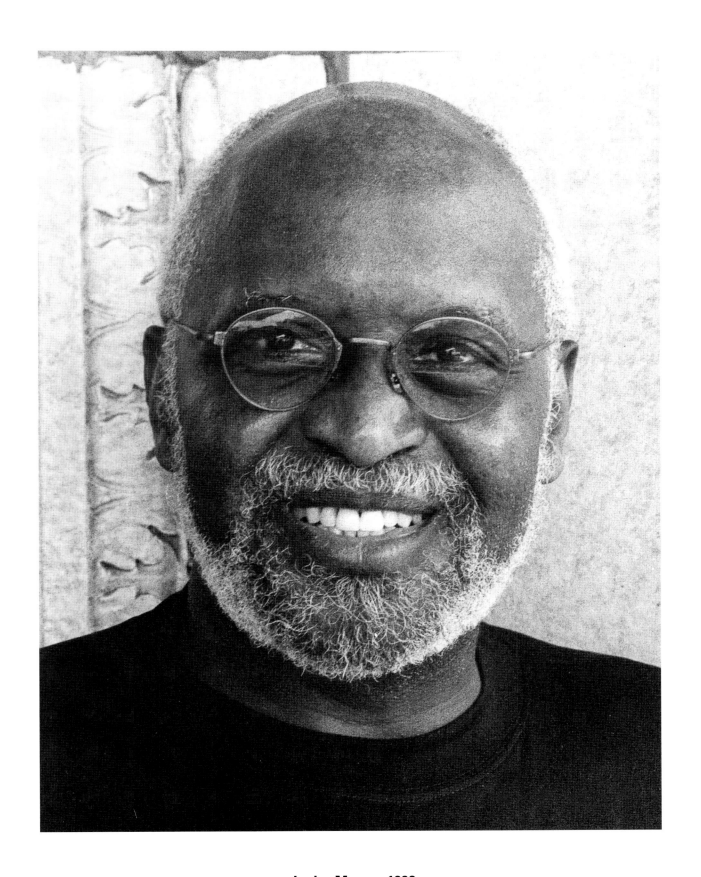

Junior Mance, 1996

Oscar Peterson

b. August 15, 1925, Montreal, Canada

Ray Brown

b. October 13, 1926, Pittsburgh, Pennsylvania

d. July 2, 2002, Indianapolis, Indiana

One of the great teams in jazz history, pianist Oscar Peterson and bassist Ray Brown joined forces in 1951, remaining together for the next fifteen years. Some of the finest guitarists were used to complete their famous and oft-recorded trio. A later revision to the mix brought a drummer aboard.

Peterson had intended to play trumpet, but for physical reasons he switched to piano. After winning a talent contest at age fifteen, he began to appear on radio programs, then joined a popular big band. He eventually formed his own trio, a format that would suit him throughout his career. His apparent role models included Art Tatum, Erroll Garner, Nat Cole, and George Shearing.

Peterson was heard, talked about, and sought after for some years by American jazz impresarios and club owners before he agreed to appear on a program in Norman Granz's Jazz at the Philharmonic series at Carnegie Hall in 1949. This connection with Granz was inevitably followed by a recording contract, which produced a virtual flood of LPs between 1950 and 1987 for the Granz-connected labels and others.

The trio often backed a well-known guest artist during a recording session. Among those whom they accompanied were Lionel Hampton, Roy Eldridge, Buddy DeFranco, Dizzy Gillespie, Clark Terry, and other mainstream and modern jazz figures, including even fellow pianist Count Basie.

Ray Brown, a master of the bass with a beautiful tone, had an enviable musical life even before linking up with Peterson. He adapted quickly to the bop scene, and by 1945 was playing with the greats of the movement. He joined Dizzy Gillespie's big band later in the decade, married Ella Fitzgerald (the union lasted but four years), recorded with other players in what was a preview of the later Modern Jazz Quartet, and was a stalwart performer in Norman Granz's Jazz at the Philharmonic concerts.

After leaving the Peterson group (he would return occasionally), Ray settled in California, where his activities were divided between playing and music management and production. He remained a respected and honored musician, and his sudden death in a hotel room in Indianapolis during a club engagement caused sadness among jazz fans everywhere.

These two men were giants of equal stature on their respective instruments, and I wanted at least one photograph of them together. The year was 1965; the place, Indianapolis's Embers nightclub. In a fairly large club, the instruments of a trio tend to be placed somewhat apart, so I chose to wait until I could get Peterson and Brown together in the dressing room. I recalled having taken pictures of Oscar backstage just ten years earlier, as he sat at a grand piano with local musicians and others on the bill (including Illinois Jaquet) clustered admiringly around the still-youthful pianist. It is sad to think that such opportunities are increasingly rare today, especially in the heartland of America.

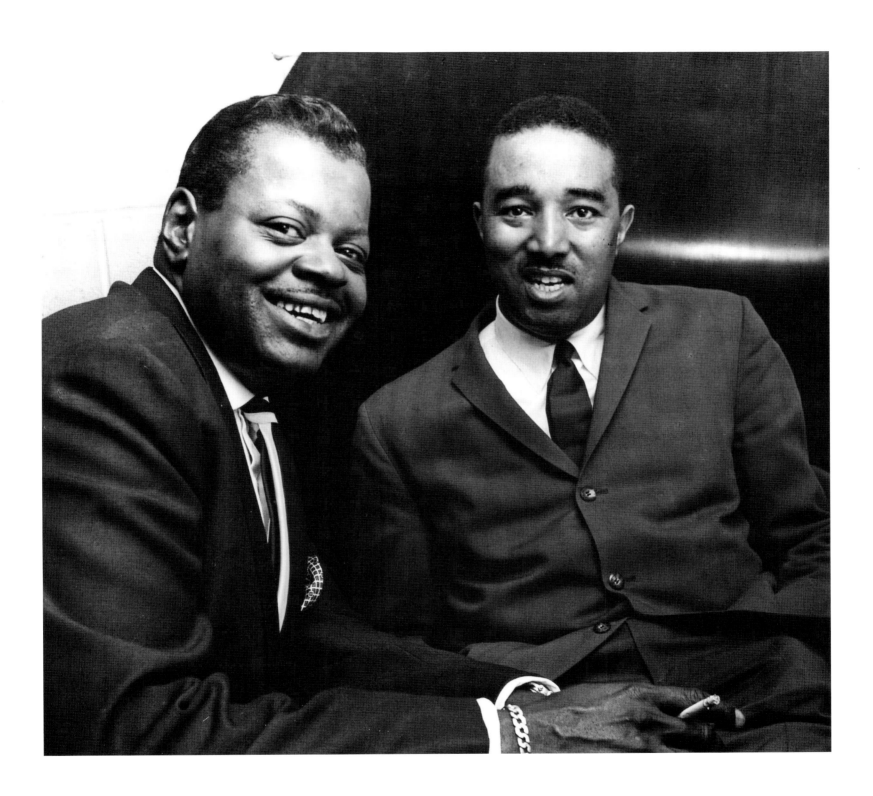

Oscar Peterson and Ray Brown, 1965

Wes Montgomery

b. March 6, 1923, Indianapolis, Indiana

d. June 15, 1968, Indianapolis, Indiana

Indianapolis takes considerable pride in its long and impressive history of home-grown jazz players. The tradition extends back to the early years of the twentieth century, but the Hoosier connections went largely unnoticed by the general public—and, for that matter, by those in power in the music world. Among the illustrious stars and sidemen from the state, none has shone more brightly than guitarist Wes Montgomery.

Wes, the oldest of three musical brothers, was twenty-three years old when he went on the road with Lionel Hampton. After a couple of years of one-nighters and the rigors of travel, he apparently made a conscious choice to abandon the big time in favor of a stable home and family situation back in Indiana. He took a day job and played locally at night. Indianapolis clubs were plentiful, as was the supply of good musicians.

Wes's unique style and inventiveness attracted the attention of visiting musicians, many of whom would jam with him after their own gigs were finished for the night. He became something of a legend in the band business. A change in his life came about in the fall of 1959, when he was signed to Riverside Records by producer Orrin Keepnews. An excellent series of recordings would follow on that and other labels. Wes became an icon of modern jazz guitar, and though he maintained his home base in Indianapolis, he was in demand from coast to coast. Having begun his career at an age when others had already passed their peak, he made the most of the few years left to him. He died of a heart attack at age forty-five.

His style, originally inspired by that of Charlie Christian, is marked by the mellowness of sound produced when the strings are played with the thumb rather than a plastic pick. Another trademark is passages played in octaves, a technique since copied by countless followers. Wes often teamed up with his brothers Monk (bass) and Buddy (piano, vibes) at home and in California, where the two were part of the Mastersounds, a successful combo that also included Hoosier drummer Benny Barth.

It isn't often that one is present at a historic moment, and it is rarer still that one recognizes that history is being made. Such a moment occurred at a small basement after-hours spot on Indianapolis's west side, where Wes's trio held forth. Wes had been backstage at one of the local theaters during a package jazz show, greeting famous friends and inviting one and all to stop by his venue afterwards. Fortunately, I had my ears open, and I hustled over to the Missile Lounge before the stage show ended.

I had a ringside seat and was sipping a beer, watching Wes set up microphones and his amplifier. Neither his drummer nor his organist had yet arrived, but suddenly the front door opened and a cluster of men entered. I immediately recognized George Shearing and Lennie Tristano. They were led to a small corner table in the shadows, and were soon joined by the famous alto sax player Julian "Cannonball" Adderley.

As soon as Wes's organist, Melvin Rhyne, arrived, I heard Wes say, "You know who's sitting over there?" Rhyne, gazing into the gloom, said, "No—who?" When he heard who they were, I swear he paled visibly!

Soon the opening set was under way, and hardly had Wes completed a few solo bars when I saw Adderley drag his chair to a position in front of the little stage. He settled his considerable bulk into it, sitting in profile to me. As the music went on, he leaned back, legs extended, mouth slightly open and eyes closed; he was absolutely knocked out.

As a result of this little episode, Riverside Records was alerted to this extraordinary guitarist by Adderley, who was one of the label's main artists. Wes Montgomery's ultimate trip to fame began then and there. As I sat there, I had the feeling that something big was happening, and the scene has never left my memory.

This photo of Wes was taken at a lounge at the Essex House, a hotel across town, earlier in the year. As much as it has been reproduced, I would greatly prefer to have a shot from that night at the Missile Lounge, when I sat helpless, with a broken flash unit!

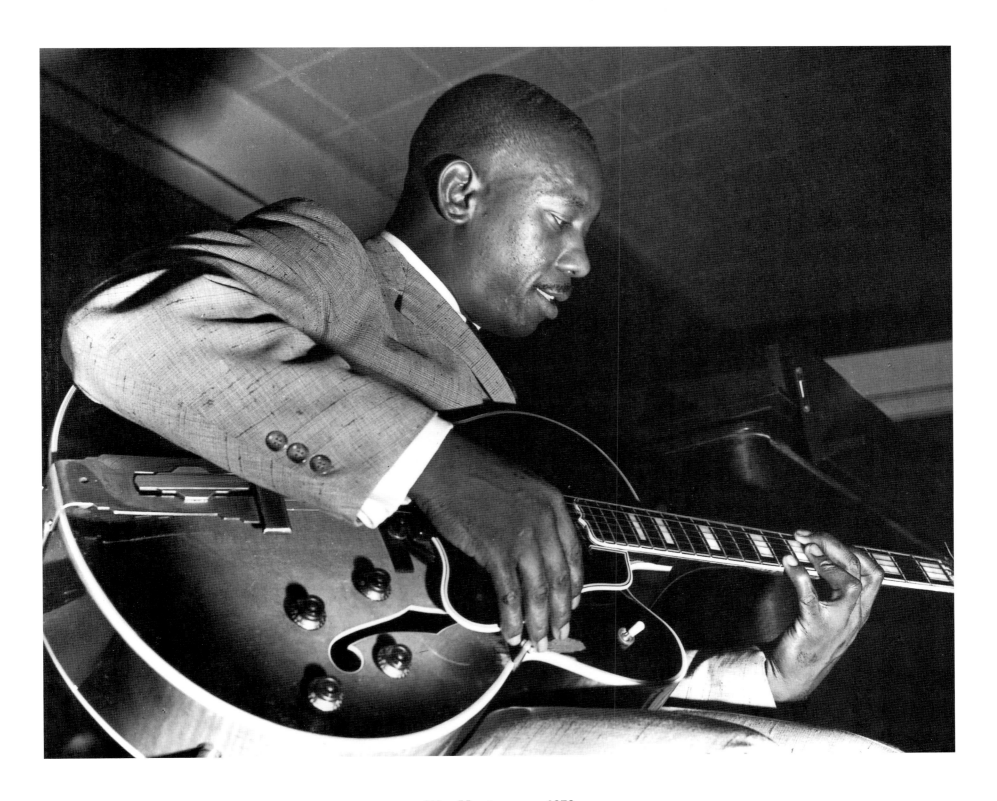

Wes Montgomery, 1959

Keter Betts

b. July 22, 1928, Port Chester, New York

William Thomas "Keter" Betts began on drums, but after graduating from high school in 1946, he switched to the bass, taking local instruction. His inspirations, not unexpectedly, were the icons of his instrument, Ray Brown, Jimmy Blanton, and Oscar Pettiford. Long associations with Earl Bostic and Dinah Washington, and a brief one with the Adderley brothers, preceded a productive move to the Washington, D.C., area.

This durable and sensitive bassist became a member of the Charlie Byrd trio, playing and making records during the period 1957–64. Their popular downtown venue was the Showboat. Records appeared on the local Offbeat label, as well as Savoy and Riverside. Keter was also present for the Byrd–Stan Getz album *Jazz Samba.* But most impressive was his twenty-four-year gig as bassist for the great Ella Fitzgerald.

Betts accompanied Woody Herman to England and Saudi Arabia, and has enriched many record sessions and jazz festivals. He maintains an active outlook, recording CDs for his own kB label.

Bass players, like drummers, are usually relegated to the back of the bandstand, though they have the advantage of being able to stand tall (if they are tall). At Elkhart one year, I had to wait until the end of a set before I could hurry to the stage and ask Keter to stay with his bass until I could get a shot. Normally the incoming band would already be filtering onto the scene as the others gathered up their instruments and left. This may look like a carefully planned studio shot of a photogenic musician, but in reality it was all over in about thirty seconds—a tribute to Keter's awareness of my needs, and to my trusty Nikon camera. Bless them both!

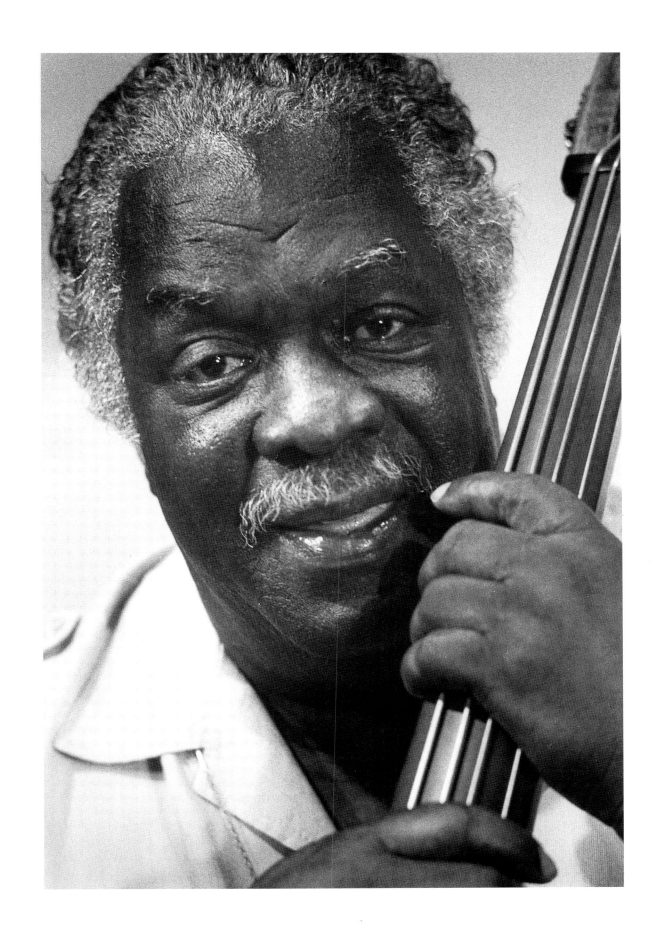

Keter Betts, 1996

Dizzy Gillespie

b. October 21, 1917, Cheraw, South Carolina

d. January 6, 1993, Englewood, New Jersey

Born into a large family, John Birks "Dizzy" Gillespie started playing trombone when he was twelve, but a year later he switched to trumpet. He was mostly self-taught, and though he later won a scholarship to music school, he preferred playing to theory.

In 1935, Dizzy moved to Philadelphia, where he joined the Frank Fairfax band, gaining valuable orchestral experience. Within two years, having created much talk in the jazz fraternity, he went to New York to audition. He didn't get that job, but he made it with the Teddy Hill band, who were about to start a European tour. He replaced his idol Roy Eldridge, a fiery trumpet star whose sensational flights were the current rage. Gillespie's style then closely resembled that of Eldridge. But he would, upon exposure to the progressive ideas expressed by a new breed of jazzmen, begin his own radical experiments with rhythms, tempos, keys, and harmonies. He was still employed by big band leaders—Cab Calloway and Earl Hines among them—and spent his off time at Minton's Playhouse, trading ideas with the likes of Thelonious Monk and drummer Kenny Clarke. His friendship and association with Charlie Parker began while he was on tour with Calloway, and ripened when both were sidemen with Hines (the second pianist was singer Sarah Vaughan!).

Numerous recordings with small record companies followed, and Dizzy became a familiar leader on Fifty-Second Street. He eventually formed his own big band, possibly inspired by the short-lived Billy Eckstine band, a true hotbed of bebop players, of which he had been a member. A musician who stayed free of the excesses of so many others, Gillespie proved to be an effective leader and, importantly, a composer of distinction.

In 1953, during a house party, someone fell on his trumpet and bent the bell at a sharp angle. Testing it to see if it would still work, Dizzy discovered to his surprise that he could hear his own notes more quickly. Also, with the bell thus displaced, he could read his music with the horn facing the microphone. Thereafter, he used a horn custom-built to his specifications. This eccentric-looking instrument, coupled with his inflated cheeks as he blew his upper-register notes, made him an unforgettable sight at performances.

A State Department–sponsored tour to Africa, the Middle East, and Asia was followed by another successful one to South America. There were many years of intense activity to follow, during which he became firmly established as one of history's most influential players. He is credited with helping to change the course of jazz itself, and certainly with restoring the trumpet to a viable position of leadership after a long period when saxophones were in the ascendancy. He died suddenly at age seventy-five, a fulfilled man.

I spent a couple of hours shooting photographs of what seemed to be an endless parade of all-star jazz players at the French Lick Jazz Festival in 1959. George Wein had booked representatives of both modern and traditional styles, as well as some who defied description. The tent just offstage was where the musicians waited to go on, and I believe that Dizzy was getting ready for his set, while Miles Davis was unwinding from his. I took two photos of the pair.

In this image, Dizzy seems to be playing one of his brilliant passages as a warm-up, while Miles, appearing disdainful, looks the other way. In fact, just minutes earlier Miles had virtually insulted the audience with his notorious rudeness onstage—turning his back as he played, and leaving the stage altogether when he was not actually playing. It would be easy to analyze this picture in terms of my description, but in the second exposure, taken a minute or so later, Miles has turned back to Dizzy, and they are exchanging broad smiles. Yes, Virginia, there is a Santa Claus, and photographs can lie.

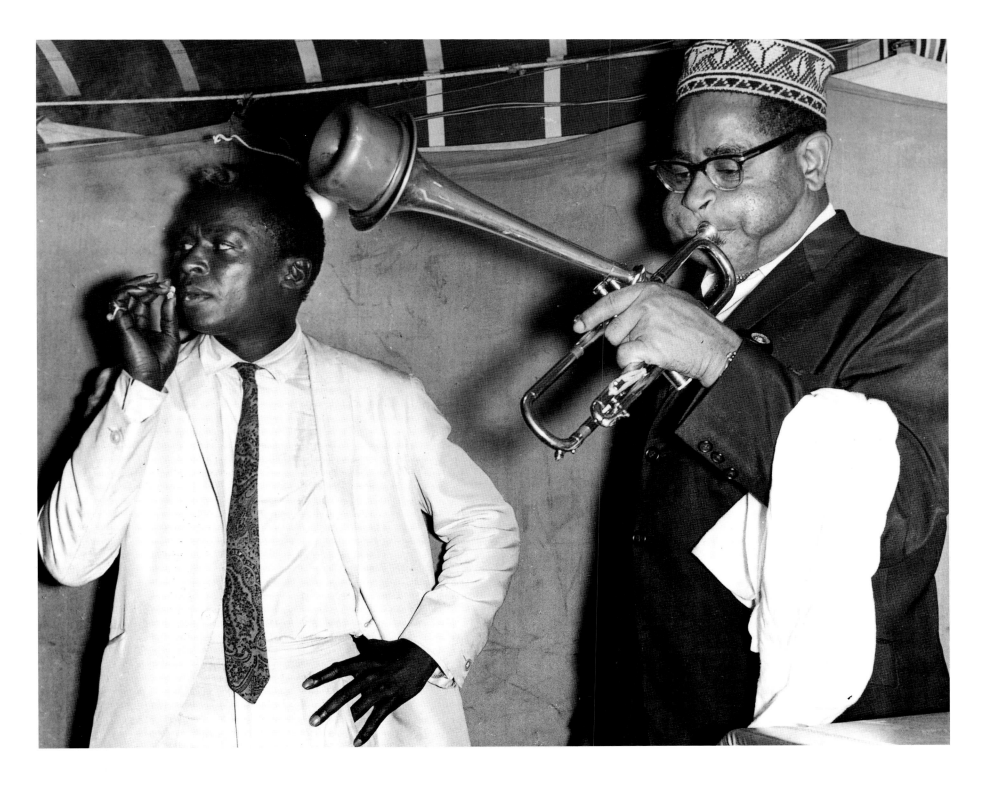

Miles Davis and Dizzy Gillespie, 1959

Miles Davis

b. May 25, 1926, Alton, Illinois

d. September 28, 1991, Santa Monica, California

Miles Davis was born into an upper-middle-class family in suburban St. Louis. His father, a dentist and breeder of pedigreed hogs, presented Miles with a trumpet for his thirteenth birthday, not realizing the heights to which his son would rise in the musical world. Young Miles received excellent formal training, and by age sixteen he was playing in a local rhythm and blues group. Two years later, he was in New York for studies at Juilliard. In reality he intended to seek out Charlie Parker, already his hero. That contact made, Parker moved himself into Davis's apartment and facilitated the young musician's entry into the nascent musical movement to be known as bebop. There were gatherings of the early pioneers at Dizzy Gillespie's house for discussions and practice.

Miles, still developing, eventually became a member of Charlie Parker's group on Fifty-Second Street, replacing Gillespie, who had quit. There were Savoy recordings during the year, which helped establish Miles as someone to watch. Later, in California, he would leave Parker's group to work in larger bands headed by singer Billy Eckstine and Gillespie. In late 1948, not satisfied with the way music was developing, Miles linked up with the arranger Gil Evans, who had surrounded himself with musicians who shared his forward-looking concepts: young players such as Tadd Dameron, Lee Konitz, and Gerry Mulligan.

The nine-piece combo that emerged, which was led by Miles, made a series of 78 rpm recordings for Capitol. They caused only a light ripple at the time, but they were to prove historic. The company put the LP version of the session, *Birth of the Cool,* on the market a full five years later. With its sublimation of emotion, fine voicings, and unusual instrumentation, including French horn and tuba, it marked one of the many changes in musical direction for which Miles would become famous. But even as this band was making its relatively few public appearances, Miles had moved on, returning to small group jazz, where he began introducing new players of talent at his recording sessions, among them Sonny Rollins and Jackie McLean.

A dark period then set in. Previously resistant to the drug scene, Miles became addicted to heroin. His career was rocky for some time, until, admirably, he went home to Missouri, locked himself in a room, and stayed there until he had cured himself.

The remaining years of his long professional life were filled with firsts. He discovered and promoted unrecognized talent, in the process leading the way to diverse approaches to playing jazz. His recordings, always eagerly anticipated by his many fans, were frequent departures from what had been expected, sometimes radically so. A list of his colleagues over the years would read like a Who's Who of modern jazz: Sonny Rollins, J. J. Johnson, Cannonball Adderley, Bill Evans, Horace Silver, Art Blakey, and emerging saxophone star John Coltrane.

New collaborations with Gil Evans produced a series of Columbia record sessions featuring Davis solos backed by lush orchestral ensembles. *Porgy and Bess* became Miles's best-selling LP ever. Davis became a byword among the general public, something not achieved by many jazz stars. His trumpet style, which minimized vibrato and remained largely in the middle register, remained consistent over most of his life, though he continued to break new ground. His experiments, which brought in such elements as electric amplification, rock, and ultimately hip-hop and rap, were not always happily received by long-time fans, but he was unwavering in his determination to stay ahead of the pack.

This image of Miles, which has been often reproduced, was made at the 1959 French Lick Jazz Festival. I was out front, trying to decide whether I should shoot my photos with the available light the stagehands had provided or use my electronic flash. I ended up using both, and the available light easily won the contest, as it usually did. Miles may have been known for showing rudeness toward his audience, but this represents one moment when he had not turned his back to us.

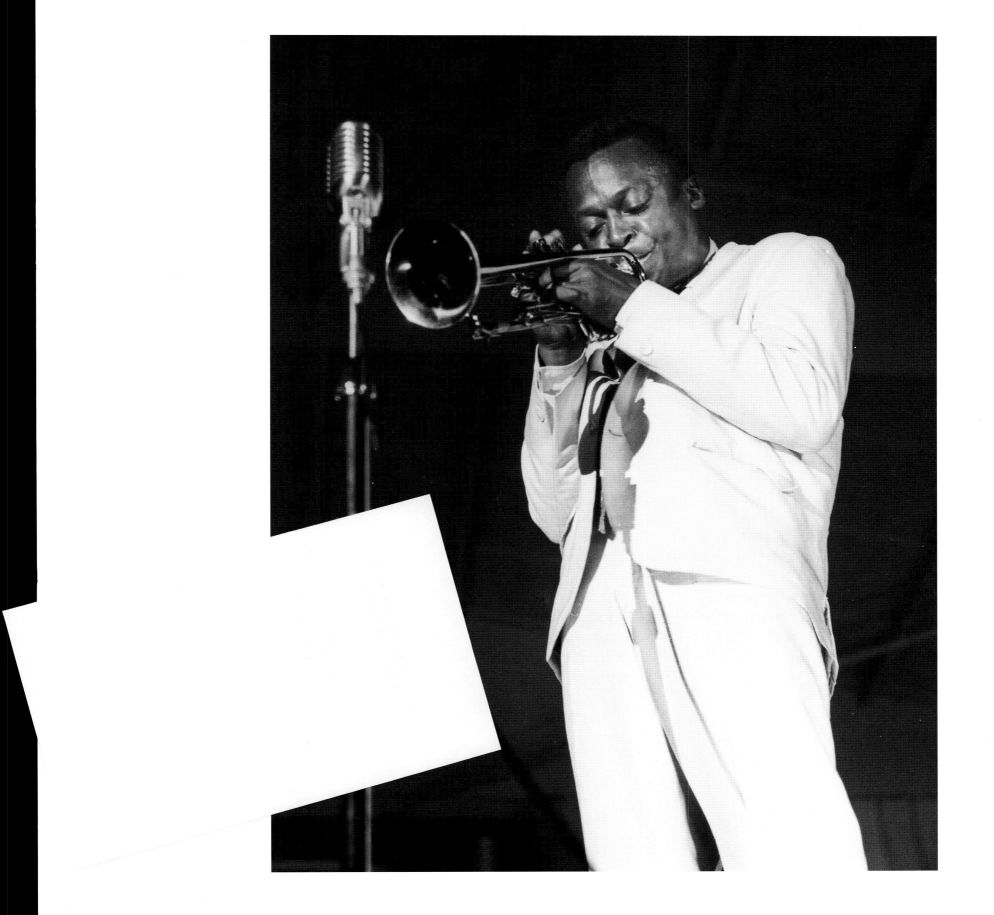

John Coltrane

b. September 23, 1926, Hamlet, North Carolina

d. July 17, 1967, New York City

So-called modern jazz is replete with musicians who have earned critical high praise in the jazz press, contributed new ways of playing their instruments, or inspired legions of devotees. Others have distinguished themselves through composition. A single player who can combine all of these is likely to be called an "immortal." Such a person was John Coltrane. He is generally regarded as the last great creative force in jazz history, on a par with Louis Armstrong, Duke Ellington, and Charlie Parker in terms of originality and influence. Since Coltrane, no one has emerged to take on this mantle.

Coltrane grew up in North Carolina, where he played clarinet before being steered toward alto sax on the recommendation of his school band leader. After moving to Philadelphia in 1939, he took formal music school training, receiving scholarships for playing and composing. He served in the Navy for two years (1945–46), after which he toured with the big bands of King Kolax and Eddie (Cleanhead) Vinson. While with Dizzy Gillespie in 1949, he started on tenor saxophone, which he subsequently played on tour with leaders such as Earl Bostic, Johnny Hodges, and Jimmy Smith. In 1955 he joined Miles Davis's Quintet. It was a mixed experience. Coltrane's relatively rough style, derived from his rhythm and blues experience, was not looked on favorably by critics, though the originality of his ideas was acknowledged.

Along the way, Coltrane became drug-addicted, which caused him to lose his job with Davis. He returned to Philadelphia and cured himself. On his return to New York, he joined Thelonious Monk at the Five Spot club (a famous engagement) and made records with Monk for Riverside. Subsequent recordings with Miles Davis, sometimes including alto saxophonist Cannonball Adderley, are memorable (*Milestones* and *Kind of Blue,* for example), but as he broke away and headed his own groups, fully exploiting his concepts and how they might be realized, Coltrane's career approached its zenith. The classic Quartet provided the vehicle; the members, besides Coltrane (who variously played tenor, alto, and soprano saxophones), were McCoy Tyner on piano, Jimmy Garrison on bass, and Elvin Jones on drums. Perhaps the culminating recording in this period is the spiritually oriented *A Love Supreme,* which has been the subject of its own book.

Jazz-minded companies such as Atlantic, Impulse, and Prestige own and periodically re-release Coltrane works, including post-Quartet combinations that are indicative of the leader's forward-looking visions or his music, sometimes marked with increased agitation and force, their gospel fervor mingled with bebop's technical virtuosity. His later efforts may have caused controversy, but his untimely death at the age of forty was mourned throughout the jazz world.

This was my first exposure to the music of Coltrane, and I count myself lucky to have caught this particular group. I remember being particularly impressed by his ability to switch instruments with such apparent ease. I now wish I had shot two or three times as many photos that evening, for I would never see him again.

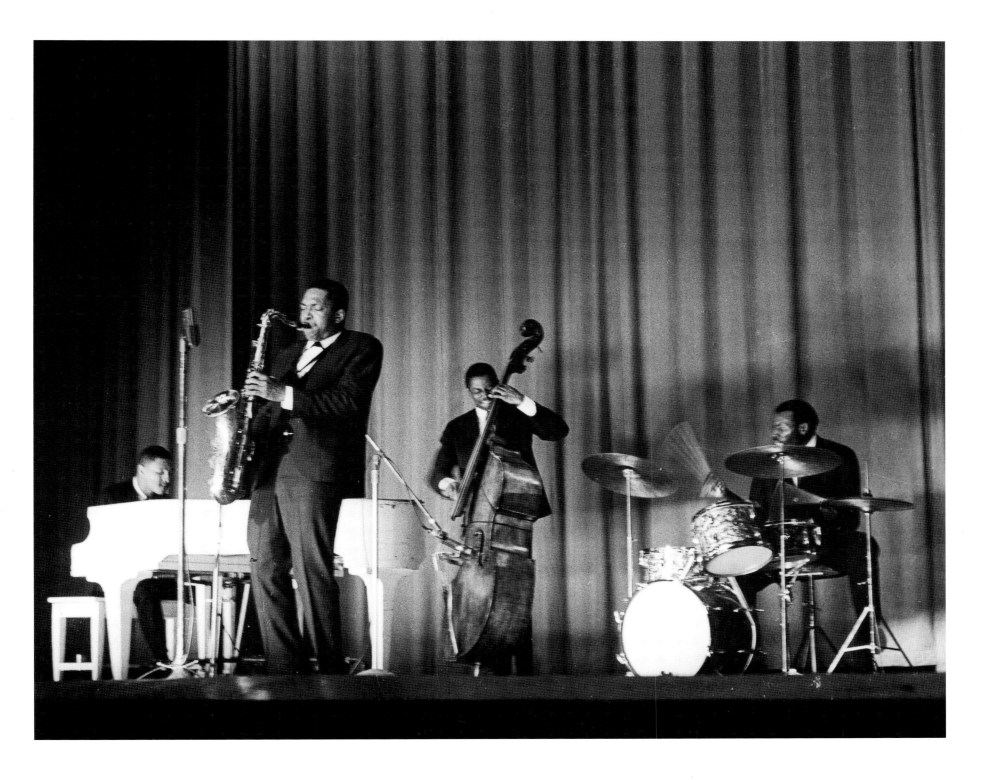

The John Coltrane Quartet, 1962 (*left to right:* McCoy Tyner, John Coltrane, Jimmy Garrison, and Elvin Jones)

Elvin Jones

b. September 9, 1927, Pontiac, Michigan

Elvin Jones is one of three remarkable musical brothers. Elvin is a drummer; Hank and Thad play piano and trumpet, respectively. Each made an impact on the jazz scene, but none more so than Elvin, whose early associations with prominent modern jazz figures of the 1950s in New York were valuable training for what was to come.

As a member of the John Coltrane Quartet for a five-year stint beginning in 1960, Jones, along with his leader, gained a place of immortality in musical history. His personal development with Coltrane would serve as a model for other drummers in this post-bop period. It has been noted that though his playing reflects a respect for previous styles (which were mainly supportive of front-line players), he elevated the drummer's role to that of a co-equal partner. The traditional drummer's timekeeping duties had long since been taken over in modern jazz by the bassist, and no one was to exploit this liberation more famously than Elvin. Following the Coltrane experience, he headed a number of small groups and toured extensively, recording many fine albums.

As was my habit, I took photos from the audience and also backstage when I could, trying to anticipate when an act was near the end of its set, so I could catch the performers as they came off. I hit the dressing room about the same time that Elvin did. Fresh from one of his demanding performances, he was drenched with sweat, and reached for a towel. Somehow I knew that the beads of perspiration were going to make my picture, and I called out "Hold off on the towel, please, Elvin." It was heartless of me, and I have to admire his patience, but I got the picture.

After developing and printing this one, I was struck by what appeared to be his hostile expression. Actually, he was the soul of accommodation, and I believe that it was merely a sense of longing for the towel and a refreshing glass of water that produced this result. Thank you, Elvin—I owe you one!

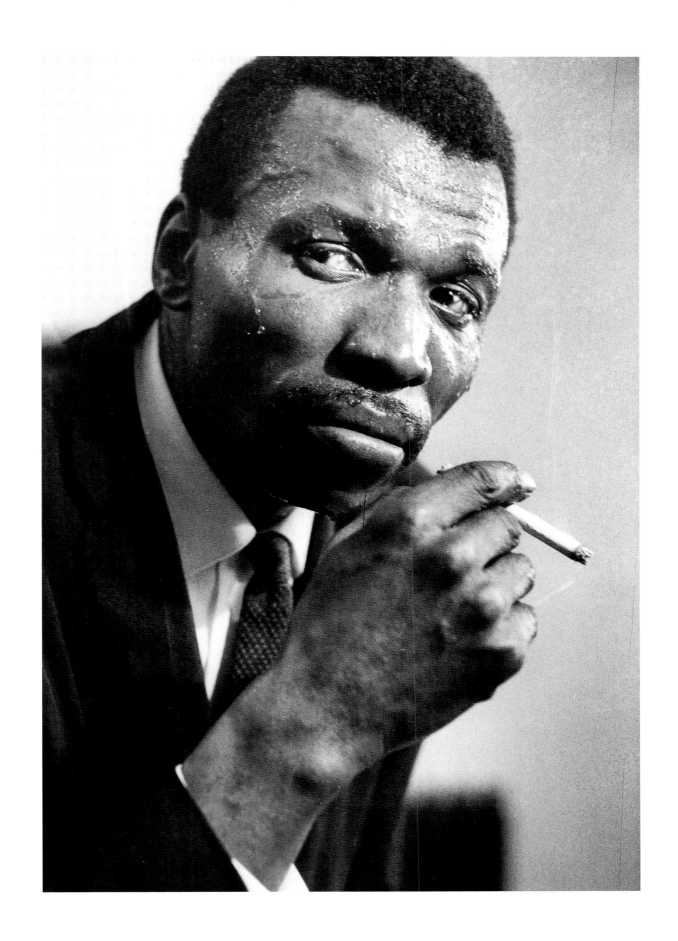

Elvin Jones, 1962

Bobby Gordon

b. June 29, 1941, Hartford, Connecticut

Randy Reinhart

b. January 16, 1953, Plainfield, New Jersey

John Sheridan

b. January 20, 1946, Columbus, Ohio

Bobby Gordon, Randy Reinhart, and John Sheridan might be categorized as part of the "third generation" of jazz musicians. Their music, however, sounds timeless, for each is at home in both "mainstream" and "traditional" styles.

While living on Long Island, Bobby Gordon had the advantage of taking lessons from a well-known clarinetist, family friend Joe Marsala. Through Marsala, he would meet such luminaries as Jack Teagarden, Eddie Condon, and clarinetist Pee Wee Russell. The influence of Marsala and Russell has permeated his playing ever since, though his personal sound is unmistakable. By age twenty-one, Bobby had already recorded his own album for Decca. He has played with his share of the great names in jazz, including Muggsy Spanier, Wild Bill Davison, Max Kaminsky, and Louis Armstrong. His warm, expressive, sometimes plaintive but always captivating clarinet sound never fails to command attention.

Cornetist Randy Reinhart was eighteen when he began to perform with well-known veteran players in the greater New York area. In 1976 he toured with the Band of America, headed by Paul Lavalle. He began to double on trombone, performing with the Happy Jazz Band in San Antonio. In the mid-eighties, he was a regular with Vince Giordano's Nighthawks in New York. Randy took part in a 50th Anniversary tribute to Benny Goodman and played an Inaugural Ball in 1989. He is much in demand by revivalist and neo-swing bands, and is prolifically represented on CDs.

A versatile pianist, a notable arranger, and a sensitive accompanist, John Sheridan is highly appreciated by jazz singers. John had his first professional jazz gig in Columbus, Ohio, with Jimmie Luellen's Novelaires when he was barely into his teens. After college, he spent four years in the U.S. Navy Band. He later joined the Jim Cullum band in San Antonio as pianist and arranger. That job lasted nearly twenty-four years. He is currently a busy freelancer.

On the shore of Lake Chautauqua in western New York stands a remarkable relic of a bygone era, the Athenaeum hotel. Photogenic inside and out, it is an ideal setting for a jazz festival, and producer Joe Boughton runs his annual fall weekends there. Three musicians relaxing between their sets onstage, and seen through a tall window, presented a picture that I could not resist. Perhaps I was moved by my admiration for each of them, but I suspect my photographer's eye motivated me the most.

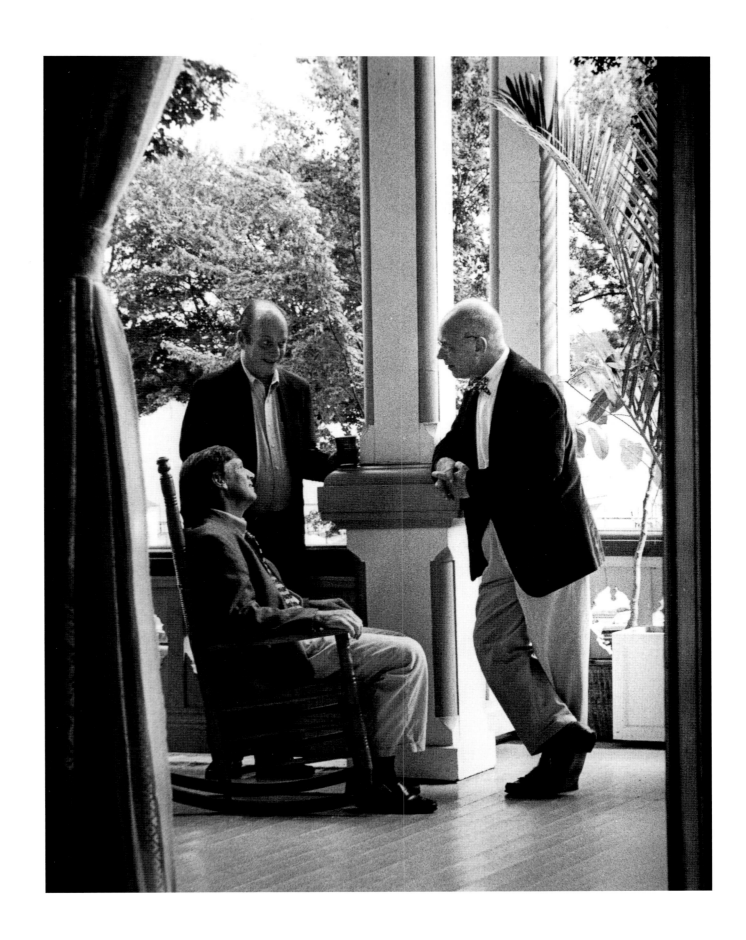

Randy Reinhart (seated),
Bobby Gordon, and
John Sheridan, 2000

Marty Grosz

b. February 28, 1930, Berlin, Germany

Marty Grosz is one of two sons of a famous father, George Grosz, the satirical artist whose classic lampoons of German society became anathema to the Nazi party, and would force the family to relocate to the United States in 1933.

While attending college in New York, Marty began to play banjo and guitar, with the accent on Dixieland and other traditional forms. He made Chicago his base for a number of years, developing his instrumental styles and building a reputation for onstage wit, a talent that has served him well in the years since. In New York he worked with the celebrated, if short-lived, duo of Bob Wilber and Kenny Davern in their Soprano Summit combo, then with the late Dick Wellstood, and also with cornetist Dick Sudhalter. In recent years he has recorded prolifically with his own units, imaginatively identified as, for example, the Orphan Newsboys. Their music is slanted toward the Swing Era.

Besides being a devotee of the great guitar stylists of the 1920s and 1930s, Marty is an accomplished jazz singer, able to call forth memories of Fats Waller and others. He is known for his surreal introductions to songs, which alone are worth the price of admission. Because these risible lead-ins may go on for minutes at a time, his musicians are generally quite rested at the end of an evening!

I have been photographing Marty Grosz in performance since his days with Soprano Summit, especially at the many jazz festivals we have both attended since the mid-1980s. His appearances always result in excellent pictures, but the photographer has to remain alert, as Marty's mobile features are bound to form fleeting expressions without warning. As a natural showman, quite aware of which lines work and which don't, he tends to use the better routines more often, but you cannot anticipate which face he will use. So you tend to shoot a lot.

This picture is one of my favorites. It captures Marty reacting to someone else's performance, at a moment when the music has really gotten to him. His expression here is completely unplanned; the joy of the music is in his face. This is the kind of image that makes it worth crouching in front of a bandstand for a whole evening.

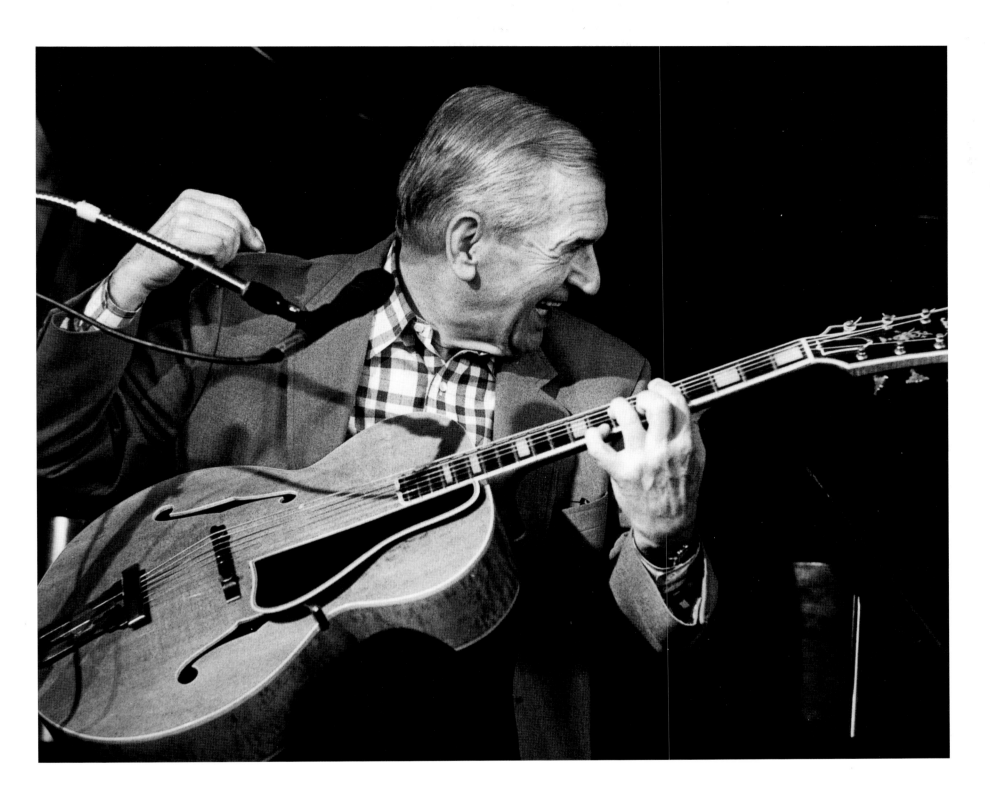

Marty Grosz, ca. 1999

Dick Wellstood

b. November 25, 1927, Greenwich, Connecticut

d. July 24, 1987, Palo Alto, California

An important pianist of the immediate postwar period, Dick Wellstood is remembered as a specialist of the so-called "stride" style of playing. He took his inspiration from the Harlem masters, who included James P. Johnson, Willie "The Lion" Smith, and Fats Waller. He moved to New York at age nineteen and was soon a member of Bob Wilber's Wildcats, a band of youths who followed the path of traditional jazz rather than progressive and bop forms. Wilber, a clarinet player, added soprano saxophone, in the style of his mentor, Sidney Bechet, from whom he took instruction.

Playing jazz and studying law competed for Wellstood's time, but he successfully completed his law degree, as had Hoagy Carmichael, an illustrious pianist of an earlier generation. Dick, like Hoagy, chose to follow music, something for which jazz fans can be thankful.

Though he became more versatile, which enabled him to work with ease in almost any musical genre, he remained faithful to his first love, stride. His many recordings are replete with styling in the Harlem manner. Dick was generally to be found in a small band setting, frequently in the company of veteran musicians whom he most admired. In time, as he became more recognized, he increasingly performed solo. His musical skills were augmented by a literary talent, which he turned toward the writing of witty liner notes. His professional career was all too short. While on an engagement in California, he suffered a fatal heart attack at the age of fifty-nine.

It seemed as though I was to encounter Dick Wellstood once every ten years. The first time, he was leading the house band at a spot in midtown New York City called Bourbon Street. Besides his regulars, there typically were two or three others who sat in and enriched the musical mix—such as Louis Metcalf, a former Ellington trumpeter, and drummer Tommy Benford, who made do with a set of brushes, a suitcase, and some sheets of newspaper.

In 1975, Dick came to Indianapolis with an all-star pickup band that purported to represent New York in a rather pretentious early jazz festival called the World's Championship of Jazz. Despite the big names in various competing bands, the winner was declared to be a traditional group from Australia, who just happened to be on tour in the U.S. and needed all the publicity they could get.

This photograph was taken the last time I saw Dick. He was a member of a remarkably cohesive and sophisticated group called the Classic Jazz Quartet. Except for a slim output on LP recordings, the band exists now only in memory. The setting here was intimate: a house party where there was no need for amplification, and the listeners—a jazz-aware group—could sit just feet away. For the record, Wellstood's colleagues were Marty Grosz, guitar; Dick Sudhalter, cornet; and Joe Muranyi, clarinet. It was 1985. In just two years, Dick would be gone.

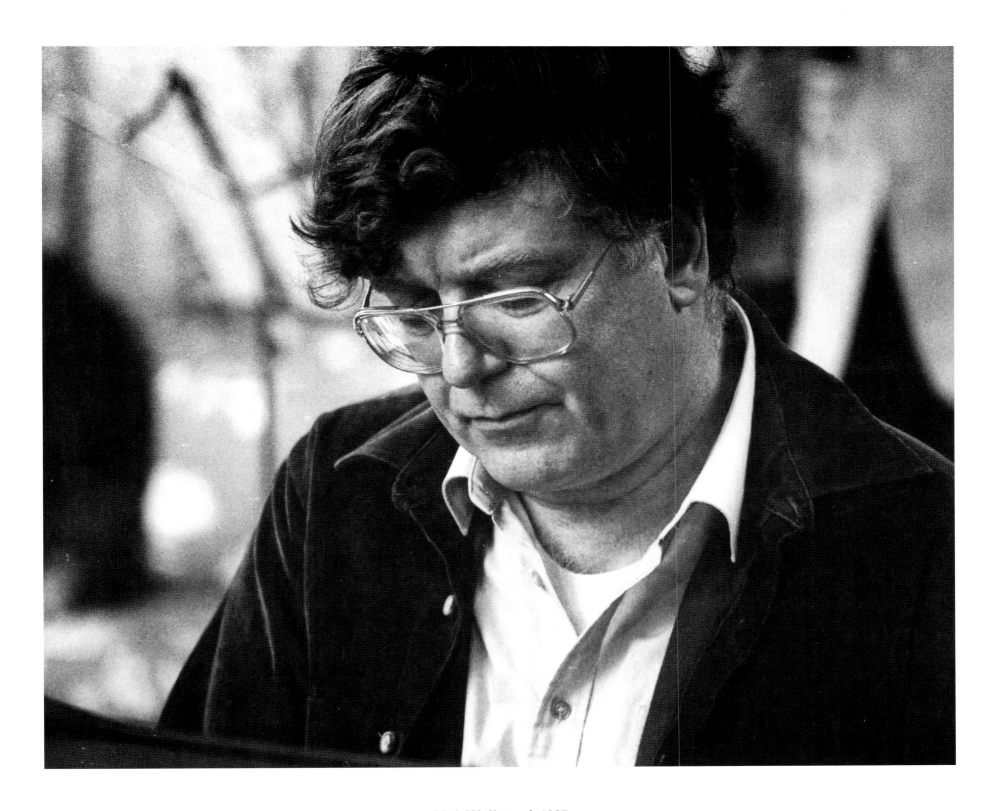

Dick Wellstood, 1985

Scott Hamilton

b. September 12, 1954, Providence, Rhode Island

Now and then, a musician appears on the jazz scene who seems to be totally out of phase with the music that is currently "in." Such a player, for example, was cornetist Ruby Braff, who barely got going as the swing craze and big bands were fading, but whose style was so compelling that he survived and prospered in spite of current fashions. Scott Hamilton entered the scene a full generation later, with a mature style based on that of saxophonist Ben Webster. As an adolescent, Scott had experimented with clarinet and piano, and even essayed blues harmonica in a local teen band. But listening to records in his father's collection at home pointed him toward the famous stylists on tenor saxophone during the Swing Era. He soon headed for New York.

He was immediately embraced by other like-minded players, such as cornetist Warren Vaché, with whom he appeared extensively. In the ensuing years, Hamilton has recorded for several labels. He is a favorite in Europe, where his festival appearances are eagerly anticipated. If he was not solely responsible for the re-emergence of mainstream jazz in the late twentieth century, he joins a very select few who can lay claim to that distinction.

It has been my pleasure to attend a number of Scott Hamilton performances, always at festivals in the Midwest. He never has failed to give his best, and I find myself watching him even when others may be soloing. Typically, he will be swaying, eyes closed, appearing to enjoy what he is hearing. He seems to be planning his next turn. When that comes, his concentration is almost palpable. I hope it shows in this action shot, which was taken in 1990 during a jazz weekend at the Riverside Inn in Cambridge Springs, Pennsylvania.

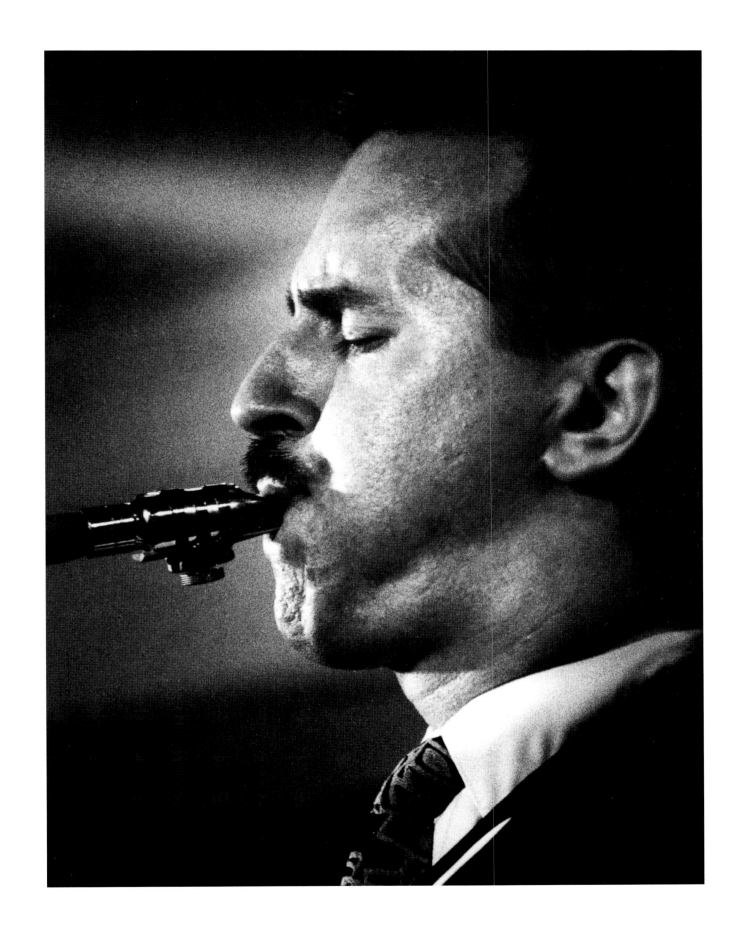

Scott Hamilton, 1990

Paul Bacon

b. December 25, 1923, Ossining, New York

Paul Bacon, one of the nation's finest book jacket designers, was born within a stone's throw of Sing Sing prison. He says that his mother, while recuperating from childbirth, struck up an acquaintanceship with the notorious racketeer "Owney" Madden, who was in the hospital being treated for gunshot wounds. Bacon recalls nothing of this, and says that his connection with Sing Sing ended there.

He began playing the ukulele (a family tradition) at age eight, but he knew nothing of jazz until some years later, when his brother's girlfriend introduced him to the records of Connie Boswell, Mildred Bailey, and Billie Holiday. Today his jazz icons are Billie, Louis Armstrong, Bix Beiderbecke, Lester Young, and Thelonious Monk.

Trained in graphic art, Paul designed record album covers for the Riverside and Blue Note firms and had his first book jacket published in 1950. He opened his own studio five years later, and has since built a national reputation with his art. In recent years he has had shows of his work at Wilkes University, in Wilkes-Barre, Pennsylvania, and at the Society of Illustrators in New York (a fifty-year retrospective). In 2002, an article about Paul appeared in *PRINT* magazine entitled "The Man with the Big Book Look."

Among professionals such as Bacon, music is a popular avocation. In recent years, Paul has managed to become a virtual full-time performer on his chosen instrument, the lowly comb. Hardly an instrument to be sneezed at, it has an honored past in the hands of vintage recording artist Red McKenzie, who provided Paul's inspiration. The principle is like that of the kazoo.

Once you have a suitable comb, all that remains is to attach a length of paper or cellophane to it, and then merely sing falsetto into it. Paul has mastered this technique and parlayed it into a second career. He takes his place in the jazz ensemble, soloing into a microphone like a buzzing cornet. Paul's pleasant, restrained vocals are also put to good use on the bandstand. At this writing, he is featured at Cajun, a downtown New York City nightspot.

I would be disingenuous if I said I approached the taking of this picture with anything less than fascination. I had never seen anyone play the comb in person, and I had heard it on only a few of the old McKenzie discs. When Paul appeared at one of the Conneaut Lake jazz parties, his ability to improvise choruses with taste and imagination told me that here was a hitherto unfulfilled musician who had found the way. I needed to get something that represented this good-natured chap and included the main tool of his trade. I decided we could do without the paper. It would be hard to do without Paul Bacon.

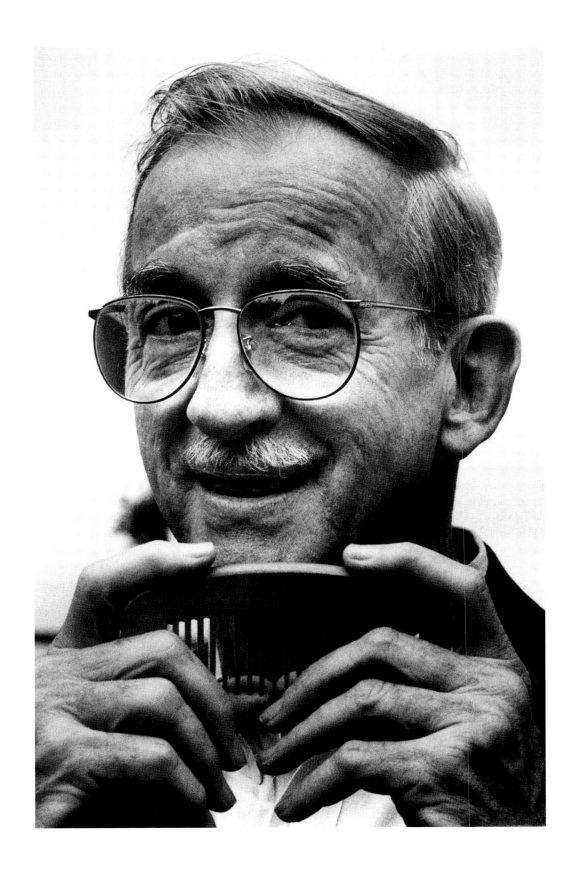

Paul Bacon, 1994

Dave Frishberg

b. March 23,1939, St. Paul, Minnesota

Dave Frishberg is an accomplished piano soloist who has extensive band experience and, when required, can be an excellent accompanist for a vocalist. Add to this a talent for composing and performing offbeat songs, and you have "something different," to say the least. He has built an enviable reputation as a wry lyricist, with melodies to match, and performs them to the delight of audiences across the country. A small sampling of his titles hints at the range of his imagination: "I'm Hip," "Van Lingle Mungo," "Dear Bix," "Sweet Kentucky Ham," and "Slappin' the Cakes on Me." Frishberg's recordings on Concord, Arbors, and other jazz labels are worth looking for.

It is rare that I attempt to photograph a musician without some sort of preparation. Normally I have either heard a recording or attended a performance. In the case of Dave Frishberg, I had not heard any of his unique songs, but as he played and sang, I began to feel how I might photograph him. I saw him as a keen, amused observer of people and their foibles. After I explained my plan for the photograph, he was quick to cooperate, and assumed the exact expression I had been hoping for. Today I look at it as one of my most successful images—a near-perfect realization of an idea.

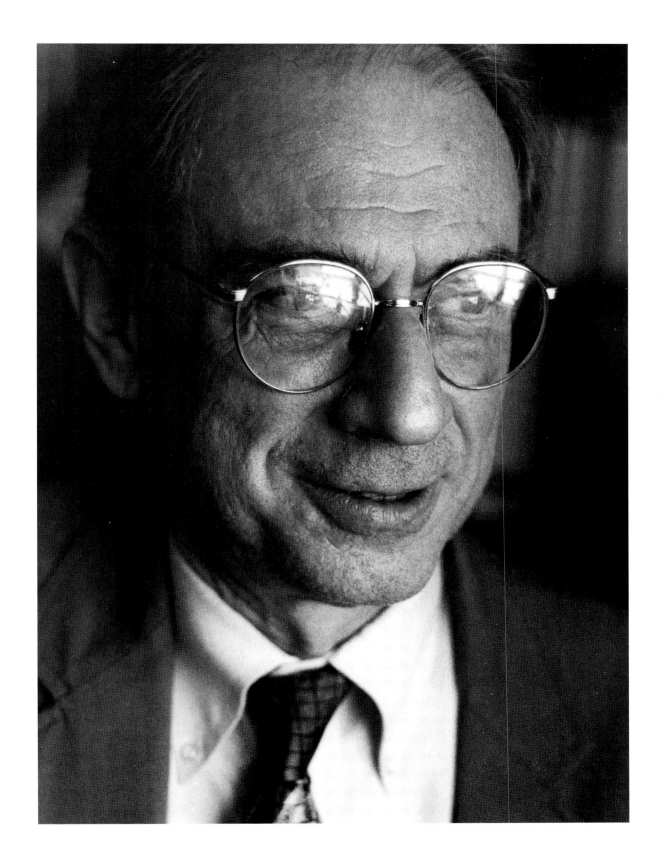

Dave Frishberg, 1995

Dan Levinson

b. July 8, 1965, Los Angeles, California

Dan Barrett

b. December 14, 1955, Pasadena, California

Dan Levinson and Dan Barrett are formidable figures in classic jazz styles. The "two Dans" both hail from California, and both are multi-instrumentalists, fine arrangers, and students of the music's history.

Dan Levinson, a specialist in clarinet and saxophone, began studies in California with the veteran "Rosy" McHargue. In New York, where he has lived since 1983, he continued to learn with the help of famous teachers and players. Extensive touring, involving foreign jazz festivals, and important engagements in the United States keep him a busy musician. He has subbed on clarinet for Woody Allen, performed for the prime ministers of Iceland and Italy, appeared at the 60th Anniversary Benny Goodman tribute at Carnegie Hall, played in off-Broadway theatrical venues, and contributed to the soundtracks for several feature films. He retains his affection for jazz of the 1920s and 1930s, often resuscitating obscure instrumental gems. He can be heard on numerous CD releases.

Dan Barrett, who is known as a trombonist of remarkable versatility, also doubles on cornet. He started in California, spent a number of years in New York, then returned to the West Coast, from where he can quickly reach the many festivals and recording engagements that come his way. Barrett has his own recognizable sound and phrasing style, but he can move on demand into the silky Tommy Dorsey sound or the growling, muted utterances of Ellington's legendary "Tricky Sam" Nanton. Further, he is not daunted by the challenge of playing progressive and other modern musical forms. He is equal to the task.

I first heard Dan Barrett in 1986, at the Conneaut Lake Jazz Festival, when he and his partner, guitarist Howard Alden, presented their quintet. The group played a mixture of material, from John Kirby to Buck Clayton, in arrangements written for the band by Clayton. After that, I was to encounter Dan in many settings, taking many photos.

With Levinson, it took longer for our paths to cross. The occasion was a performance of all-star musicians at a weekend of jazz in Meadville, Pennsylvania. The venue was an eighty-seat room on the second floor of an old market building. In the hallway immediately outside the music area, I was struck by the wonderful window area and its photographic possibilities. I asked the two Dans to provide some human interest for this setting, and this is how it turned out.

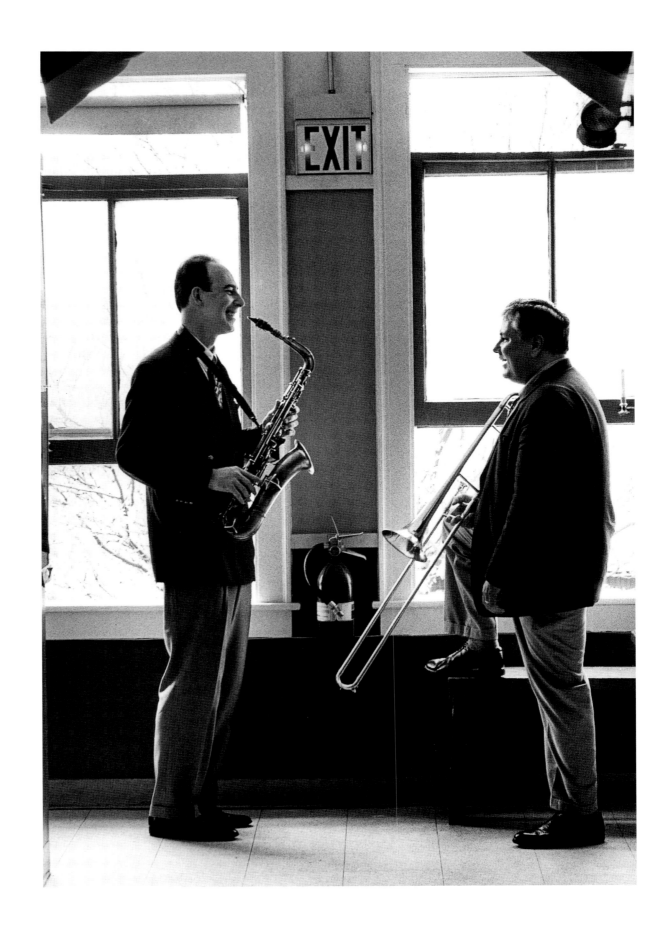

Dan Levinson and Dan Barrett, 1998

Howard Alden

b. October 17, 1958, Newport Beach, California

In an era when the music scene teems with guitarists good, bad, and "different," it is refreshing to hear players who can combine respect for the past with modern innovations. Such a musician is Howard Alden. His deceptively youthful look hides an almost limitless reservoir of talent and knowledge.

Growing up in California, he began to play at age ten. He was self-taught for several years, using recordings for inspiration. After some formal instruction, and professional experience around Los Angeles, he met Dan Barrett, with whom he became closely associated. Their fledgling quintet, given impetus by former Count Basie trumpet star Buck Clayton, proved popular here and abroad, even as both leaders worked heavy schedules outside of the partnership.

One of the pleasures of Alden's life has been appearing on record with one of his all-time idols, George Van Eps. He has mastered the seven-string guitar technique pioneered by Van Eps, and enjoys the challenge of playing duets with fellow guitarists such as "Bucky" Pizzarelli. He can be heard on dozens of CDs and at popular music festivals, where he may turn to his banjo with equal aplomb.

This photograph, taken in the late 1980s, is a favorite of mine because of the concentration displayed, yet without the physical strain that inevitably shows up during demanding solo passages. Howard, like all great players, insists on doing his best at all times, and the exertion is obvious. Here he was reading the music during an ensemble passage, and I liked what I saw.

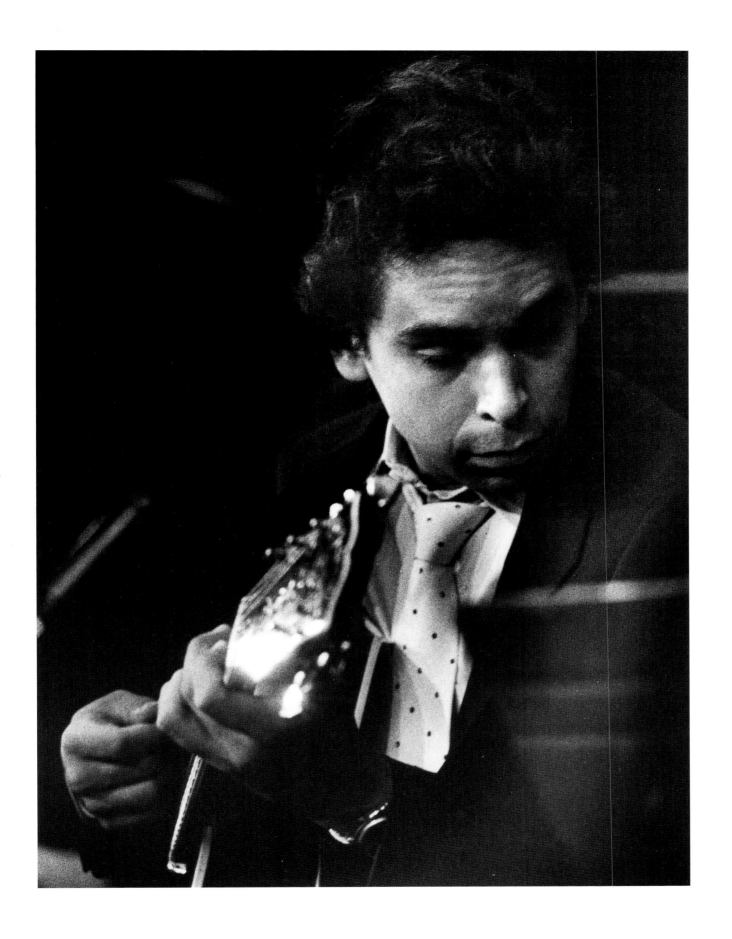

Howard Alden, 1986

Michiko Ogawa

b. December 4, 1962, Osaka, Japan

A winsome emissary from Japan whose delicacy of manner and innate modesty belie a formidable keyboard talent, Michiko Ogawa, or "Riko," as she as familiarly known, arrived unheralded in the United States as a member of the Yoichi Kimura Trio. The occasion was the fiftieth reunion celebration of the Salty Dogs, a long-lived campus jazz band at Purdue University in West Lafayette, Indiana. Kimura, a drummer, had been a member of one of the final editions of the group, and he brought his trio from Japan to the event. With Ogawa on piano and Nobuo "Nobby" Ishida on bass, the threesome were an instant hit. Since then, they have made annual appearances at the Arbors "March of Jazz" festivals and various jazz societies. They invariably earn a standing ovation.

Michiko began studying classical piano at age three. She joined a jazz group at Keio University in Tokyo when she was twenty. Showing a special affinity for the music of Scott Joplin, Jelly Roll Morton, James P. Johnson, and Willie "The Lion" Smith, she plays this sometimes muscular music flawlessly. These diverse selections are interspersed with other jazz material in her appearances here and at home, where she has been playing at the New Suntory 5 in Osaka since 1993.

Her solo concerts in Japan have been either all-jazz or all-classical. Her work is available on several CDs by the Kimura trio, and there is a CD of her recital, in which she performs an impressive rendition of the entire Gershwin *Porgy and Bess* suite. Her versatility onstage with prominent American jazz musicians is by now well-established, and has resulted in at least one CD on the Arbors label.

I happened to be present for the Salty Dogs reunion at Purdue University, and took great pleasure in hearing "Yo" Kimura and his colleagues. I was hardly prepared, however, for the breadth of Michiko's repertoire, which encompassed much of the history of early piano jazz. Her posture at the piano, ramrod-erect, is a pleasure to behold, and her acknowledgment of applause is sincere. There is an obvious openness about the three members of the trio, an ability to comfortably relate to the jazz community, which automatically wins over an audience.

On the occasion of this photograph, taken at one of the Arbors festivals, I was photographing not only an accomplished pianist, but a beautiful woman. If my camera could talk, I am sure it would have said "thank you."

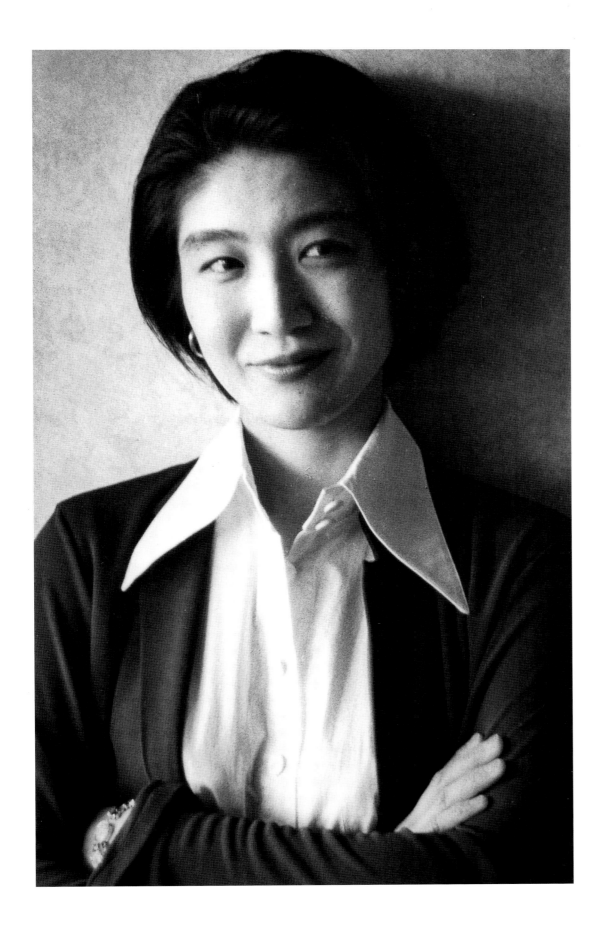

Michiko Ogawa, 2000

Joe Williams

b. December 12, 1918, Cordele, Georgia

d. March 30, 1999, Las Vegas, Nevada

Joe Williams has been called "the last of the great big band singers." Because of his success with blues-based songs such as "Every Day I Have the Blues," it is not difficult to place him in that genre, but even a cursory look at his recorded output will show the eclecticism of his repertoire.

Joe grew up in Chicago, where he began to sing professionally with various combos, including a large jazz band headed by Jimmie Noone. There were other leaders who saw in this performer a promising talent—Andy Kirk, Lionel Hampton, Coleman Hawkins—but not until 1954 did he make a long-term connection. Having worked in the septet that Count Basie led for two years, he rejoined Basie as the pianist was rebuilding his big band. Joe would soar to international fame during the next seven years with Basie. Some have said that Joe's presence had much to do with this band's success. His appearances elicited the same kind of adulation from youthful audiences enjoyed by Billy Eckstine. His name sold tickets, and it sold records, of which there were to be many.

A durable singer, Williams spent the rest of his career as a club artist, working with various combos and finally his own trio. He maintained a rich, expressive voice and youthful vigor into his eighties, still pulling them in.

This photograph is from a series I shot at Elkhart, Indiana, during the city's annual jazz festival. I had not seen Joe with Basie, but I had caught him once in a Cleveland club. This time, however, he had his own trio. The bright spotlights of the Elco Theatre took me back to my early amateur days, when virtually all my stage photos were beautifully lit for me by the men in the booth far above. All I had to do was wait for the right gesture; the right expression came along. There were so many of these that I had a problem selecting the shot that best represented Joe.

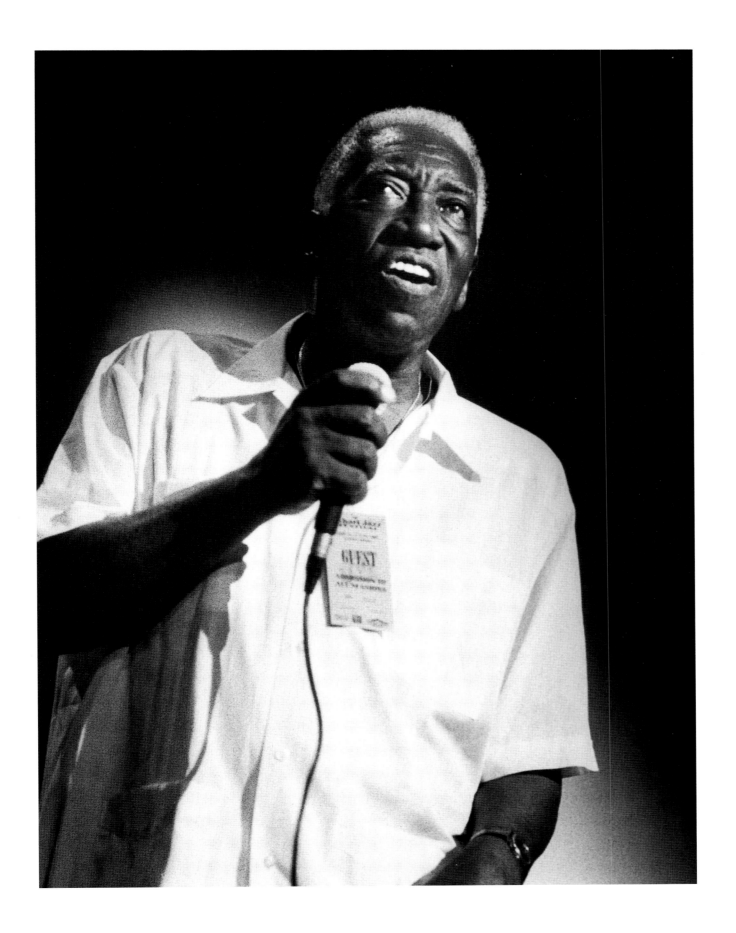

Joe Williams, 1998

Anita O'Day

b. October 18, 1919, Kansas City, Missouri

Anita O'Day can best be described as a jazz musician whose instrument happens to be her voice. Blessed with physical hardiness and an unquenchable talent, she has triumphed in a life of many challenges. Like most of her famous contemporaries, she came to maturity in the big bands, starting with Gene Krupa's in 1941. Her vocal partnerships with trumpeter Roy Eldridge were a winning combination onstage and on record. Think of "Let Me Off Uptown" and you have the idea. There were later associations with Woody Herman and, notably, Stan Kenton.

Anita's style is highly rhythmic. It incorporates scat-singing (a rarity among big band vocalists) and is marked by spontaneous digressions from the melodic line. She has also been gifted with fine diction, as critics have noted.

After the big bands, Anita performed as a solo attraction, and recorded a number of excellent sides with studio orchestras. Her personal problems were candidly detailed in her autobiography *High Times, Hard Times.*

The Indianapolis Jazz Club, of which I was a founding member, booked Anita and her trio one weekend evening. This was an unusual event, for the club had a history of presenting only traditional jazz and Dixieland. I had seen Anita in person only once, and that was on a theater stage. I made sure to take a lot of film to the concert. To my delight, not only did she sing convincingly in her well-known style, but her body language was dramatic. The effect was magical, offering me many good opportunities with the camera.

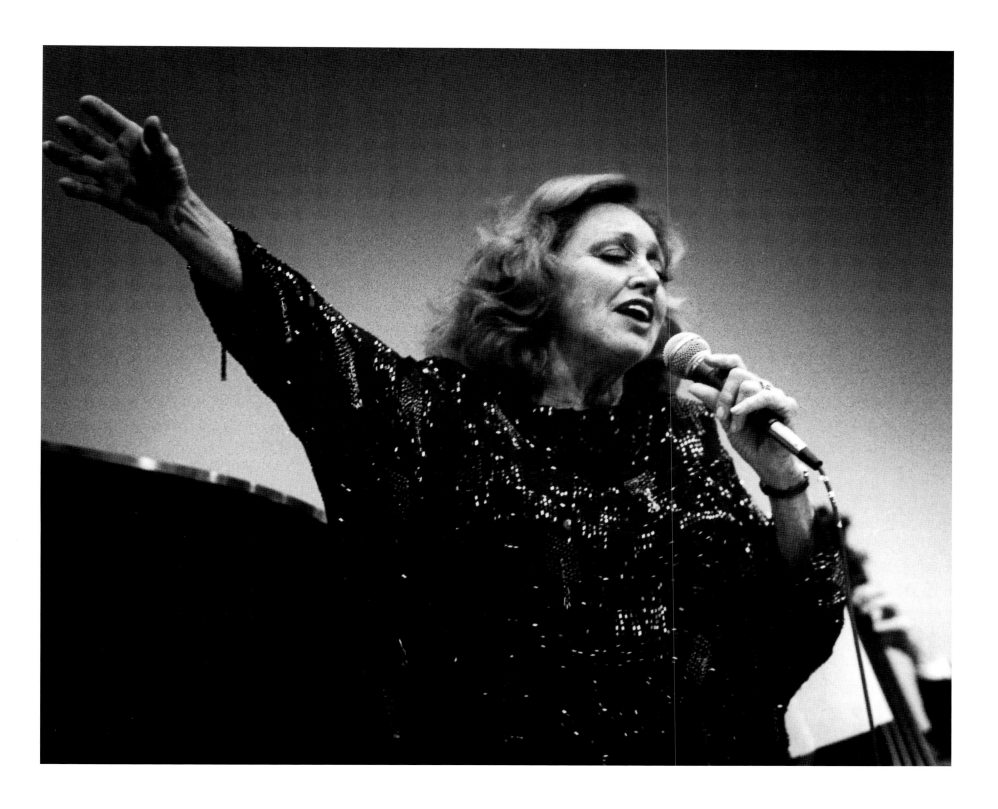

Anita O'Day, 1985

Bobby Short

b. September 15, 1926, Danville, Illinois

Who comes to mind when you hear the words "male cabaret singer"? Many people would start with Bobby Short and then hesitate, for this artist appears to stand alone in what he does. Bobby combines an innate appreciation for the singular melodic charm and the sometime worldliness of America's better songs with a vocal delivery that can range from a near-shout to a soft-spoken murmur. He not only sings, he communicates. The drama of his presentation is enhanced by his excellent diction and the pleasant huskiness of his voice.

This array of talent, which includes effective self-accompaniment at the keyboard, has been honed over decades, from the day when Short left his home town at age eleven to embark on his long career. As a child performer, he worked in vaudeville, from Chicago to New York and the Apollo Theatre. The need to return to Danville and complete high school caused a temporary hiatus, but in 1943 he resumed his musical career. Along the way he met and was influenced by pianists Nat Cole and Art Tatum. He also gained musical and management help from Phil Moore, himself a legendary musician and coach.

A contract with Atlantic Records was followed by a booking in 1968 at the Café Carlyle in New York, which proved to be virtually a permanent gig. Bobby still plays at this Madison Avenue spot for months every year, delighting fans old and new.

In Indianapolis, the American Pianists Association, originally formed to support the aspirations of young classical pianists, embarked on a similar program to assist promising jazz performers. Each year, the contestants would be judged by a panel of well-known pianists. In 1996 Bobby Short served as a judge, and I was permitted to attend a press conference where he and the others were interviewed. Stealing him away for a hurried series of close-ups at a nearby window was not easy, but I think he warmed to the informality of the moment, and we were able to get this image, one that I think is as close to the definitive picture of him as I could ever get.

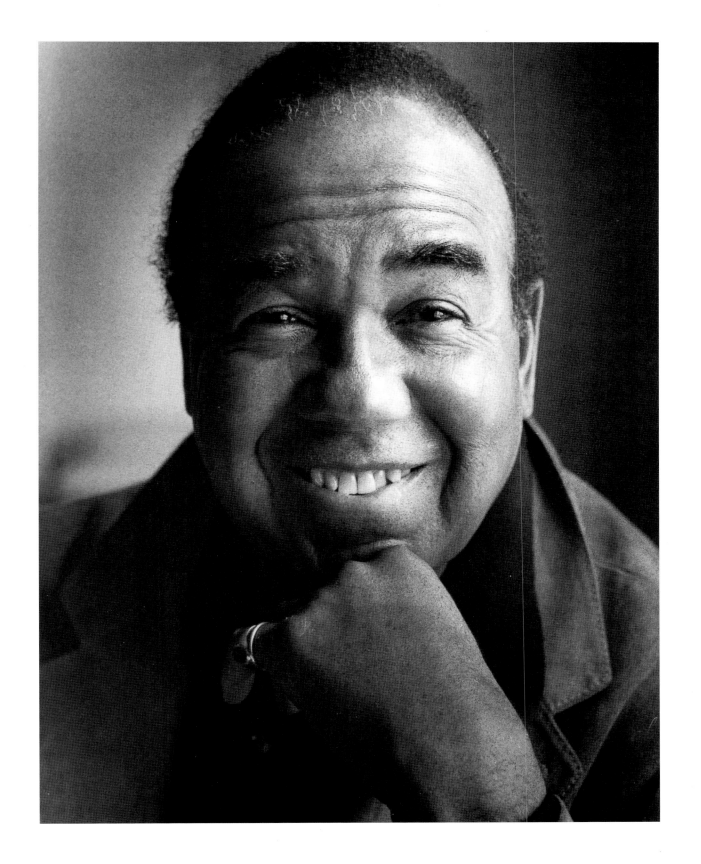

Bobby Short, 1996

John Hammond

b. December 15, 1910, New York City

d. July 10, 1987, New York City (?)

A member of the wealthy Vanderbilt family, John Hammond took an early interest in jazz. Coming of age during the Depression, he sought to build public awareness of the music in a number of ways. His enthusiasm and persistence got him space as a columnist for the music journal *Melody Maker* in Great Britain, where appreciation for American jazz was high. Unable to gain traction with record companies in his own country, he negotiated deals with British firms for special sessions to be recorded in New York and released on overseas labels. These turned out to be classics.

A lifelong crusade for racial equality extended beyond his musical interests. He was at one time vice president of the NAACP and was a perennial member of the board. In the mid-1930s he personally covered the explosive Scottsboro trial for *The Nation* and *The New Republic*.

Space does not permit me to list the tremendous number of firsts that can be attributed to Hammond's efforts. I could point to his role as talent scout and star-maker, with Benny Goodman, Count Basie, Billie Holiday, Charlie Christian, Teddy Wilson, and the boogie-woogie pianists Meade Lux Lewis, Albert Ammons, and Pete Johnson as well-known beneficiaries. He may fairly be regarded as a principal catalyst in making the Swing Era possible. If this claim seems extravagant, reading the literature of jazz ought to confirm its validity.

A notable highlight was his production of a pair of major all-star concerts, "From Spirituals to Swing," at Carnegie Hall. Here he brought together some of the tributaries that form the mainstream of jazz: the blues, gospel, boogie-woogie, and swing. Fortunately, the concerts are available through recordings.

As a Columbia Records executive, he continued to exert his influence. He was either the discoverer or developer of talents beyond jazz, among them Bob Dylan, Aretha Franklin, Pete Seeger, and Bruce Springsteen. In later years he connected with Vanguard Records, a classical recording firm, and through them issued a masterful series of jazz performances by artists who had been neglected or whose careers were in need of renewal.

My one and only chance to photograph John Hammond was at a record collectors' convention in Pittsburgh in 1974. He was seated on a stool before an audience of knowledgeable jazz fans, some of whom had equally keen memories and opinions. John warmed to the occasion and spoke at length about his experiences in jazz, sprinkling his talk with anecdotes and involving, it seemed, nearly everyone who had ever recorded. It was a fascinating afternoon, and I got the feeling that John Hammond, like Jelly Roll Morton, was not one to play down his personal contributions. But he was a delight to photograph. His animated face and expressive hands made him a natural subject. One jarring note: The background looks like something Henri Matisse might have painted on a bad day.

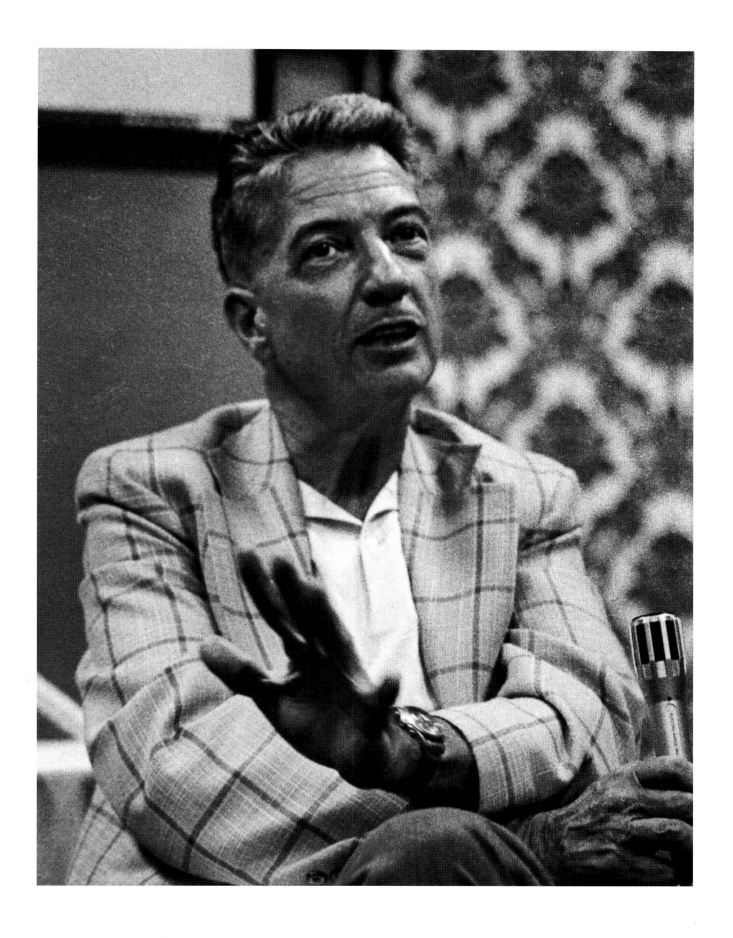

John Hammond, 1974

George Avakian

b. Armenia, March 15, 1919

One of the great names in the recording industry, George Avakian remains active in his seventh decade as a producer and writer. His list of credits is unmatched.

Only four when his family came to the United States, George has said that he first heard jazz and dance bands on the family radio, but just thought of it as "different" music. The *Let's Dance* programs on Saturday nights brought the then-unknown Benny Goodman band through the loudspeaker. Soon the music got a title—"swing"—and lent its name to an entire era. As a teenager, and editor of the student paper at Horace Mann School in New York, George did an interview piece on Goodman, his first effort at writing about jazz.

One of George's classmates, Julian Koenig, had an older brother, Lester, who was a senior at Dartmouth. Lester, a jazz enthusiast, was told about this kid who kept babbling about swing records. Lester asked, "What does he think of Louis Armstrong?" George's opinion was relayed: "He's good, pretty flashy, and he sings kind of funny." Upon hearing this, Lester guessed that George had heard only Armstrong's recent big band discs. "I'm coming home for Thanksgiving weekend, so bring him over on Saturday and I'll knock his ears off."

The day after the event found George firing off an irate letter to Brunswick Records, telling them that they should reissue the Armstrong records made for OKeh, which they controlled. He never got a reply. Some time later, as a student at Yale, George met the scholarly Marshall Stearns, one of the early collectors and researchers of the music, who invited him to listening and discussion sessions at his home. George's career path became apparent.

George has been credited with producing the first jazz "album," Decca's *Chicago Jazz,* in 1939. He then joined Columbia Records as a producer and annotator of reissue albums and singles of his choice. Aside from prior Bessie Smith and Bix Beiderbecke memorial albums, this was the start of the first reissue program. After eighteen months, military service intervened. After George's return from the Pacific in 1946, he rejoined Columbia as a regular staff member. He was there for the start of the LP format, which afforded extended recording times and encouraged the writing of much new original material.

During Avakian's years with Columbia, historic albums by established stars bore his imprint. He was present at the birth of the Duke's *Ellington Uptown* and *Ellington at Newport,* Miles Davis's *'Round Midnight* and *Miles Ahead,* Brubeck's *Red, Hot and Blue,* and Erroll Garner's *Concert by the Sea,* to name a few. Other jazz and pop artists whose sessions he has supervised include Eddie Condon, Keith Jarrett, Sonny Rollins, Charles Lloyd, Mahalia Jackson, Johnny Mathis, the Everly Brothers, Bob Newhart, and Liberace. He takes special pride in his albums of Louis Armstrong, considered among the best ever made by the great jazzman. A pair of these, *Satch Plays W. C. Handy* and *Satch Plays Fats,* are especially treasured.

Upon leaving Columbia in 1958, George took his great talents to other labels, including World Pacific, Warner Bros, and RCA. He has freelanced in the control room and at his typewriter ever since.

In New York, when I was busy photographing musicians, I failed to photograph many of the writers and critics I met along the way. These individuals, too, were and are important to the history of our music. So, of course, are the individuals who produced the records of jazz. In photographing John Hammond, I belatedly began to correct what I now see as a serious omission. I got the opportunity to photograph George Avakian at a jazz weekend in Libertyville, Illinois, several years ago. The ease with which he deals with strangers with cameras is evident in the picture.

George Avakian, 1997

Nat Hentoff

b. June 10, 1925, Boston, Massachusetts

Nat Hentoff is neither a musician nor a musicologist. He is a writer with a particular affinity for jazz and its players, the way they think and the conditions under which they work and play. Much of his life has involved sharing with others what he has seen and heard along the way. For half a century, Hentoff has had a hand in some of the more memorable events in jazz as editor, essayist, critic, columnist, reviewer, media consultant, director of artists and repertoire for Candid Records, lecturer, and author.

The general public is not likely to be aware of this portion of Hentoff's resume. He is more likely to be recognized for his regular column in the *Village Voice* or the *Wall Street Journal,* or for his occasional appearances on TV talk shows or in other forums. Like as not, he will be writing or speaking on the subject of civil rights, the First Amendment, or a discovered injustice.

But listen to the voice in his heart as he reminisces about a day etched in memory:

> A cold winter afternoon in Boston, and I, sixteen, am passing the Savoy Café in the black part of town. A slow blues curls out into the sunlight and pulls me indoors. Count Basie, hat on, with a half smile, is floating the beat with Jo Jones's brushes whispering behind him. Out on the floor, sitting on a chair which is leaning back against a table, Coleman Hawkins fills the room with big, deep, bursting sounds, conjugating the blues with the rhapsodic sweep and fervor he so loves in the opera singers he plays by the hour at home.
>
> The blues goes on and on as the players turn it round and round and inside out and back again, showing more of its faces than I had ever thought existed. I stand, just inside the door, careful not to move and break the priceless sound. In a way I am still standing there.

Such is one man and his love of something greater than he could imagine. Yet Hentoff went on to write and edit books. He never tired of what Whitney Balliett has called "the sound of surprise."

Asked once what he was most proud of, he responded quickly that his high point was working as co-consultant (with Balliett) on a landmark jazz television program, *The Sound of Jazz,* broadcast live over the CBS network in 1957. It was one of those magic moments in the medium's adolescence, when jazz at its purest, in all of its forms, met a production team that understood. It has never been matched—not even close.

It took me many decades to finally meet this writer in person, though we'd had occasional contacts by letter or phone, and I rejoice that he was tolerant of my clicking away as he engaged in conversation with my companion. It is also good to know that there are men such as Hentoff who can become passionate about things that really matter.

Nat Hentoff, 2001

Dan Morgenstern

b. 1929, Munich, Germany

How do you describe a man whose place in the jazz world is as solidly based as that of any musician, whose broad understanding and deep appreciation of the music are almost uncanny, and who exudes the enthusiasm of youth after nearly sixty years as a scholar, writer, critic, archivist, and editor?

Dan Morgenstern, who was born in Germany and reared in Vienna and Denmark, is the son of a journalist whose strongly anti-Nazi writings inevitably put him and his family in jeopardy, resulting in their eventual relocation to the United States in 1947. Already a confirmed jazz fan in Denmark, Dan headed for his private Mecca, fabled Fifty-Second Street in New York, where jazz clubs rubbed brownstone shoulders with one another, and through whose open doors a cacophony of competing sounds could be heard—jarring but sweet music to his young ears. He never looked back. A talent for writing led him into editorial positions at *Metronome* and *Jazz* magazines. By 1964 he was New York editor for *Down Beat,* later serving for seven years as its chief editor, based in Chicago.

A brief biographical sketch such as this can only skip across the highlights of Morgenstern's full range of activities. He would be well-remembered for his critical writings alone. Or his many perceptive album liner notes. Or his many columns published here and overseas. Or his contributions to standard jazz reference works. Or his university-level teaching at several institutions. But perhaps his most lasting achievement is his more than twenty-five years of service as director of the Institute of Jazz Studies at Rutgers University. This repository of jazz information, research materials, memorabilia, oral histories, and recordings of all kinds is the largest such resource anywhere, and requires a dedicated staff from top to bottom. It is in good hands.

One busy, noisy night at the Stuyvesant Casino, I had paused in my customary coverage of every musician on the stand when I began to hear the sound of angry bees behind me. Glancing around, I saw the redoubtable cornetist Wild Bill Davison blowing at a group of young men lined up at one of the front-row tables. They were blowing back, but each of them was equipped with a kazoo! The scene was too good not to shoot, so I did.

This was in 1949, and it must have been a decade later when I realized who the young men were. They were among the most serious-minded of researchers and collectors in New York. Two of them founded and published the informative monthly Record Research, *another became a jazz columnist, and another was the twenty-year-old Dan Morgenstern.*

Dan and I have since become friends, and though our meetings are limited to the occasional festival or jazz gathering, I enjoy the warm familiarity of our get-togethers. I am reminded of one man's description of Dan: "If jazz had a pope, it would be Dan Morgenstern." I look forward to my next audience.

Dan Morgenstern, 1998

Epilogue

Last but not least, an affectionate nod toward beloved bass player and fellow jazz photographer, the late Milt (the Judge) Hinton.

Milt Hinton, 1988

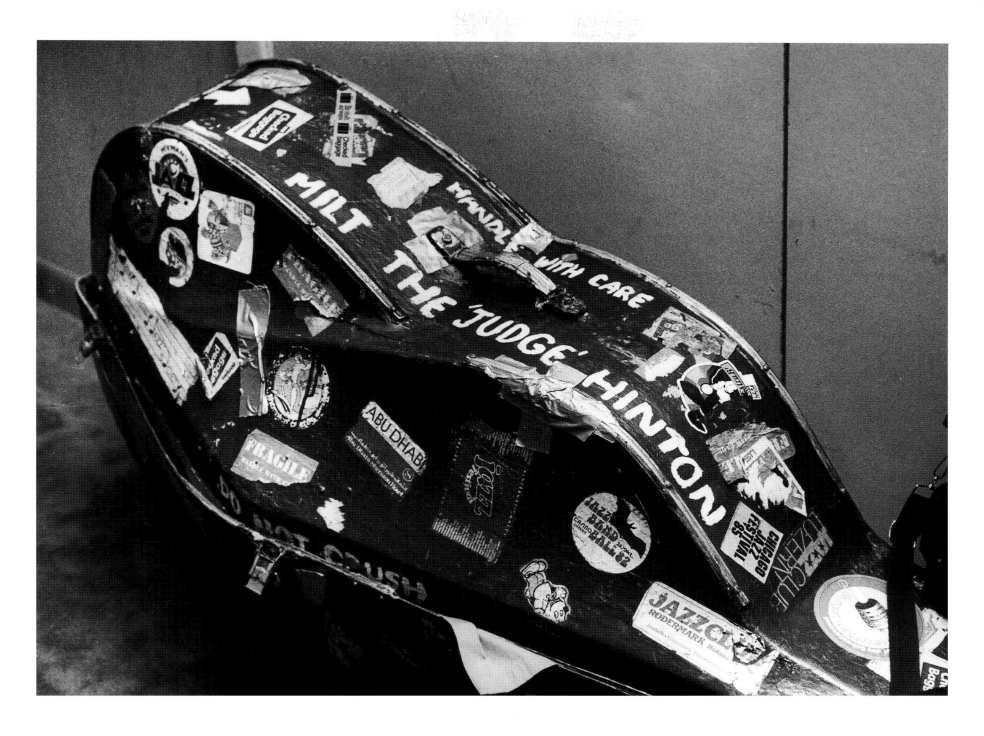

"A Case for the Judge"/ Milt Hinton's bass case, 1986

Duncan Schiedt

has photographed jazz musicians for sixty years. He is the author of several books, including *The Jazz State of Indiana* and *Twelve Lives in Jazz,* and is co-author of *"Ain't Misbehavin'": The Story of Fats Waller* with Ed Kirkeby and Sinclair Traill. Schiedt's original and archival photographs were featured in Ken Burns's landmark PBS series *Jazz,* and his work has appeared in international art exhibits and trade and academic publications worldwide.

Book and Jacket Designer: Sharon L. Sklar

Copy Editor: Jane Lyle

Compositor: Sharon L. Sklar

Typefaces: Adobe Caslon, Univers Condensed, and Ellington

Book and Jacket Printer: Four Colour Imports